Chinese
Dress in Detail

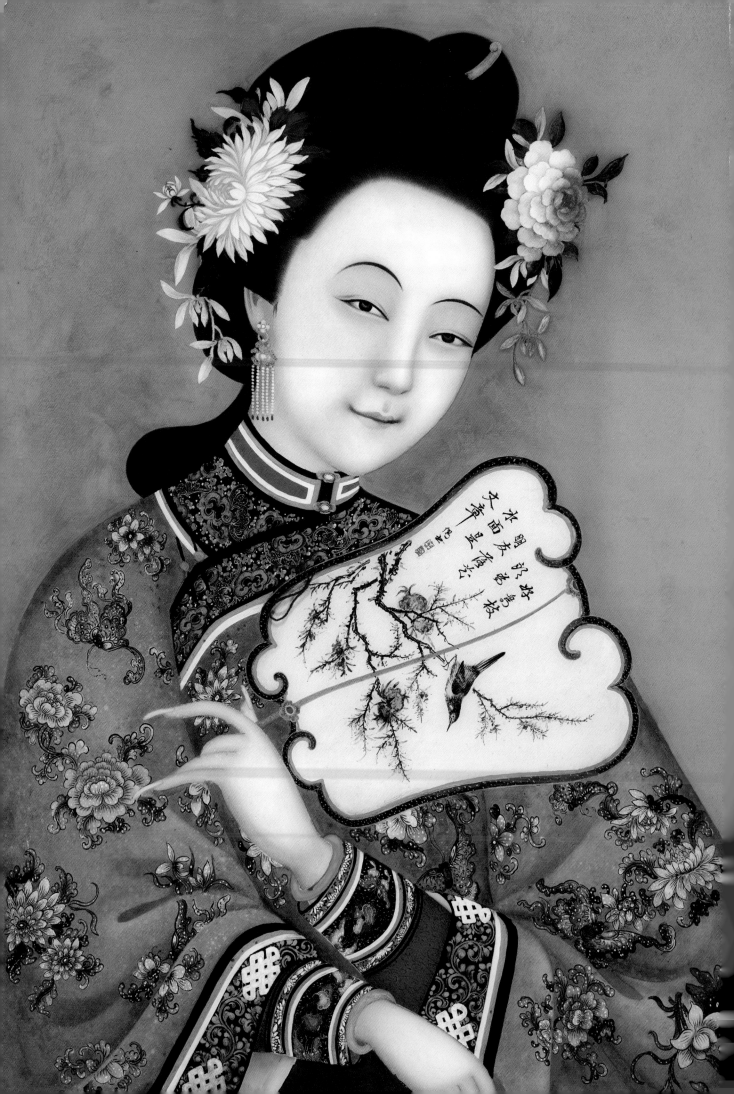

Chinese
Dress in Detail

Sau Fong Chan

Photographs by Sarah Duncan

Thames &Hudson | V&A

Frontispiece:
Woman Figure Holding a Fan. Guangzhou, 1800–50
(detail; see full work on p. 48)

First published in the United Kingdom in 2023 by
Thames & Hudson Ltd, 181A High Holborn, London WC1V 7QX,
in association with the Victoria and Albert Museum, London

First published in the United States of America in 2023 by
Thames & Hudson Inc., 500 Fifth Avenue, New York, New York 10110

British Library Cataloguing-in-Publication Data
A catalogue record for this book is available from
the British Library

Library of Congress Control Number 2023939225

ISBN 978-0-500-48093-9

Printed in Bosnia and Herzegovina by GPS Group

Be the first to know about our new releases,
exclusive content and author events by visiting
thamesandhudson.com
thamesandhudsonusa.com
thamesandhudson.com.au

V&A Publishing
Supporting the world's leading
museum of art and design,
the Victoria and Albert
Museum, London

Contents

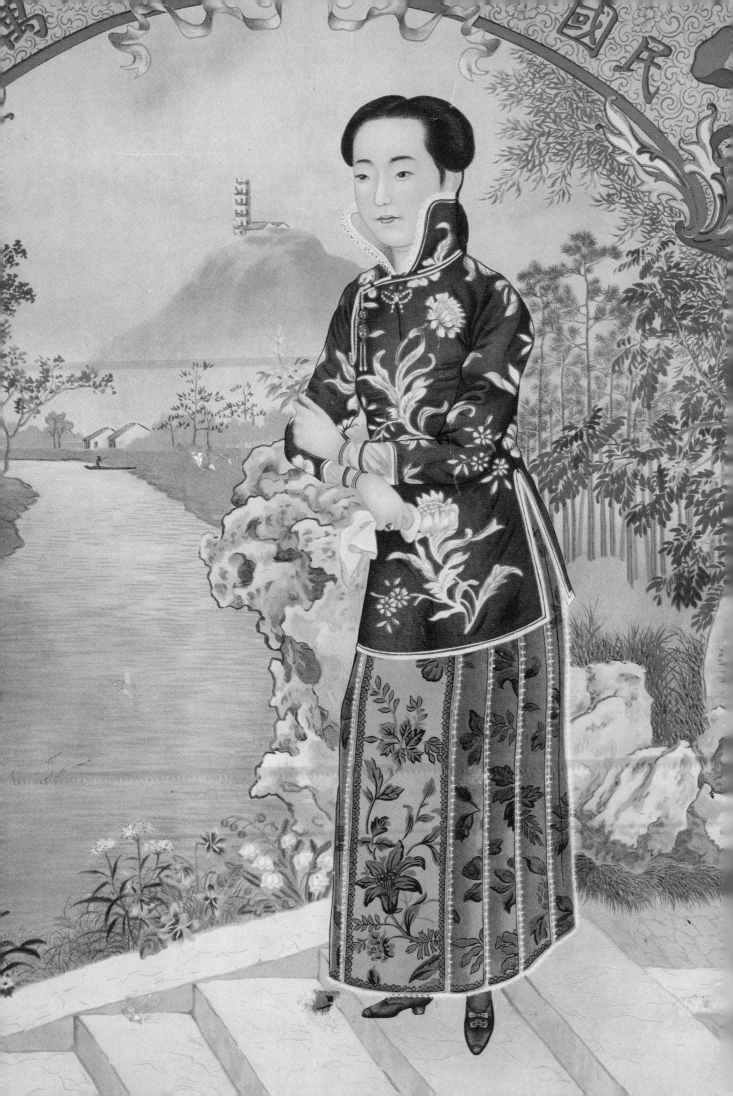

INTRODUCTION

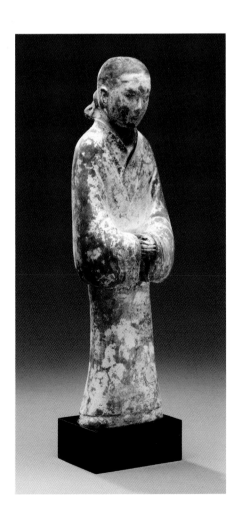

Dress in China has long been used to reveal and regulate status. The *Liji* (Book of Rites) and *Zhou li* (Rites of Zhou), ancient texts on ritual that date back to the Zhou dynasty (1051–221 BCE), prescribed different colours and fabrics to be worn according to the rank of the wearer. The *Liji* also noted the importance of wearing hats as a marker of both status and being a member of a civilized society. Wearing the hair in a topknot held by combs, pins or other adornments was also seen as essential socially for all classes and genders.

In the Warring States period (475–221 BCE), boys were initiated into manhood through a capping ceremony (*guanli*), and girls were given hairpins for dressing their hair in a ceremony known as *jili*, to signal that they were now grown women. Bone was one of the most frequently used materials for hairpins in the Shang (c. 1600–1046 BCE) and Zhou dynasties (see p. 39). The tomb of Fu Hao, a female warrior and consort of the Shang king Wu Ding (r. 1250–1192 BCE), contained several hundred hairpins carved from bone. Similar pins have also been found in other royal tombs at Anyang, the capital city of the Shang dynasty, in Henan province, signifying their social and sartorial importance.

Along with the written sources, our knowledge of early Chinese dress is further augmented by pottery figures, mural paintings and textiles discovered in the tombs of aristocrats. These tomb figures were buried along with the deceased in the belief that they would have roles to perform in the afterlife. Whatever the person needed after death was provided, including replicas of servants, food, stoves, soldiers, horses and carriages. Many figures are modelled in a highly realistic manner, and provide vivid evidence of contemporary dress over the centuries, and the changes in fashion.

The Victoria and Albert Museum has been acquiring examples of Chinese dress since 1863, and now holds one of the most important collections outside China. This introduction provides an overview of Chinese fashion across two millennia, celebrating its diversity and honouring its makers and wearers. The garments featured include those worn by the various ethnic populations of China, and across a broad social stratum. They are arranged thematically, from headwear to footwear, with accompanying photographs that illustrate both the beauty and variety of the garments, as well as the many ways in which issues surrounding making and wearing have been resolved. Some of the pieces were made and worn in urban centres, and some in rural areas, but all played an equally important part in the presentation of self to the world.

China's Earliest Fashions

The principal item of clothing in the Han dynasty (206 BCE–220 CE) was a long, flowing robe called a *shenyi*. This T-shaped, wrapped garment had wide sleeves and front panels that closed, one over the other, to form a V-shaped neckline. It was worn on formal occasions by all classes, although the elite would wear silk versions made from generous amounts of fabric. Everyday dress was more practical. Men and women would wear a shorter version of the robe, called a *shan* or *ao*, over trousers (*ku*) or a skirt (*qun*). Women's skirts were usually pleated or gathered below the waistband, which added volume and allowed for ease of movement.

During the Han dynasty, China was a unified state, and it was at this time that the networks of trade known as the Silk Routes were established. Silk and other commodities were transported from the capital Chang'an (present-day Xi'an) across Central Asia to the Middle East, and onwards to Europe by sea. These ancient trade routes played an important role in connecting Asia and Europe, forging cultural exchanges and, above all, stimulating the expansion of silk consumption.

In China, as elsewhere, social, economic, political and cultural changes were reflected in fashion. Under the Sui (581–618 CE) and Tang (618–907 CE) dynasties, China was reunified after three centuries of political division. The trade along the Silk Routes flourished, attracting about one million foreigners, half of whom lived in Chang'an, which was transformed into a vast international metropolis under the Tang. The Tang dynasty, often referred to as China's 'Golden Age', was one of the most prosperous periods in Chinese history. China was also receptive to foreign influence during this period: the fashions, hairstyles and make-up of the urban elite, and textile designs more generally, demonstrated the influence of the Iranian and Turkic peoples of Central Asia, whose clothing in turn reflected their horse-riding culture.

Tomb figures epitomized Tang ideals of beauty and fashion, and revealed the widespread adoption of *hufu*, meaning 'barbarian' or 'foreign dress'. One popular fashion of the 7th century – comprising a narrow-sleeved blouse, a high-waisted skirt gathered below the bust and a scarf, with various jackets worn over the ensemble – did not originate in China, and was probably introduced from Iran. Women began to wear their hair in a high chignon, and as the style became more exaggerated, they would wear false buns on top of their heads. Elite women would adorn their hairstyles with combs and hairpins made from gold and silver (p. 38), sometimes with real or artificial flowers.

BELOW LEFT
Figure of two girls. Earthenware with slip and pigment, China, Northern Wei period, 400–525. Purchased with Art Fund support, the Vallentin Bequest, Sir Percival David and the Universities China Committee. C.865-1936

BELOW RIGHT
Figure of a woman. Earthenware with pigments, China, 625–700. Bequeathed by Mr W.W. Simpson through Art Fund. C.1180-1917

OPPOSITE, ABOVE LEFT
Figure of a woman holding a dog. Lead-glazed earthenware, China, 700–50. Purchased with Art Fund support, the Vallentin Bequest, Sir Percival David and the Universities China Committee. C.815-1936

OPPOSITE, ABOVE RIGHT
Figure of a woman on horseback. Lead-glazed earthenware, China, Tang dynasty, 700–50. Purchased with Art Fund support, the Vallentin Bequest, Sir Percival David and the Universities China Committee. C.95-1939

OPPOSITE BELOW
Figure of a Central Asiatic groom. Lead-glazed earthenware, China, 700–50. C.117-1913

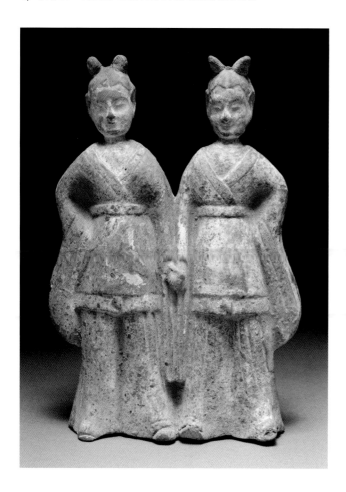

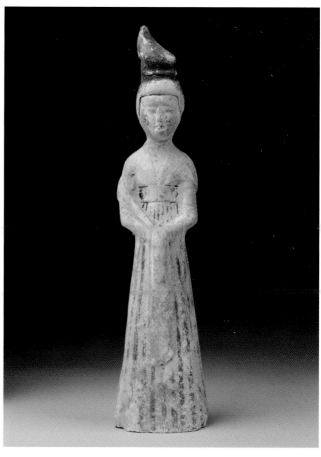

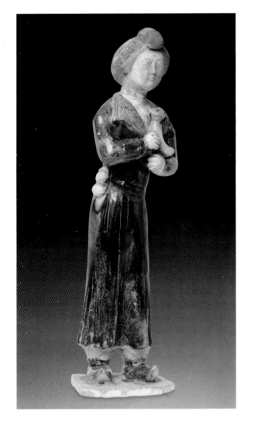

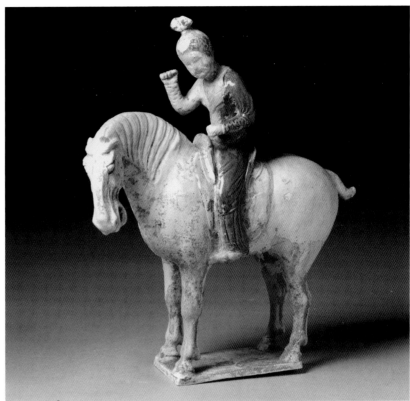

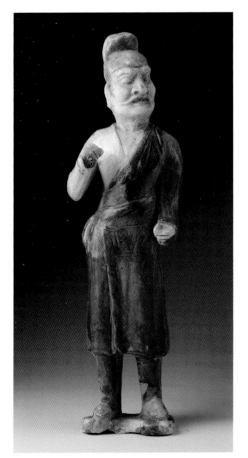

The sight of men and women dressed in *hufu* was a common one on the streets of Chang'an during the 7th and early 8th centuries. Cross-dressing among women of the court and wider aristocracy was also fashionable in the Tang dynasty, and they favoured the styles worn by Central Asiatic grooms and Sogdian merchants, which featured a classic kaftan with long, tight sleeves, a tailored bodice and flared skirt, and front panels that closed one over the other and could be folded down to form lapels. The kaftan was worn over trousers, and was often paired with knee-high boots. This type of dress was particularly suitable for riding, hunting and playing polo, and Tang women were able to enjoy such pursuits, having greater freedom than at any time before.

One woman in particular possessed unprecedented power in politics, becoming the only female in Chinese history to rule in her own right. Wu Zetian (r. 690–705) was the wife of the Tang emperor Taizong (r. 626–649) and later seized power by manipulating her second husband, the emperor Gaozong (r. 649–683), who was weak and suffered from ill health. Despite a posthumous reputation for being merciless and unscrupulous in her ambitions, Wu Zetian proved to be a capable ruler, who carried out many reforms. These included the implementation of state examinations for recruiting government officials, thus creating a bureaucratic system that was based on merit, rather than hereditary privilege and personal recommendation. She is also credited with supporting women's rights by allowing women to be financially independent and to be educated in philosophy and politics.

Although China's early fashion trendsetters were members of the ruling elite, by the 8th century developments in women's clothing were being inspired by the costumes of dancers. Dance and music formed an important part of social life in the Tang capital. The most popular type of entertainment was the *huxun wu*, or 'Sogdian swirl', a dance introduced by the Sogdians, native people of modern Uzbekistan and Tajikistan who had traded in China since the 4th century, bringing exotic goods and luxuries, as well as their arts and customs. The influence of Sogdian dance costumes on the long, narrow dangling sleeves of women's dress

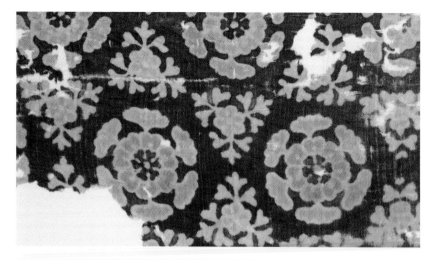

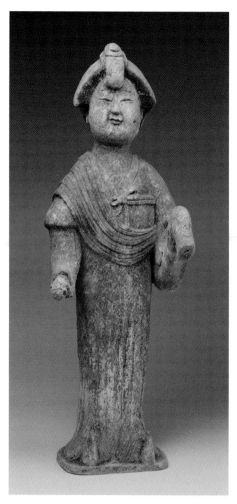

is evident. There were also shifts at this time around notions of the ideal silhouette for women, as the fashion for a slender figure made way for a curvier body shape. Yang Guifei, the favourite concubine of the emperor Xuanzong (r. 712–756), had a voluptuous figure that was much admired and copied, and being plump became fashionable.

During the first half of the 8th century, floral motifs emerged as a new textile design trend favoured by elite women. Dominated by a large floral medallion with smaller clusters of flowers filling the interstices, the origin of the design can be traced back to the Sasanian Empire (224–651) of early Iran. Rosettes were found not only on silk textiles, but also on silverware and ceramics. As technological advances were made in dyeing techniques, the patterning of silk textiles using the more economical resist-dyeing method became widespread. Known as *jiaxie* (squeezed board), the technique was first developed during the 4th and 5th centuries and involved clamping folded fabric between two concave carved wooden boards, pierced with holes to allow the dye to penetrate the silk. *Jiaxie* was used particularly for patterning lightweight plain-weave silk fabrics.

Many of these early clothing styles formed the basis for developments in Chinese dress over the next millennium. Textile consumption and technological innovations prompted new designs and increasingly fine and elaborate materials. During the Song dynasty (960–1279), *kesi* (tapestry-weave silk introduced in the Tang dynasty under the Uygur influence) became the most highly prized of all Chinese textiles. While silk continued to be reserved for the elite, cotton cultivation spread throughout China and replaced hemp and ramie as the main fibre used in clothing for the general population.

ABOVE LEFT
Fragments with floral designs. Clamp-resist dyed plain-weave silk, from Dunhuang, China, 700–900. Stein Textile Loan Collection. On loan from the Government of India and the Archaeological Survey of India. LOAN:STEIN.544, 592

ABOVE RIGHT
Figure of a noble woman. Earthenware with pigments, China, 750–800. FE.47-2008

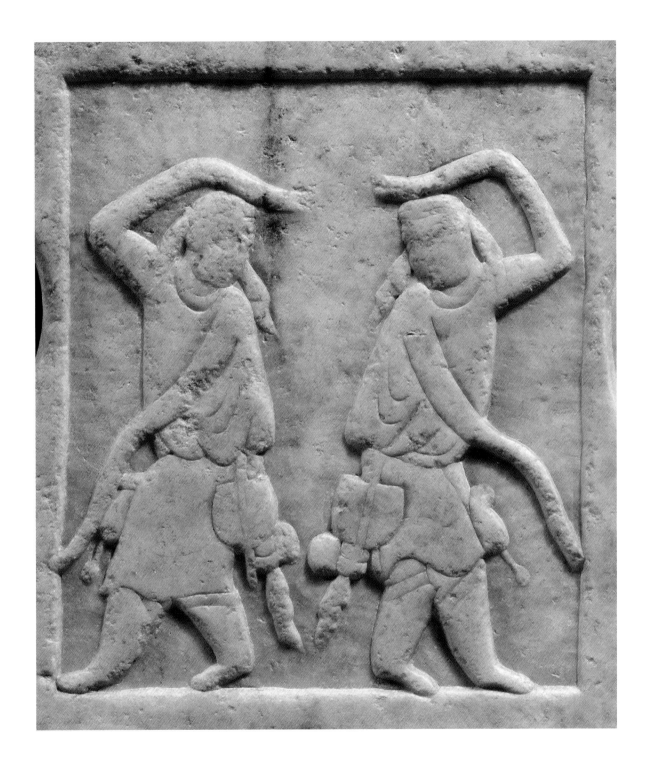

ABOVE
A dancing scene from a funerary couch made for
a Sogdian official. Carved marble, north China, 550–77.
Purchased with Art Fund support, the Vallentin Bequest,
Sir Percival David and the Universities China Committee.
A.54-1937

The Ming Dynasty Onwards

In the Ming dynasty (1368–1644), the major technological development was satin-weave silk, characterized by its smooth, lustrous surface. Glossy satins were mostly used for clothing. From the 15th century, China's silk production was concentrated in the Jiangnan region, south of the Yangzi River. The principal imperial silk workshops outside Beijing were located in Suzhou, Hangzhou and Nanjing. The 'dragon robe', a garment decorated with large dragons and other auspicious symbols, was adopted in the Ming and Qing (1644–1911) dynasties as standard court attire for imperial families and government officials. Rank badges on the front and back of an outer robe indicated an official's position within the bureaucratic hierarchy. Bird emblems were used for civil servants and animals for the military, embroidered or woven (p. 166).

Commercial embroidery workshops thrived in the late Ming period, when embroidery became a major medium for patterning silk. Illustrations

BELOW

Dragon robe for an imperial concubine of the first rank, page from manuscript of *Illustrated Regulations for Ceremonial Paraphernalia of the Present Dynasty Qing Dynasty*. Ink and colour on silk, Beijing, 1736–95. 869-1896

OPPOSITE

Uncut silk for a woman's robe. Satin-weave silk; embroidery in silk and metallic threads, China, 1850–1900. Given by Messrs Spink and Son Ltd. T.151-1961

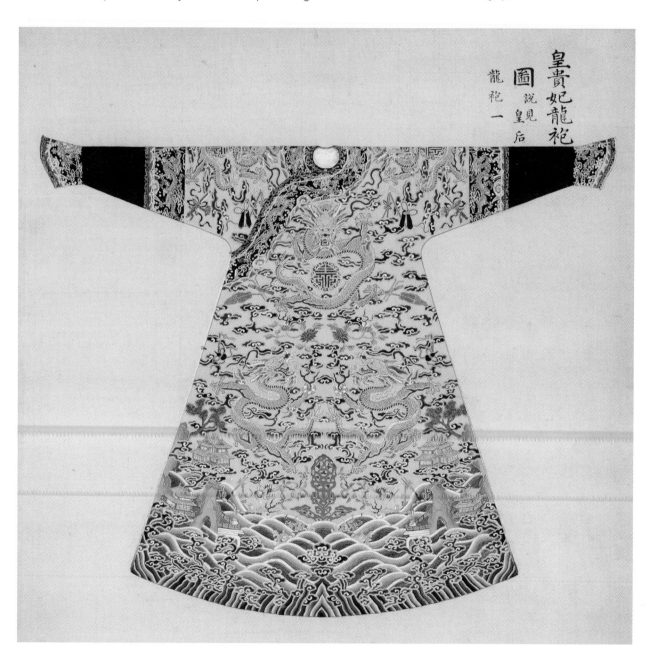

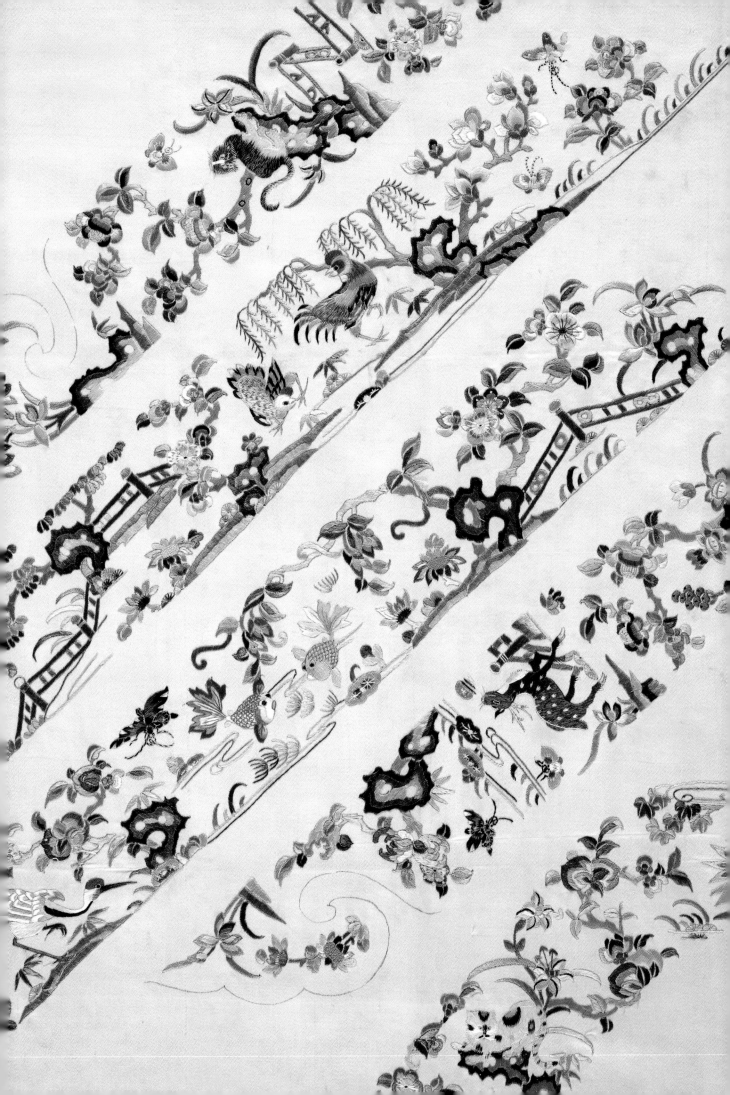

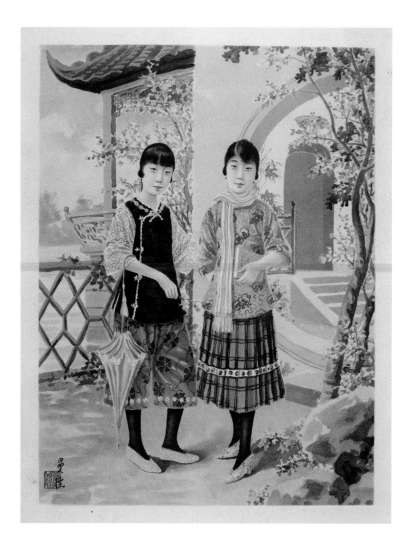

in woodblock-printed books provided basic models of designs, derived from nature, literature, painting, mythology and religion, and were used to decorate clothing and personal adornments. These were chosen not only to reflect the status of the wearer, but also the occasion, as specific motifs were believed to bear auspicious meanings that would ensure happiness, health and prosperity.

After the 1911 Revolution, which brought an end to China's last imperial dynasty, fashion styles began to appear that were deemed appropriate for the urban elites of the new era. Young women and girls preferred to wear clothing and footwear that embodied modernism, using imported western materials to trim their outfits and choosing fabrics with minimal ornamentation (pp. 68, 105 and 126).

In the 1920s and '30s, a new type of dress called a *qipao*, or *cheongsam* in Cantonese, evolved in Shanghai. This was restyled from a Manchu long robe and promoted as a fashionable dress by female celebrities and educated women. By the middle of the century, the *qipao* was generally accepted as China's 'traditional' dress and was popular in Hong Kong and Chinese communities overseas. During the tumultuous years of the Cultural Revolution (1966–1976), the *qipao* was denounced as a symbol of feudalism, but following the economic reform of 1978 it made a gradual comeback, mostly worn by women in the hospitality industry or on special occasions such as weddings or state events.

ABOVE
Poster of two women by Zheng Mantuo (1888–1961). Coloured lithograph on paper, China, c. 1920. FE.487-1992

OPPOSITE
Painting of a tailor. Watercolour and ink on paper, Guangzhou, c. 1790. D.1516-1886

Tailor-Made to Ready-Made

Historically, professional tailors in China were mostly men, working in their own establishments or taking the tools of their trade to their clients' homes. How well a bespoke garment fitted was determined by the tailor's skill in taking measurements. He would also have made notes regarding posture, movement or slight differences in the shape of the shoulders – all of which would be accounted for when making the final garment. A popular Chinese saying, *liang ti cai yi* (meaning that one should act according to actual circumstances), derives from the story of a master tailor in the Ming dynasty who would ask his clients numerous questions about their lifestyles in order to cut perfectly fitted garments that would suit their needs.

Making a T-shaped Chinese robe, as worn by the tailor in the painting below, required two lengths of fabric for the body and upper sleeves. One loom width would be used for cutting each half of the garment, including front and back, the integral upper sleeve and an opening for the neckline. Two lower sleeves and a side-fastening flap would be cut from a third, shorter loom width. The tailor would chalk the lines of the pattern pieces directly onto the cloth before cutting, with rice-paste starch often applied along the cut edges to prevent fraying. There is no seam on the shoulder, only a straight vertical seam down the centre back to join the two widths together. The overlapping section is joined to the rest of the garment down the centre front.

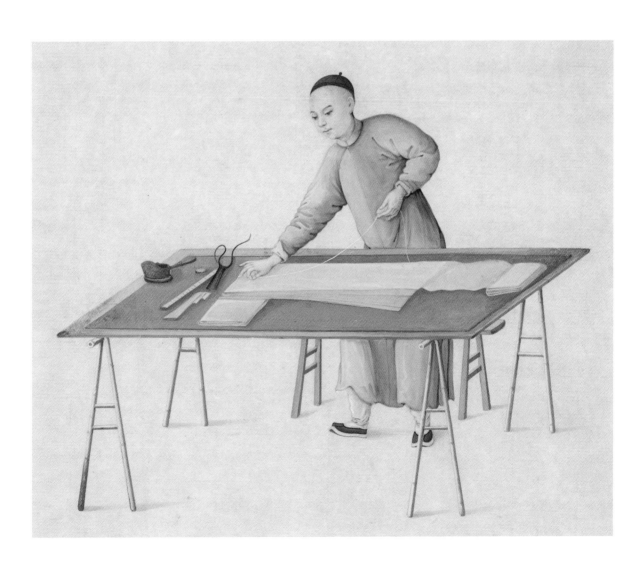

Finally, the robe is folded in half horizontally at the shoulder level, with the side seams continuing underneath the sleeves to join the front to the back. Pressing with an iron during the sewing process ensured a neat, professional finish. The iron, first developed in the Han period, was in the form of a cast-bronze pan with a long handle, filled with hot charcoal. This prototype continued to be used until the early 20th century; in the 19th century some versions had metal pans that were more ornate and made from coloured enamels decorated with floral patterns.

During the Qing dynasty, professional silk workshops began to produce pre-patterned fabrics that were woven or embroidered to delineate the outlines of a garment (pp. 113 and 166). Tailors would then cut around the patterns and stitch them together. Although the time spent on constructing garments was shortened, these pre-patterned fabrics were still of the highest quality and beyond the means of most of the population. The uncut silks, however, were part of the efforts made by silk workshops to facilitate the standardization of ready-made clothing.

Mass-produced ready-to-wear garments were primarily for local consumption, but were later also exported overseas to meet the demand of the Chinese diaspora living across South East Asia. The black shop sign visible in the painting below is inscribed with the word *chengyi*, indicating that the shop sold ready-to-wear garments. The shop sign on the left, in the shape of a woman's robe, is for a secondhand clothes dealer known as a *guyipu*. Wealthy people sent their old clothes, or those that were no longer fashionable, to *guyipu* who sold not only used garments, but also new ones with a slightly inferior quality of finish or made from leftover fabrics. Sometimes they also acted as pawn shops and provided valuations and credit for old garments. The trade in secondhand clothes thrived in the 19th century, and played an important role in the circulation of a fashion system in China.

OPPOSITE
Dress length showing one half of the front, sleeve and a collar band of a woman's gown. Silk velvet; embroidery in silk threads, China, c. 1900. Given by Mr J. Burnet Geake. T.3B-1914

RIGHT
Painting of shop signs by Zhou Peichun Workshop (active c. 1880–1910). Album page, watercolour and ink on paper, Beijing, China, c. 1900. E.3162-1910

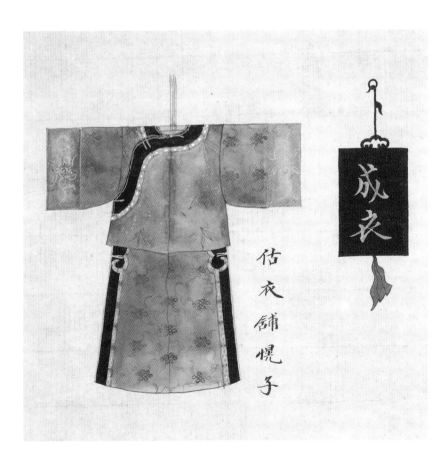

Hanfu and Gen Z

By the year 2000, China was experiencing the fastest economic growth of any country in the world, and had become the largest manufacturer and exporter of clothing. Consumers were by this time fully exposed to global fashion, but the first two decades of the 21st century ushered in a revival, led by China's young people, of *hanfu*, the traditional clothing of the Han people, who make up over 90 per cent of the population. China is home to fifty-six ethnic groups, some of whom still wear traditional costumes at festivals as markers of ethnic identity, but the historic dress of the Han people had mostly disappeared.

The new trend began as a subculture movement in the early 2000s, initiated by millennials who took pride in wearing *hanfu* in public and organized activities where people could dress up and learn about traditional Chinese culture. At first, these garments were handmade or bought from fellow enthusiasts, but in 2005 the first online store to sell *hanfu* opened. In recent years, the fashion-conscious Gen Z has popularized *hanfu* through social media, impacting the fashion sector and the country's economy.

Born from the late 1990s to the early 2010s, when the one-child policy was still in effect, China's Gen Z came of age at a time of tremendous economic growth. Unlike their parents, who rejected such garments as reminders of a long-forgotten past and unsuitable for everyday wear, young people dared to approach *hanfu* in the spirit of fun and experimentation. Growing cultural pride

BELOW
Hanyang zhezhong styling of wearing *hanfu*.
Fanajin, China

OPPOSITE
'New Chinese-style' bridal wear, Tianxi collection by Jusere, Suzhou, China, 2022

has led to a revisiting and appreciation of their roots, and an embracing of *hanfu* as a way of expressing cultural identity, rather than worshipping western luxury brands. They wear *hanfu* on formal occasions, such as Chinese festivals or weddings, and some even enjoy wearing it for everyday. Today, there are *hanfu* styles for all generations. The surge in popularity has transformed the *hanfu* economy into a business opportunity extending beyond the sale of clothing to other related industries, including beauty products, film and television, animation and games, and tourism and museums.

While Gen Z spend much of their time socializing, shopping and gaming online, they also enjoy meeting at large social gatherings such as *hanfu* festivals, where they wear carefully considered costumes, complete with the make-up, hairstyles and accessories of the period. Another popular social activity is cosplay ('costume play'), which involves dressing up and pretending to be fictional characters, inspired by gaming, comics or *wuxia* novels, a highly popular genre about the fictional adventures of martial artists in ancient China. In *wuxia* cosplay, a unique form that combines costume and martial arts, participants dress as *wuxia* characters and perform martial-arts routines in public. The transformative power of these personalized outfits allows cosplayers an immersive experience, temporarily obscuring their everyday identities.

A new wave of designers has joined in this revival and given *hanfu* a fresh spin, creating new garment types for everyday that are hailed as the 'New Chinese' style. Contemporary *hanfu* provides wearers with scope for experimentation and self-expression. It has inherited elements of traditional dress, adapting them to suit modern lifestyles. *Ma mian qun*, a Han woman's pleated skirt (see pp. 98, 101), is constantly being re-imagined and paired with a contemporary blouse and accessories, making it easy to mix and match as part of everyday dress.

Gen Z's desire to pursue individual freedom is reflected in a unique styling of *hanfu* known as *hanyang zhezhong*, which refers to the playful combination < of Chinese and western elements to form an eclectic aesthetic, often by mixing classic and retro styles of western dress with *hanfu*. Garments in pastel tones, flowers, pearls and hats are all used to evoke relaxed, romantic country vibes. Young couples are increasingly turning to traditional wedding ceremonies, and opting for either historic outfits or 'New Chinese'-style wedding dresses inspired by *hanfu*. There are also genderless *hanfu*, as well as *hanfu* for pets.

Chinese dress has not, as is so often perceived, been static. Instead, it is constantly evolving, drawing inspiration and skills from the past in the creation of new fashion. The garments featured on the following pages offer the opportunity to observe such changes, with a focus on those details so often overlooked in other explorations of Chinese fashion.

OPPOSITE
'Galaxy Evoque' and 'Spring Visitor' by Xue Bai for
Ni Meng Chinese Traditional Clothes Studio, China, 2021

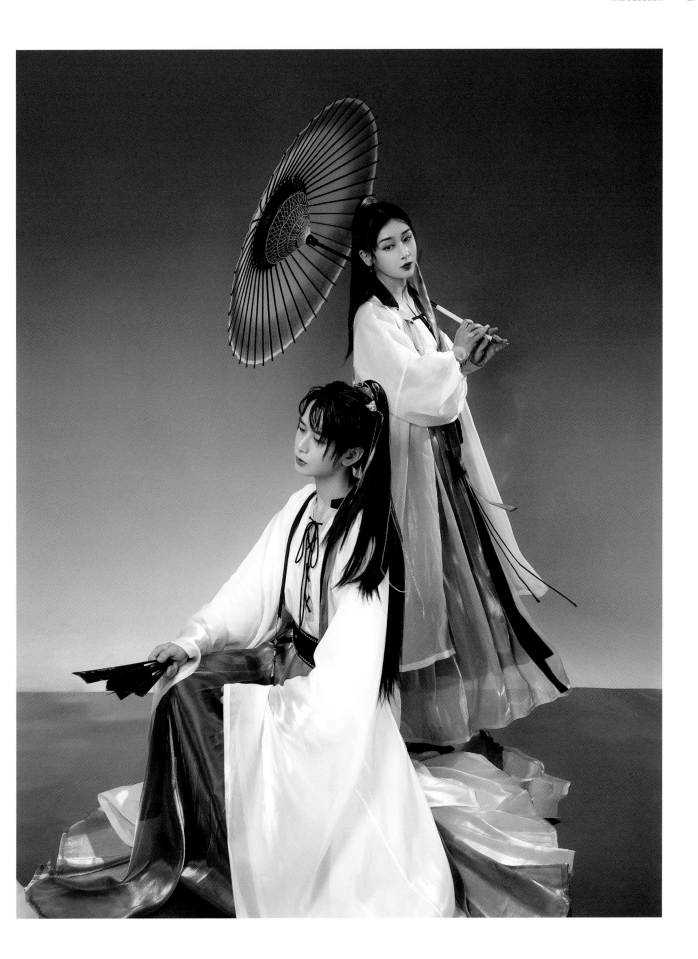

1. Headwear

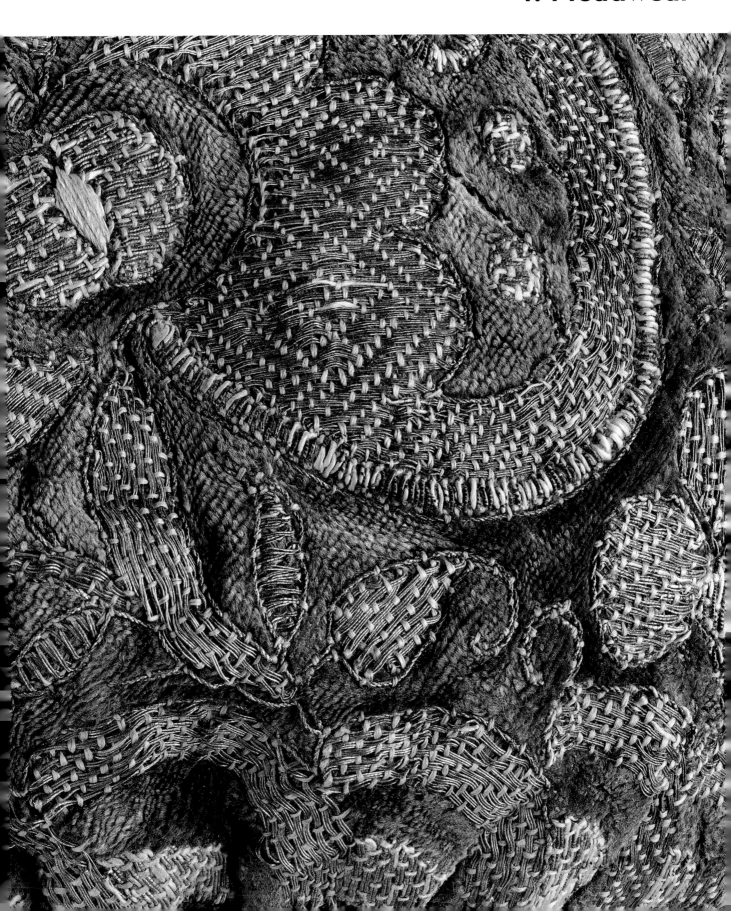

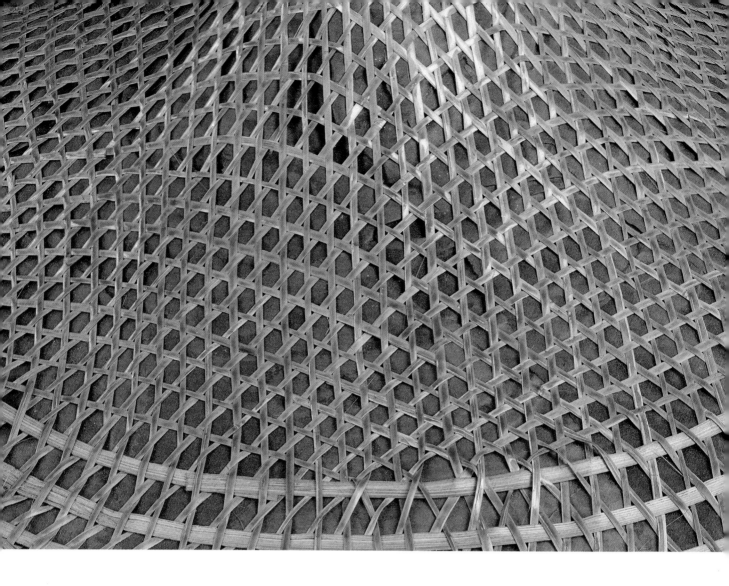

Wide-brimmed hat (*douli*)

Woven bamboo; rattan;
bamboo leaves; tung oil
Hong Kong, 1950–80

Supported by the Friends of the V&A
FE.185-1995

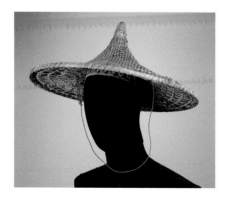

Wide-brimmed hats such as this are called *douli*, and were worn by farmers, fishermen and Buddhist monks to shield them from the sun and rain. This example is formed by a two-layered bamboo mesh structure, with a hexagon weave pattern created by three sets of bamboo strips positioned at a 60° angle to each other.

Bamboo-weaving is an ancient craft in southern China, where the warm temperature and high humidity offer optimum conditions for this fast-growing plant. Bamboo is flexible and can be easily manipulated during the weaving process to compress or form conical shapes, allowing rainwater to run easily off the edge of the brim. A circular bamboo support is inserted inside the crown to ensure the hat fits securely to the head. The final step was the application of tung oil to the exterior to provide a waterproof finish

This bamboo hat with a dropped brim is a typical style worn by fishermen living on boats along the south Chinese coast, who called themselves 'water-faring people'. The wide, sloping brim offered good sun protection, making this hat less vulnerable to squally winds than the bamboo hat opposite. Woven into the top of the crown is an octagon, which resembles the Eight Trigrams, a protective charm for safeguarding the wearer from harm while at sea.

Drop-brim bamboo hat
Woven bamboo; rattan
Hong Kong, 1950–78

Supported by the Friends of the V&A
FE.183-1995

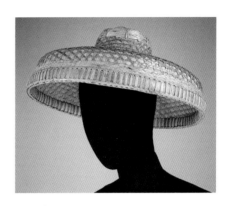

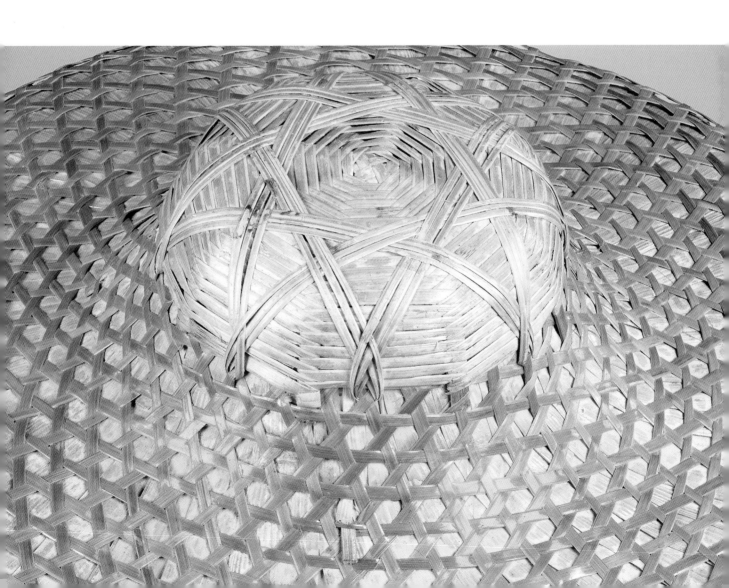

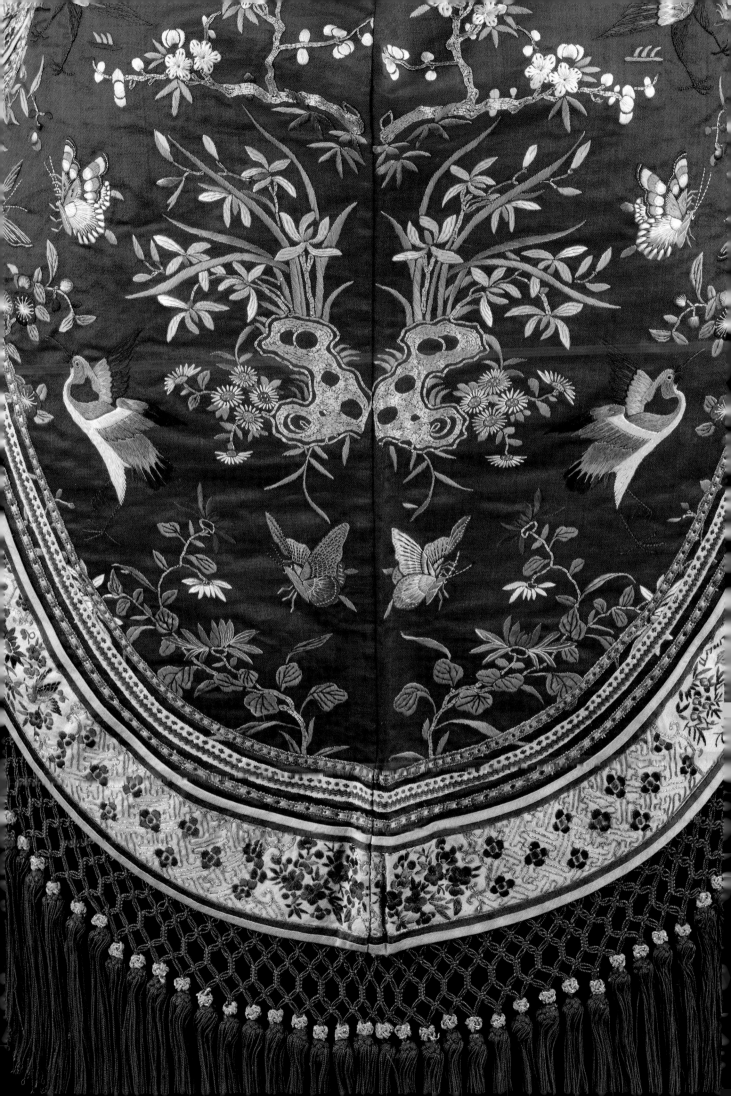

This woman's hood is known as a *fengmao* (wind hat), and was worn with a cloak when travelling in cold weather. It has a large, round crown designed to fit over elaborate hairstyles, and a long, curved back trimmed with blue silk macramé and a tasselled fringe. The vibrant magenta colour of the silk gives the hood an intense and flamboyant appearance. It was probably dyed with one of the earliest synthetic colours imported from Europe from the late 1870s onwards. The hood is richly embroidered with various birds, butterflies and flowers, which convey wishes for longevity, prosperity and beauty to the wearer.

This hood once belonged to Queen Mary (1867–1953), the consort of George V (r. 1910–1936), who was an avid collector of all kinds of objects, including many from China.

Hood for a woman (*fengmao*)
Satin-weave silk; embroidery
in silk and metallic threads
China, 1875–1900

Given by HM Queen Mary
T.109-1964

Woman Dressed in Winter Clothing
Watercolour and ink on paper
Guangzhou, 1800–30

7879

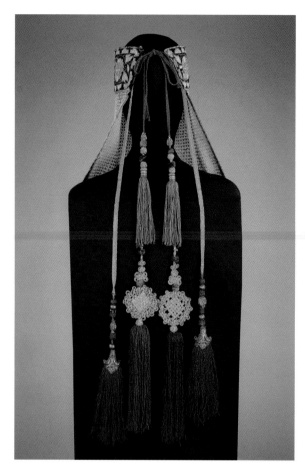
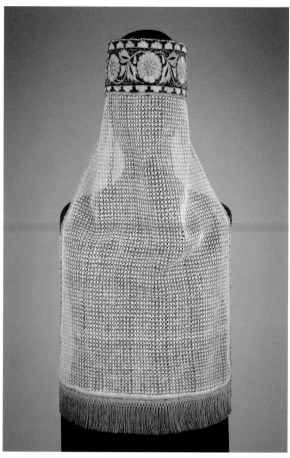

Veil for a Uygur woman
Cotton; silk velvet; silver;
embroidery in metallic threads
Yarkand (Shache), Xinjiang, c. 1873
2141(IS)

Street Scene in Yarkand (detail)
Book illustration, lithograph on paper
Sketched by T.E. Gordon, 1873; published
in T.E. Gordon, *The Roof of the World*,
Edinburgh, 1876

Heidelberg University Library

This spectacular full-face veil (the front is shown above right) would have been worn by a Uygur woman of the urban elite in the late 19th century. It was part of the collection of Sir Thomas Douglas Forsyth (1827–1886), a British administrator in India, acquired during his second expedition to Xinjiang in 1873. The sketch by Sir Thomas Edward Gordon (1832–1914), Forsyth's second in command, illustrates the local 'winter fashions' they observed during their travels.

Married Uygur women generally styled their hair in two braids and donned otter fur-trimmed caps worn over large, white squares of muslin. They concealed their faces with veils in public, but would throw the veils back over the caps when on horseback to allow for clear vision. The technique of pulled-thread embroidery – simply pulling and stitching some of the warp and weft threads together to create small holes – was used to create the openwork effect of the cotton mesh. Unlike most forms of embroidery, the stitches were not designed to be seen. The veil was secured with four tasselled ties, ornamented with various knots in metallic threads – including two very complex endless knots – and interspersed with velvet and silver beading.

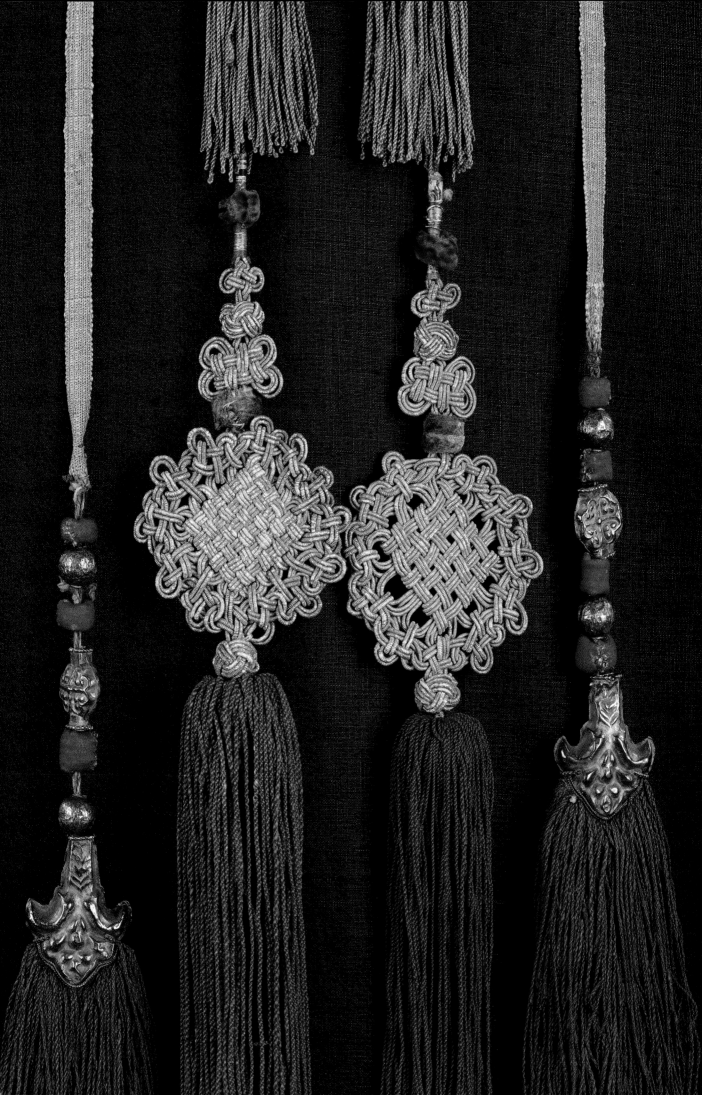

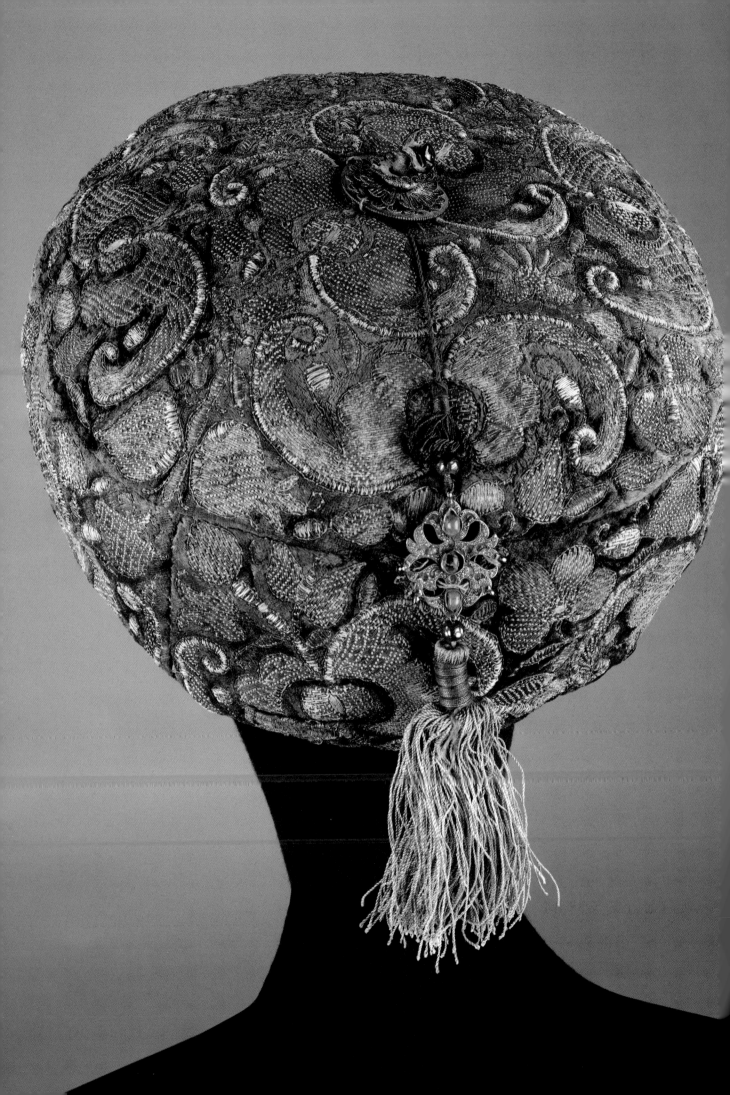

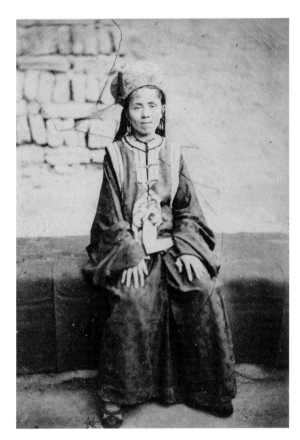
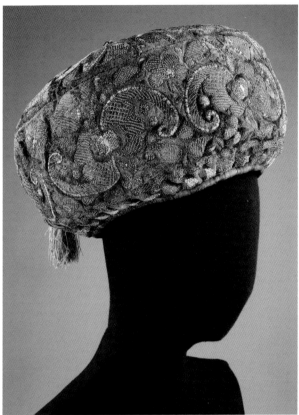

This tasselled spherical cap, similar to a Victorian gentleman's smoking cap, is a winter hat that was probably worn by an aristocratic woman in the city of Hami (Qumul). Located in eastern Xinjiang, Hami had a long history of interaction with China, and its local princes paid tribute to the Qing empire. The inspiration for motifs used on items of Hami clothing came mainly from nature and inherited traditional ornament, sometimes adapted from other cultures, including those of the Han Chinese.

The turquoise velvet of this cap is embroidered predominantly with flying bats and pomegranates in heavily laid and couched work, using silver threads and yellow silk. The bat is a Chinese symbol of happiness and good fortune, while pomegranates are a local fruit and a popular motif for Uygur embroidery. The embroiderer showed creativity and a meticulous attention to detail by adding further couched stitches to make a diamond-lattice pattern on the wings of the flying bats.

Cap for a Uygur woman
Silk velvet; embroidery
in metallic threads
Xinjiang, c. 1873
2067(IS)

Hami Muslim Woman
Photograph
Xinjiang, 1875
Adolf-Nikolay Erazmovich Boiarskii
National Library Foundation, Brazil

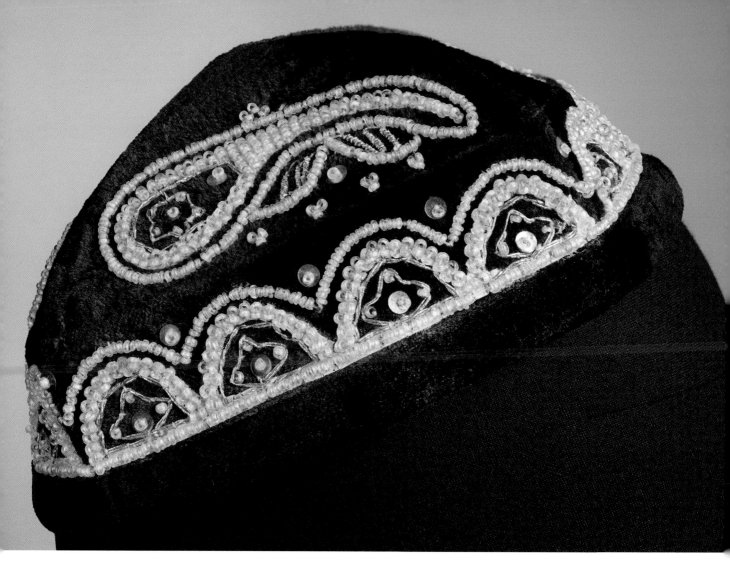

Skull cap for a Uygur woman (*doppa*)

Silk velvet; embroidery in glass beads, sequins and metallic threads
Xinjiang Uygur Autonomous Region, c. 1980

Given by Verity Wilson
FE.16-1983

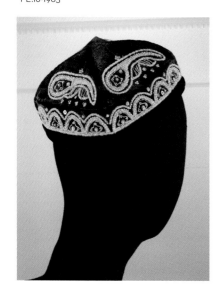

The Uygurs wear embroidered skull caps (*doppa*) as part of their everyday clothing. *Doppa* serve an important function in Islamic religious practice, and also express cultural identity. The crown of this cap is made from green velvet, embroidered with coloured sequins, gold threads and clear glass beads stitched in yellow threads, which give a golden hue to the beads. On the top of the cap are four large *badam* patterns, each in the shape of a teardrop with a curved end. *Badam* is the Persian word for almond, a plant native to Central Asia and Xinjiang. The motif is regularly used in the decoration of local carpets and textiles. Uygur men generally wear the so-called 'almond-pattern' caps (*badam doppa*) in white embroidery on black velvet.

Based on a vendor's note attached to the inside, we know that this is a woman's hat. The donor bought the cap, together with two others (see opposite), in the capital city of Urumqi in 1980, shortly after China reopened its borders as part of the Open Door Policy.

Caps are the most elaborate part of traditional Uygur dress, and there are many regional variations in the decoration, which can also identify the sex, age and profession of the wearer. Colourful skull caps are worn by young women. This example has a square base, and is designed to be folded up when not in use. It comprises four triangular panels, each of which has an identical stylized rose pattern, embroidered in tent stitches with cotton threads in shades of red and blue against a contrasting green background. The canvas-work embroidery gives the textured surface the appearance of a flat-woven carpet.

The Uygurs call this type of cap *tashkent doppa*, tracing its origin back to a popular style worn in Tashkent, the capital of Uzbekistan. The term is now a generic one used to describe a geometric floral-pattern skull cap with tent-stitch embroidery.

Floral skull cap for a Uygur woman (*tashkent doppa*)
Silk velvet; embroidery in cotton
Xinjiang Uygur Autonomous Region,
c. 1980

Given by Verity Wilson
FE.17-1983

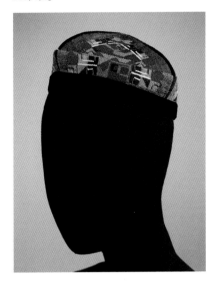

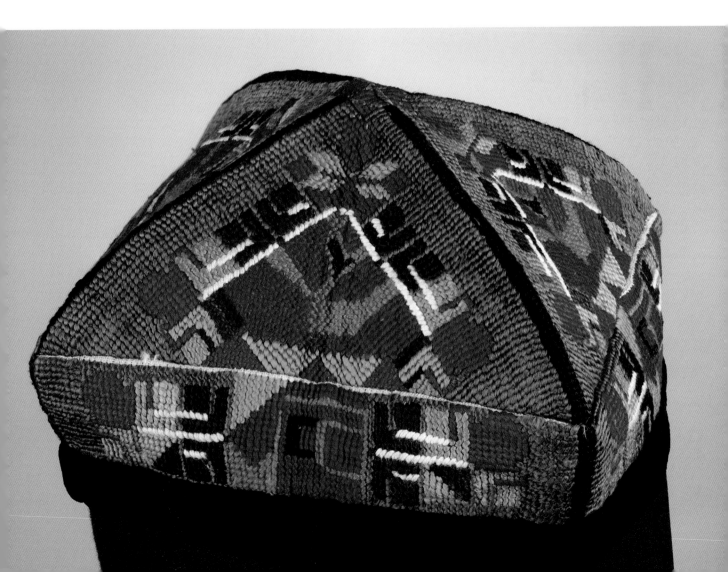

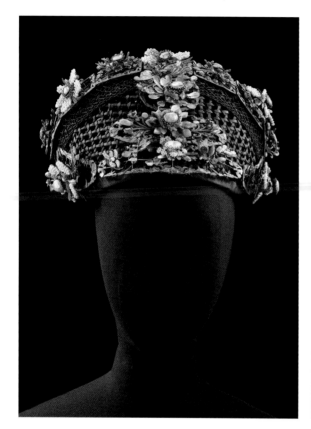
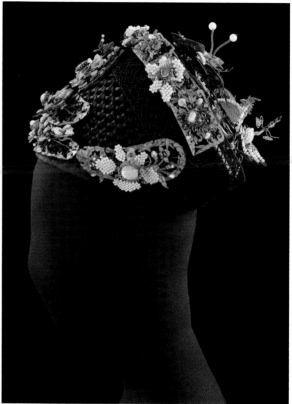

Headdress for a Manchu court lady (*dianzi*)

Gilt copper alloy; kingfisher feathers; gemstones; glass; pearl simulants; silk netting; rattan
China, 1860–1900

Given by Mrs Jennifer Barker
M.118-1966

This horse hoof-shaped headdress (*dianzi*) would have been worn by a court lady during festive occasions. The distinctive shape, which also appeared on the cuffs and heels of other courtly attire, is a vestige of the horse-riding heritage of the Manchu dynasty. The front is richly decorated with twelve floral plaques, each embellished with kingfisher feathers, imitation pearls and a mixture of natural gemstones and simulants in glass. The back has a large flower, flanked by two phoenixes and a butterfly. All of these ornaments are attached to the headdress with coil springs, allowing them to 'tremble' as the wearer moves, similar to the *en tremblant* jewelry worn in 18th-century Paris.

By the late 18th century, when the production of natural pearls was exhausted, imitation pearls were imported from Europe or sourced locally in Guangdong province to meet demand. Three varieties of imitation pearls have been used in this example, including glass bubbles painted on the interior with a pearl-like substance made from fish scales, known as *essence d'orient*; glass bubbles with the same coating, but painted on the exterior; and wax beads coated with *essence d'orient*.

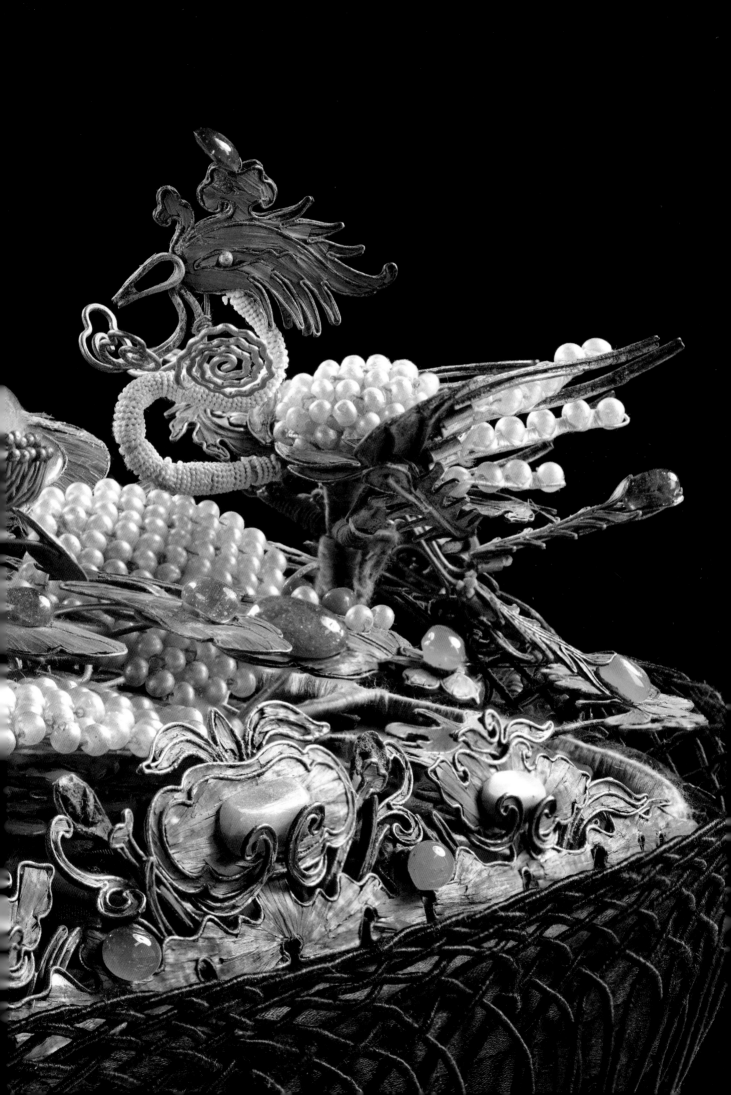

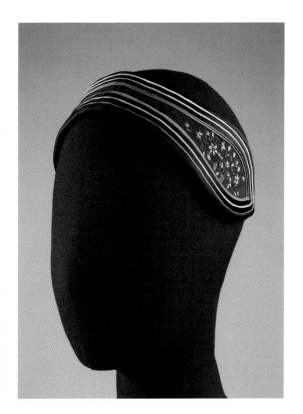

Married Chinese women wore headbands (*mo e*), which were made or bought as part of the wedding dowry, to signal their marital status. It was the convention for a married woman to wear her hair drawn back into a bun at the nape of the neck. As this hairstyle caused the hairline to recede, on reaching middle age women would wear an embroidered band across the forehead for warmth, as well as for beauty.

This shaped headband is narrow in the centre, before broadening out with an embroidered design of flowers in a vase at each end. Colourful satin piping delineates the curved contours, giving this simple headband its striking appearance.

Headband for a woman (*mo e*)
Silk damask; embroidery
in silk; silk satin
Hong Kong, 1910–60
Supported by the Friends of the V&A
FE.170-1995

***Man Selling Squares of Painted
Paper as Window Panels***
Watercolour and ink on paper
Beijing, 1885
Zhou Peichun Workshop
(active c. 1880–1910)
D.1588-1900

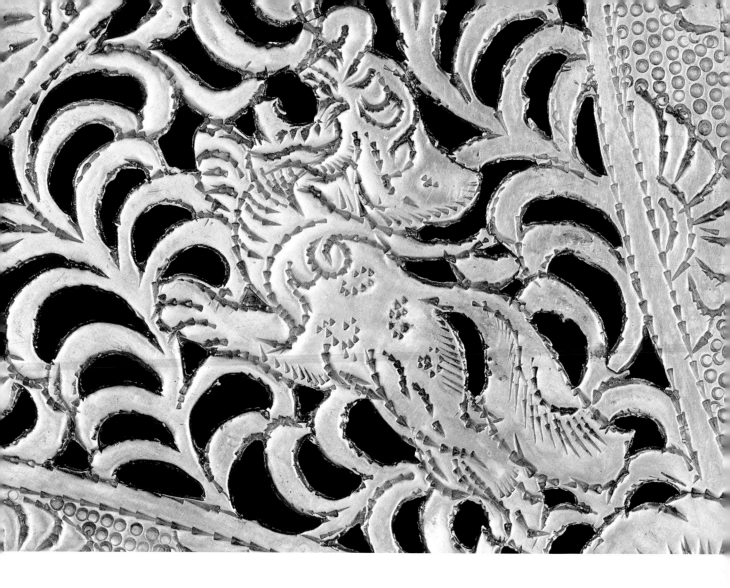

Hairpins (*zan*)

Silver; chased, pierced and parcel-gilt
China, 618–907

Purchased with Art Fund support, the Vallentin
Bequest, Sir Percival David and the Universities
China Committee
M.628A-1935

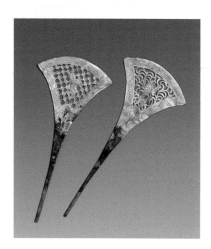

The Tang dynasty marked the high point in the crafting of gold and silver hair ornaments, with both the technique and style showing the influence of Persian and Sasanian silverware. These two hairpins (*zan*) have been beaten into shape from sheet silver. The finial decoration is in openwork: on one pin, a lion roars amid leaf scrolls; on the other, a flying bird is seen against a cross-pattern. Both motifs are surrounded by a border of half-palmettes and further enhanced by the gilding of the pattern areas, a technique that also protects the silver surface from tarnishing.

As women's hairstyles became higher and more sophisticated, new types of hair accessories were developed to dress them. Royal and aristocratic women wore buns of false hair decorated with an elaborate array of silver hairpins like these to dazzle and impress. Hairpins also became significantly larger, ranging from 20 to 35 cm (8 to 14 in.) in length. The number of hairpins worn was also indicative of the wearer's social status.

This bone hairpin (*ji*), carved with the figure of a stylized bird, is one of the oldest hair ornaments in the V&A. Although both men and women wore hairpins, its original owner was probably a woman. Numerous similar hairpins have been found in the tombs of aristocratic women in Anyang, the capital city of the Shang dynasty, the earliest recorded dynasty in China's history. This is also when the earliest form of Chinese writing developed, and silk use was widely distributed throughout China.

Hairpins crafted from animal bones such as cattle, pigs and deer were luxury items produced by local workshops for the elite. In ancient China, such hairpins symbolized an important rite of passage for young women, indicating they were ready to marry. Marking the transition from childhood to adulthood, girls began to style their hair in buns with a pair of hairpins from the age of fifteen.

Hairpin (*ji*)
Carved bone
China, 1100–1046 BCE

Purchased with Art Fund support, the Vallentin Bequest, Sir Percival David and the Universities China Committee
A.51-1938

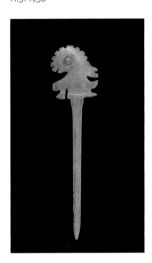

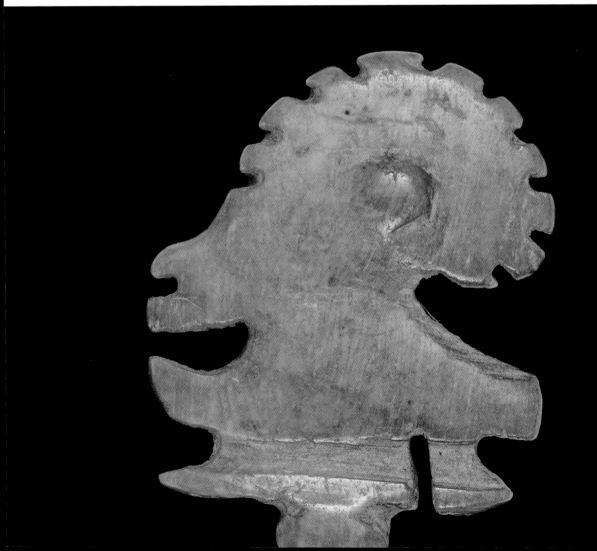

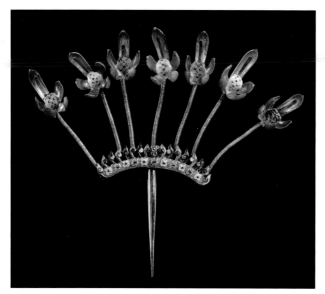

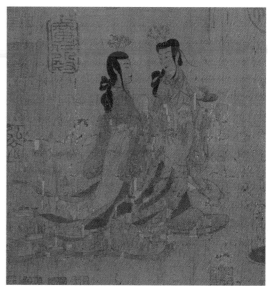

Hairpin (buyao)
Silver-gilt; enamelled
Stamped 'Baocheng' (寶成)
China, 1880–83

1265-1883

**Admonitions from the Instructress
to the Court Ladies (detail)**
Handscroll, ink and colours on silk
China, 400-700
After Gu Kaizhi (c. 344-406)

The British Museum, London

Seven orchid blossoms adorn this enamelled silver-gilt hairpin, each set on a spring mount. Hair ornaments such as this are called buyao, meaning 'step and sway', alluding to the 'trembling' action that occurs when the wearer moves. The technique of incorporating movement into the design of head accessories is believed to date back at least 1,500 years. It involved creating mobile parts, which often featured delicately quivering flowers, insects or birds mounted on wire-coiled springs to suggest realistic movement and height.

Such hair ornaments became fashionable among court ladies during the 5th and 6th centuries. The allure of these hairpins lay in the grace and elegance they imparted, which gave the impression that the wearer was floating along in the breeze, as shown in a scene with two palace ladies from The Admonitions Scroll.

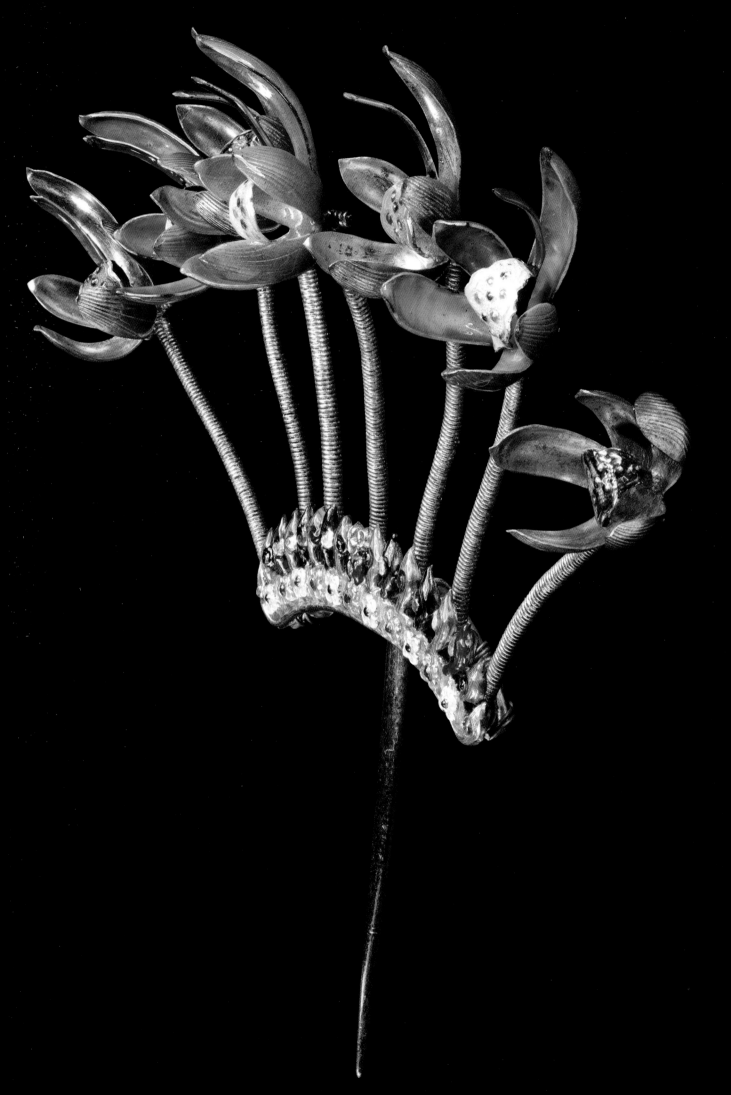

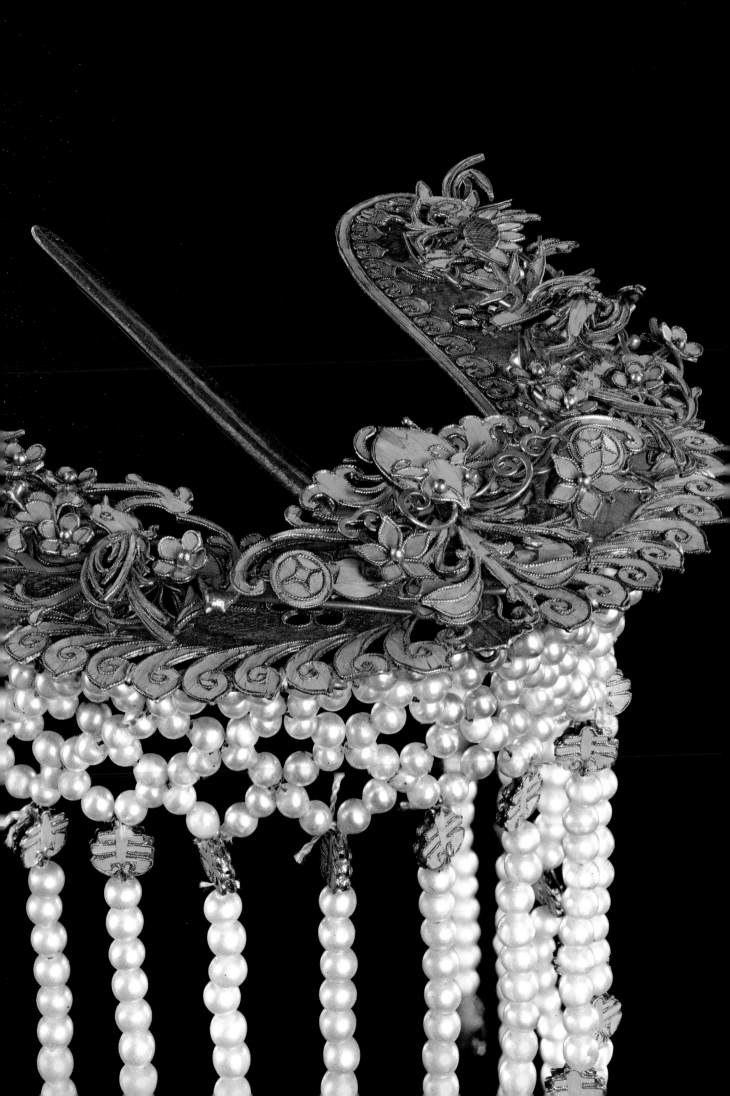

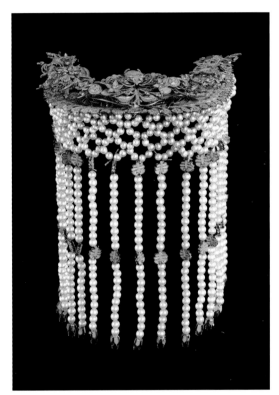

This remarkable hairpin would have certainly drawn attention to its wearer. Made from silver-gilt and U-shaped, it has 'trembling' ornaments of a bat, birds and flowers, mounted on wire springs and decorated with kingfisher-feather inlay. From these are suspended netting and strings of imitation pearls with drop pendants in red glass. Fashioning head accessories with kingfisher feathers on precious metals is an ancient craft that is unique to China. The technique is known as *diancui* ('dotting kingfisher feather'), referring to the painstaking process of cutting the feathers into tiny pieces and gluing them onto the shaped metal using animal adhesive.

'Trembling' hairpins decorated with kingfisher feathers were prized for their lightness and iridescent turquoise colour by women of the nobility and the wealthy merchant class during the 18th and 19th centuries. The V&A bought this eye-catching hairpin in 1883 from the International Colonial and Export Exhibition in Amsterdam, when the use of feathers on women's hats and other garments was the height of fashion in Europe and America.

Hairpin (*buyao*)
Silver-gilt; kingfisher feathers; imitation pearls; glass beads; silk thread
Stamped 'Baocheng' (寶成)
China, 1880–83

1238-1883

Jeweller Pasting Kingfisher Feathers on a Silver-Gilt Frame
Watercolour and ink on paper
Beijing, 1885
Zhou Peichun Workshop
(active c. 1880–1910)

D.1652-1900

Hairpin (*buyao*)
Pith paper; brass; animal glue
China, 1850–75

FE.48-2021

Artificial flowers
Plain-weave cotton; silk; wood
Miran, 300–400

On loan from the Government of India
and the Archaeological Survey of India
LOAN:STEIN.628

This quivering hairpin was fashioned using the now lost craft of making artificial flowers by hand, a thriving industry in Yangzhou in the 18th century that employed thousands of workers, male and female. The flowers were made of paper derived from the pith of the plant, known as *tongcao* (*Tetrapanax papyrifer*), which was native to southern China and Taiwan. The white pith paper was thin, brittle and translucent; when damp, it became flexible and could be moulded into shapes that would remain after drying. It could also be easily dyed to create realistic looking petals.

Chinese women, regardless of age or class, had a long tradition of wearing natural or artificial flowers. The fashion of wearing *tongcao* flowers was so popular that an imperial workshop was set up in 1723 to produce them exclusively for court use.

Artificial flowers have a long history in China. The group illustrated here, dating to the 4th century, was recovered from the oasis town of Miran, in northwest China, by Sir Aurel Stein in the early 1900s. The blossoms are of plain-weave cotton or silk, with wooden pegs and tufts of threads to represent stalks and stamens. They may have been votive offerings made by worshippers at the Buddhist shrine in Miran.

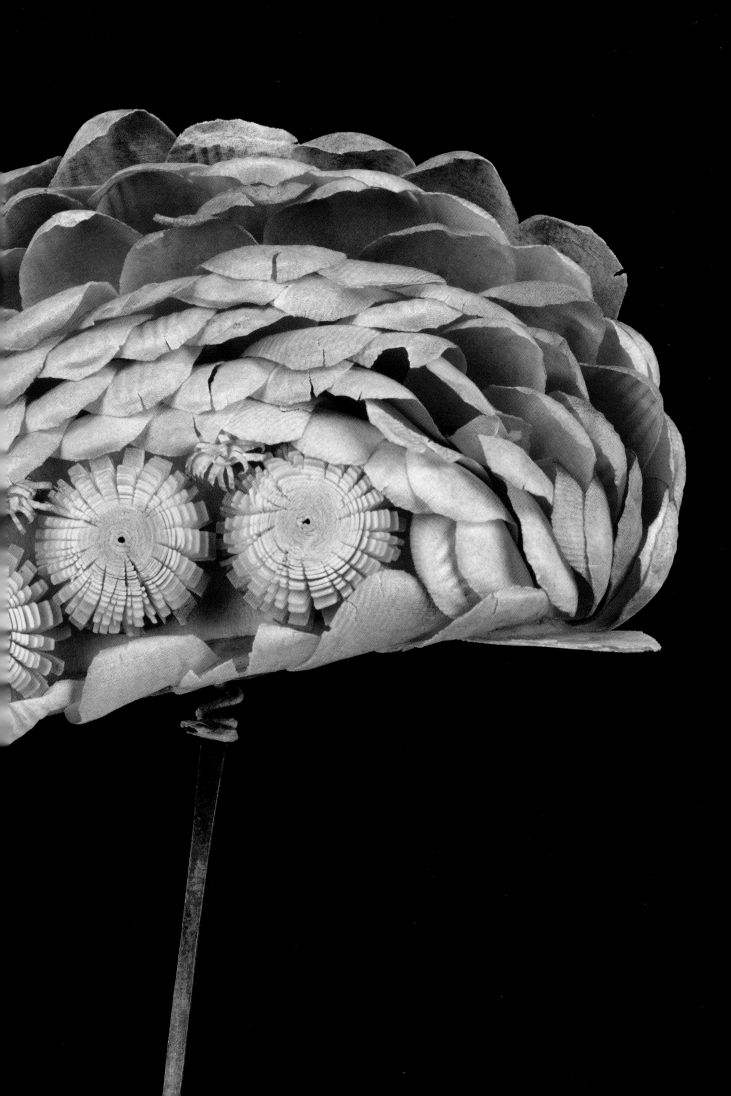

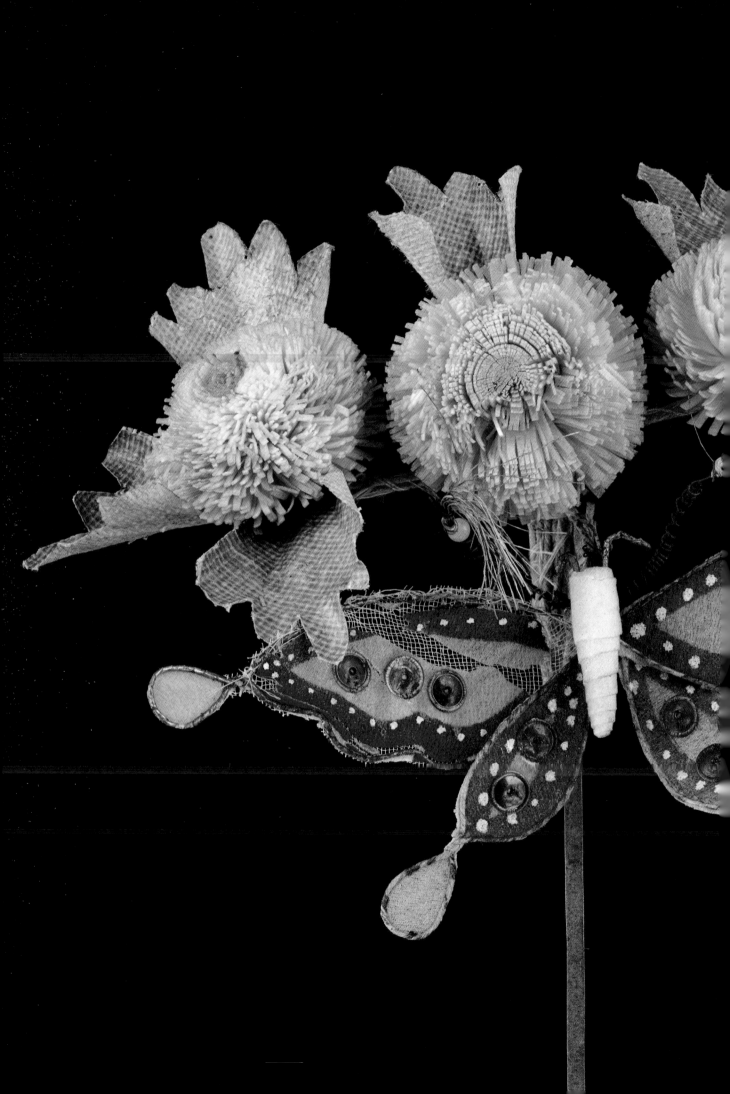

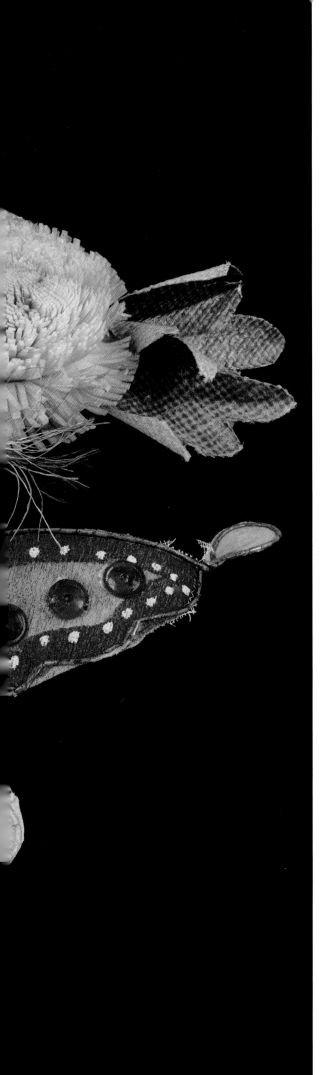

Hairpin (*buyao*)
Pith paper; watercolour; plain-weave
cotton; sequins; brass
China, 1850–75

FE.39-2021

Itinerant Vendor of Artificial Flowers
Watercolour and ink on paper
Beijing, 1885
Zhou Peichun Workshop
(active 1880–1910)

D.1651-1900

'Trembling' artificial flowers and a butterfly adorn this intricate hairpin, made by a craftsman who created the blossoms with ingenuity and a keen understanding of the materials. Small segments of pith were partially dyed in pink, then skilfully cut to represent the densely layered petals. The leaves are made from plain-weave cotton, with an application of a green shiny coating on the uppermost side. Fine iron wires and pith paper were used to fashion the butterfly, with the wings further embellished with watercolour and glass sequins. This combination of flowers and butterflies was immensely popular in China.

The hairpin was previously on loan to the V&A from H.M. Commissioners for the Exhibition in 1851. It is one of the few known surviving examples of the traditional Chinese craft of *tongcao hua* (pith-paper flowers). The painting depicts a street vendor selling pith-paper artificial flowers, with the scene described in the accompanying caption.

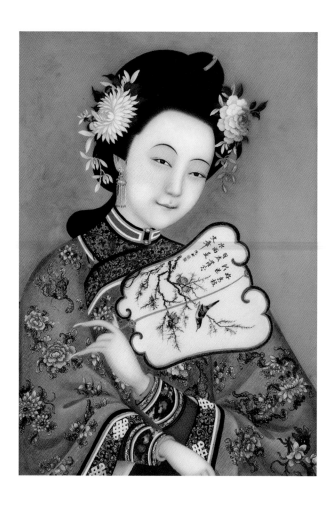

Hairpin
Silk; iron
China, 1850–75

FE.28-2021

Woman Figure Holding a Fan
Coloured pigment on glass
Guangzhou, 1800–50

1150-1852

To create this hairpin, waste-silk was fashioned into a bunch of bright-red artificial flowers and green leaves. The material is made from silk fibres in a non-woven structural process that made use of leftover raw silk not otherwise suitable for reeling and spinning. After undergoing the process of boiling, rinsing, beating and drying on a bamboo mat, the final product becomes a thin sheet of silk, smooth as a piece of paper, and is known as 'silk paper' or 'floss sheet'. After dyeing, the fabric would be treated with a sizing agent to promote adhesion. This could be agar-agar, isinglass (fish-glue) or starch obtained from wheat or rice, depending on what was available locally.

Red artificial flowers such as these were widely worn during festivals and special occasions like weddings, as red is an auspicious colour representing happiness and good fortune. To make such realistic silk flowers, craftsmen would sometimes incorporate dried natural plant materials to create the stamens, and use special pressing tools to imprint the leaves with natural-looking veins.

This hairpin represents the cymbidium orchid, which has been cultivated in China for thousands of years. Since the time of Confucius (551–479 BCE), it has been associated with the nobility and integrity of a true gentleman, an allusion to the wild orchids that grow in deep valleys with no one to admire their beauty and fragrance. Members of the literati class began to identify themselves with the orchid, and it became a popular subject for scholar artists. It has also been used to symbolize the true beauty of a woman.

The orchid blossoms and the large, dull green leaves of this hairpin are made from waste-silk, also known as 'floss sheets'. The slender leaves feel rather stiff, and are probably made from ramie ribbons obtained from the stems of *Boehmeria nivea*, a member of the nettle family native to China. The term 'ramie ribbons' describes the bark and adhering fibre, which are separated from the stalk. The material was widely used for fine bookbinding and millinery.

Hairpin
Silk; ramie; iron
China, 1850–75

FE.29-2021

Album page with an orchid
Watercolour on paper
China, 1850–86

D.987-1886

2. Necklines and Shoulders

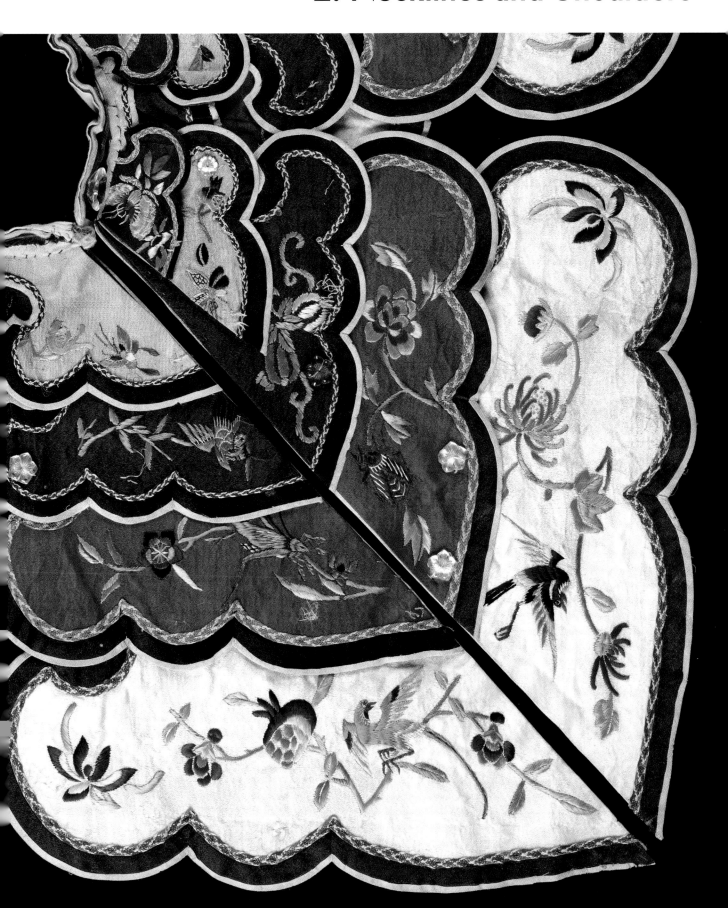

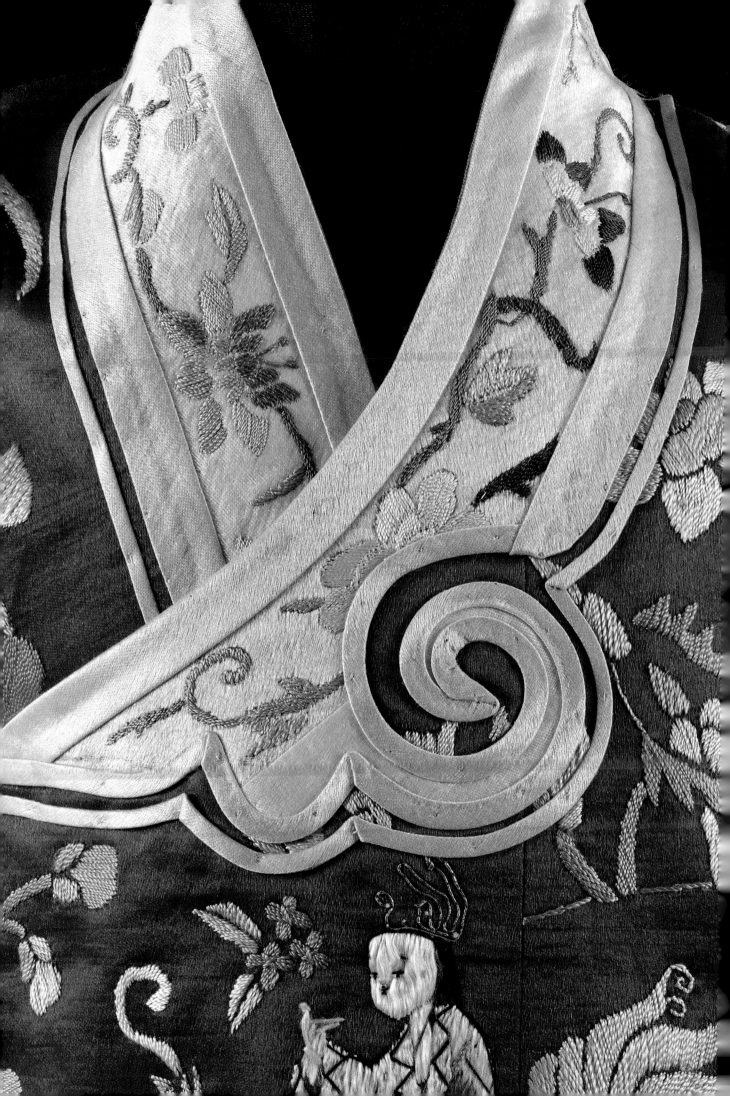

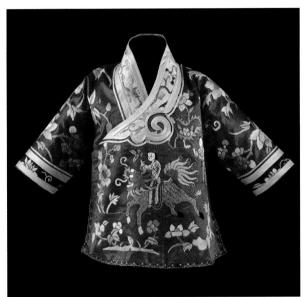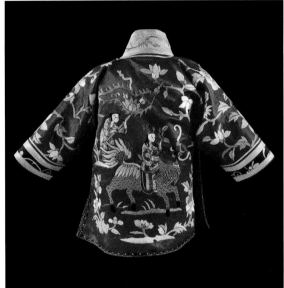

This early 20th-century child's jacket is in the style of a Ming dynasty upper garment called an *ao*. Such jackets are characterized by a front overlap, which closed on the wearer's right side, held by a pair of ties. The overlap section of the collar band is beautifully shaped into a half '*ruyi*-cloud' pattern, a wish-granting symbol. The embroidered white length of silk that forms the collar band is edged with narrower strips of bias-cut ice-blue silk, following the curved outline. Similar edgings have been applied around the cuffs. The main body is a strong red: a colour associated with joyous occasions. The gold-crowned figure riding on a *qilin* in the centre depicts a wish for a son who will be successful in government high office.

The jacket is part of a complete set made in northern China in 1915 for a European family, the Perriams, by their Chinese neighbours. It was the custom in China to present families with colourful clothing for a child, often before the birth. The baby was a girl.

Jacket for a child
Satin-weave silk; embroidery
in silk and metallic threads
Jinan, Shangdong province, 1915

FE.12-1986

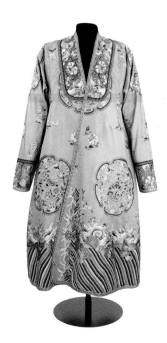

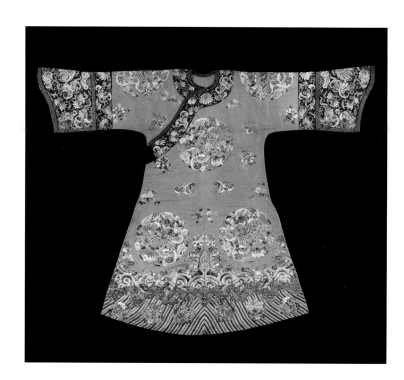

Outer coat for a man (*chapan*)
Twill-weave silk; embroidery
in silk and metallic threads
Yarkand (Shache), Xinjiang, c. 1873

2157(IS)

**Festive robe for a Manchu
woman (*jiapao*)**
Twill-weave silk; embroidery
in silk threads
China, 1821–50

Purchased with Art Fund support
T.209-1948

An affluent man in Yarkand county (known today as Shache) in the Xinjiang Uygur Autonomous Region would have worn this pale-green outer coat (*chapan*) over another eye-catching silk robe on special occasions. The *chapan* was the standard robe for outdoor wear, worn by both men and women in the urban areas of Xinjiang. The cut shows a strong Central Asian influence, with a front opening without fastening and long, narrow sleeves to cover the hands as a sign of respect.

The coat was remade from a festive robe made for a Manchu court lady. The alteration includes the removal of the side-fastening overlap across the front and lengthening of the sleeves. The added lengths were embroidered in a similar style to the original, with fruiting branches and floral sprays, but in chain-stitch, rather than the satin-stitch embroidery of China. The neckline and cuffs were applied with external facings embroidered with butterflies, pomegranates and peonies in coloured silks on a couched gold thread background, adding rigidity and opulence. All of the edgings have been finished with floral motifs in silk ribbons.

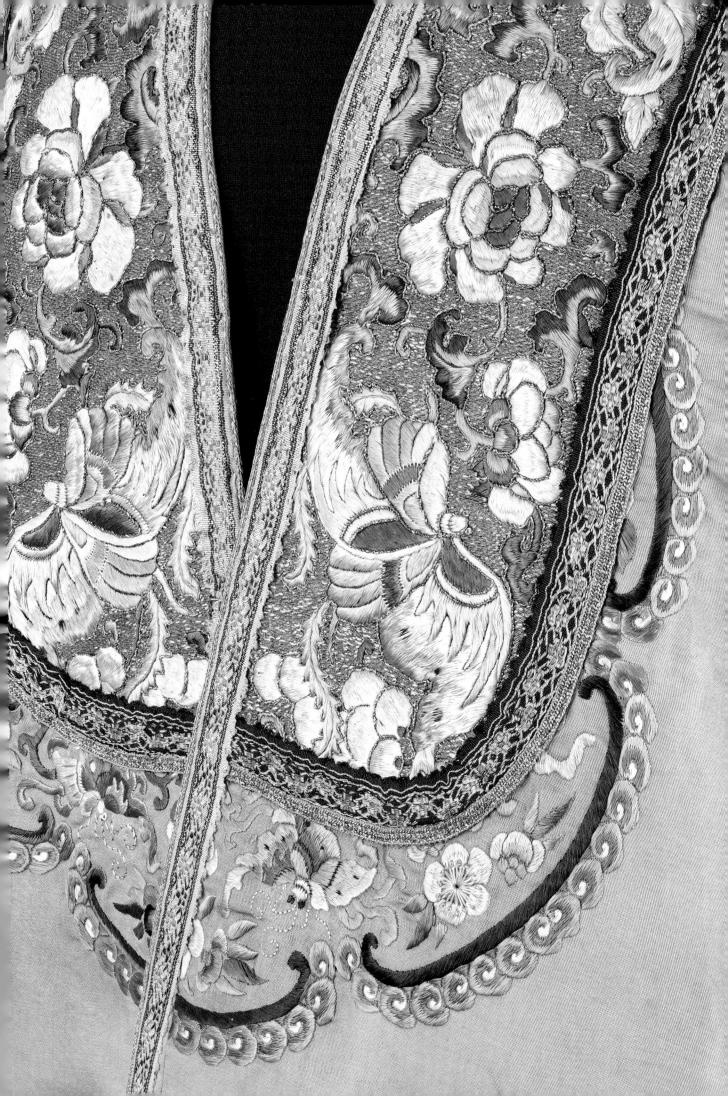

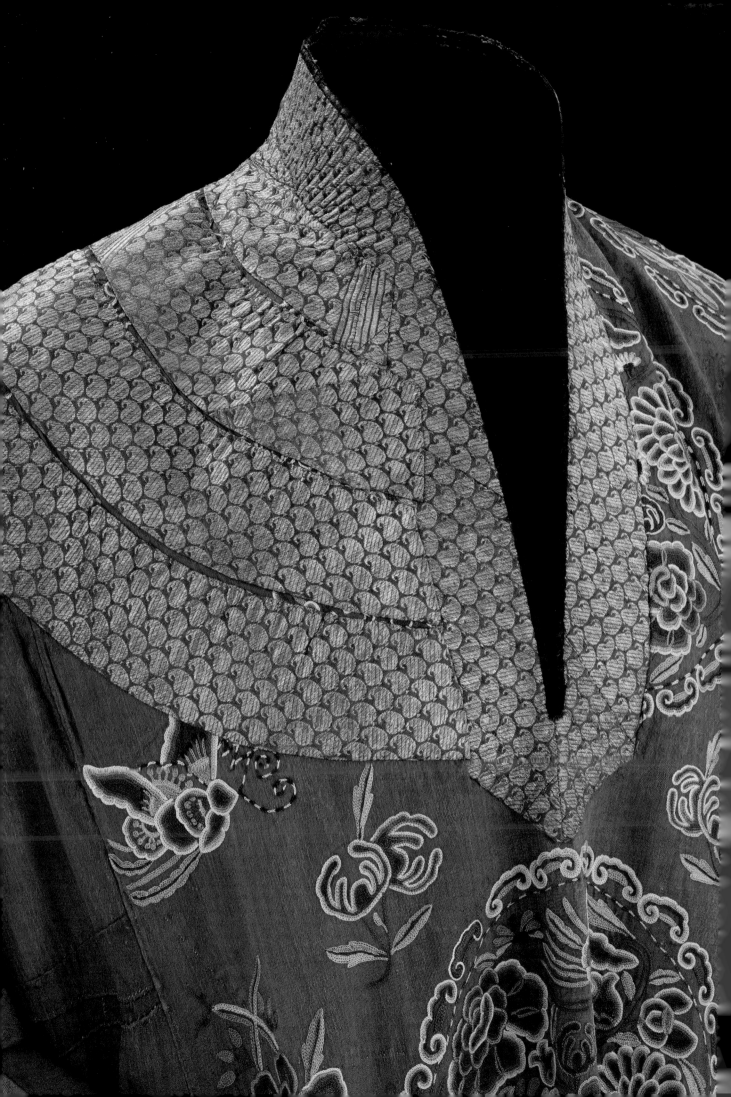

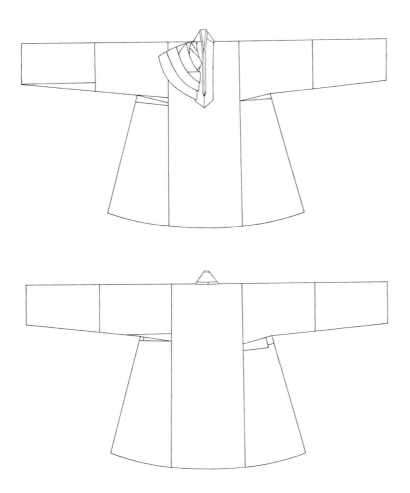

This tunic for a woman (*kongnak*) is made from a narrow length of embroidered blue silk, draped over the shoulders to hang down the body, front and back, all the way to the hem, with a circular cut made for the neck opening. Long, straight sleeves are attached to the body piece. Two flaring pieces, narrow at the top and wider at the bottom, are attached to the side of the tunic below the sleeves. Gussets joining the sleeves to the flaring sides allow for greater freedom of movement. The asymmetrical neck and shoulder decoration comprises four crossbars of patterned red and gold silk from India, with each strip carefully cut and manipulated into an arch shape as it was sewn onto the tunic.

In Khotan, this was a distinctive garment of the *juwan* (married woman with children), and could only be worn following the birth of the first child. A special ceremony (*juwan toyi*) would be held to give the mother the honorific title of *juwan*. The colour of the crossbars also denotes marital status and wealth: green or red for married women, and black for widows. For wealthy families, Indian gold cloth was used.

Tunic for a woman (*kongnak*)
Silk damask; embroidery in silk threads
Khotan (Hetian), Xinjiang, 1800–1900

Given by Captain George Sherriff
T.31C-1932

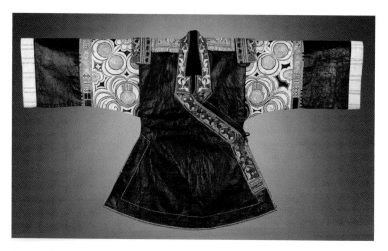

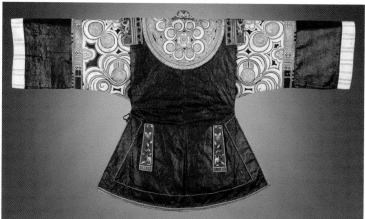

Festive jacket for a Miao woman
Plain-weave cotton; wax resist-dyeing;
embroidery in silk and metallic threads
Guizhou, 1940–80

FE.29-2004

A Miao woman living in the mountainous area of southwest China
would have worn this cotton jacket over a long skirt, complete with
an elaborate silver headdress, during festive celebrations. Miao women
are famous for their textile-making skills: since they do not have their
own written language, the Miao people use the decorative patterns
of their clothing for storytelling and as symbols to document their
history and culture.

The spiralling patterns (*wotuo*) placed around the neck and arms
of this jacket are associated with water worship. They were made with
a *ladao* ('wax-knife'), which itself was made from two or more fan-
shaped copper blades mounted onto a bamboo handle, to apply wax
onto the cotton fabric. After dyeing the cloth in a vat of indigo, the
wax would be removed by boiling the fabric in hot water, resulting
in a white pattern against a blue background.

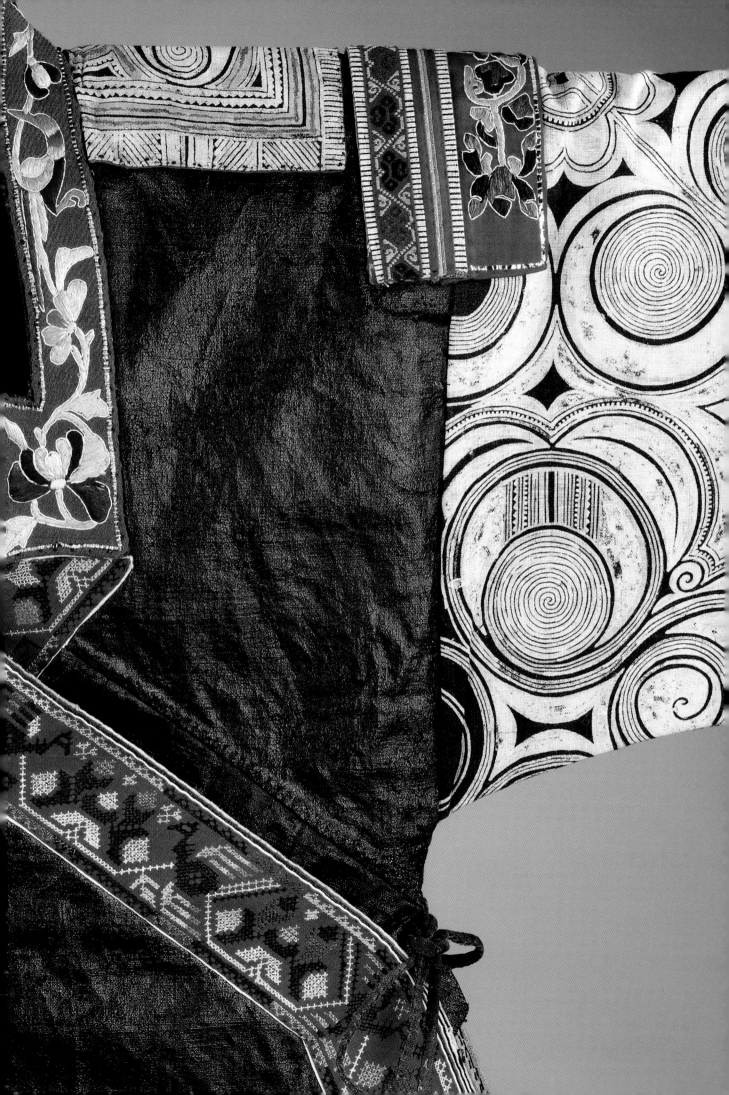

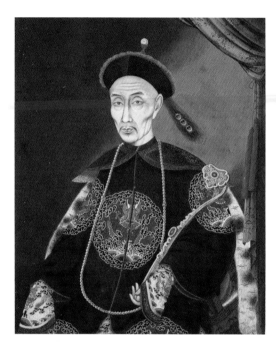

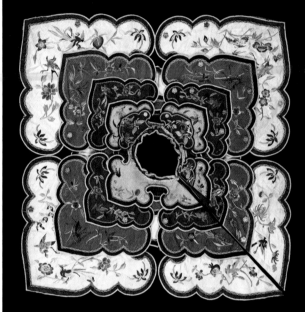

Cloud collar (*yunjian*)
Satin-weave silk; embroidery in silk and
metallic threads; moulded glass beads
China, 1875–1911

Given by Mrs Muriel Carpenter in memory
of Rev. Ebenezer Mann
FE.16-2006

Portrait of a High-Ranking Chinese Official
Watercolour and ink on paper
China, c. 1800

E.637-1911

This cape-like garment, or 'cloud collar', would have formed part
of a bride's outfit, worn over a red wedding robe. Detachable collars
of this type were originally used to wrap around the neck and shoulders
to protect expensive silk garments from staining by greasy hair oil. They
were often embellished with exquisite embroidery and could be worn
with different sets of clothes.

The conventional cut of this type of collar comprises four-lobed
cloud ornaments, joined by a narrow neck band. The cloud motif, in its
stylized form, resembles the head of a *ruyi*, as held by a Chinese official
in the painting (above left). *Ruyi*, meaning 'as you wish', were decorative
tokens of good fortune, often given by the Chinese as gifts, and the
embroidered design of flowers, butterflies, birds and pomegranates
decorating this five-tiered collar represent wishes for prosperity,
a happy marriage and many children.

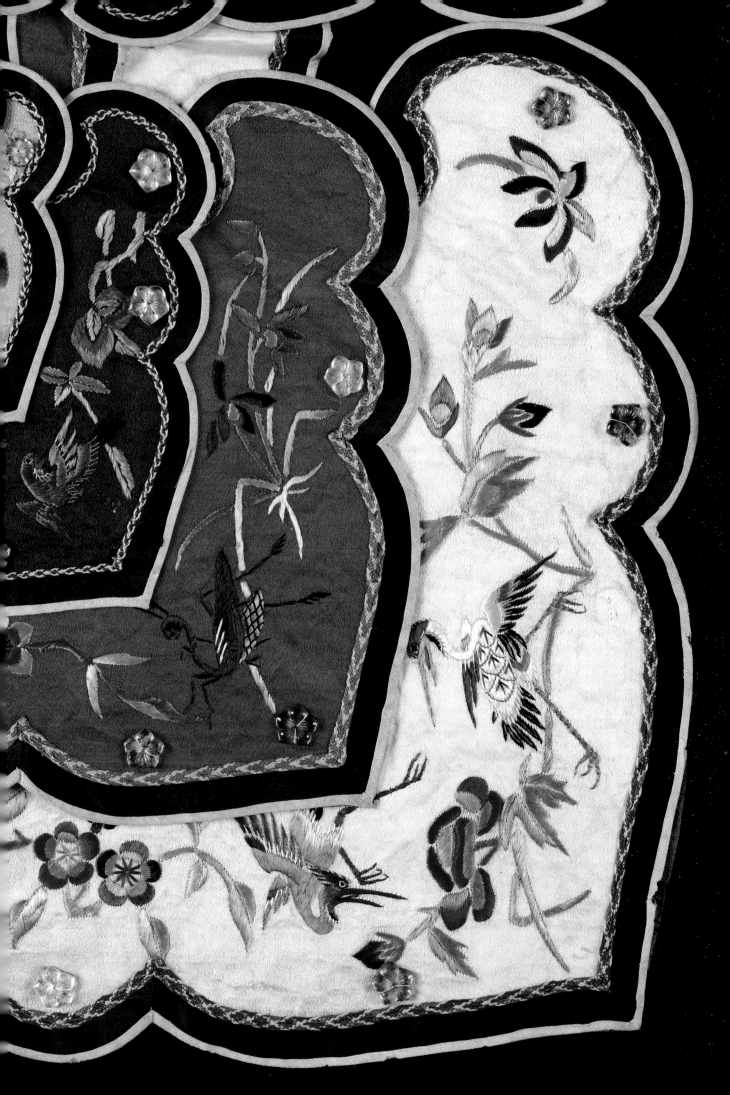

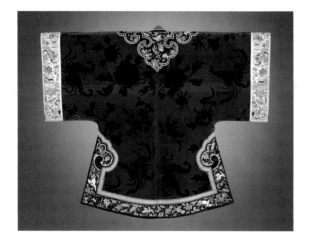

Jacket for a Han woman (ao)
Voided silk velvet; embroidery
in silk and metallic threads
China, 1875–1900

Bequeathed by Mr T.B. Clarke-Thornhill
T.201-1934

This calf-length jacket, known as an ao, would have
been worn by a Han Chinese woman in winter over
a wraparound pleated skirt. It is made from navy-blue
velvet, with cut-pile designs of butterflies and flowers
scattered across the main body. A 'cloud collar' of black
satin, embroidered with flowers and fantastic birds
in coloured silks and gold threads, is sewn down
onto the garment, a new style that developed in the
19th century. The external facings along the line
of closure, side vents and hemlines are embroidered
with designs to correspond to those at the collar.

Coordinated sets of collars and borders to be used
as trimmings for a woman's dress were produced
by professional workshops. Uncut examples of similar
edgings show how these were made (see p. 113).
Professional draughtsmen designed and traced
patterns in ink onto silk fabric, which was then supplied
to female embroiderers. Tailors would then buy yards
of uncut embroidered facings to embellish new
garments, or to provide customers with an easy way
to update their outfits with the latest fashions.

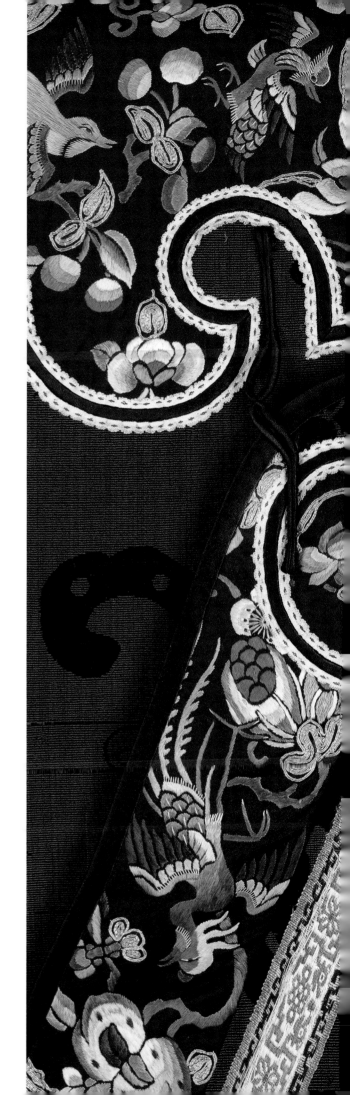

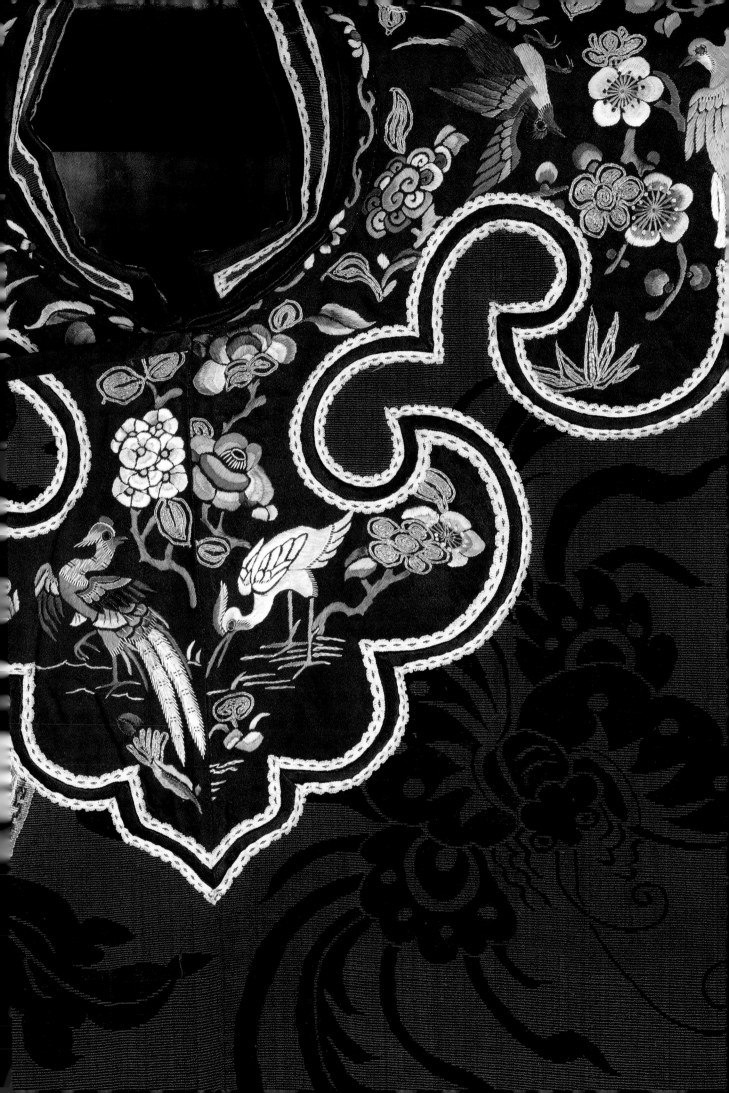

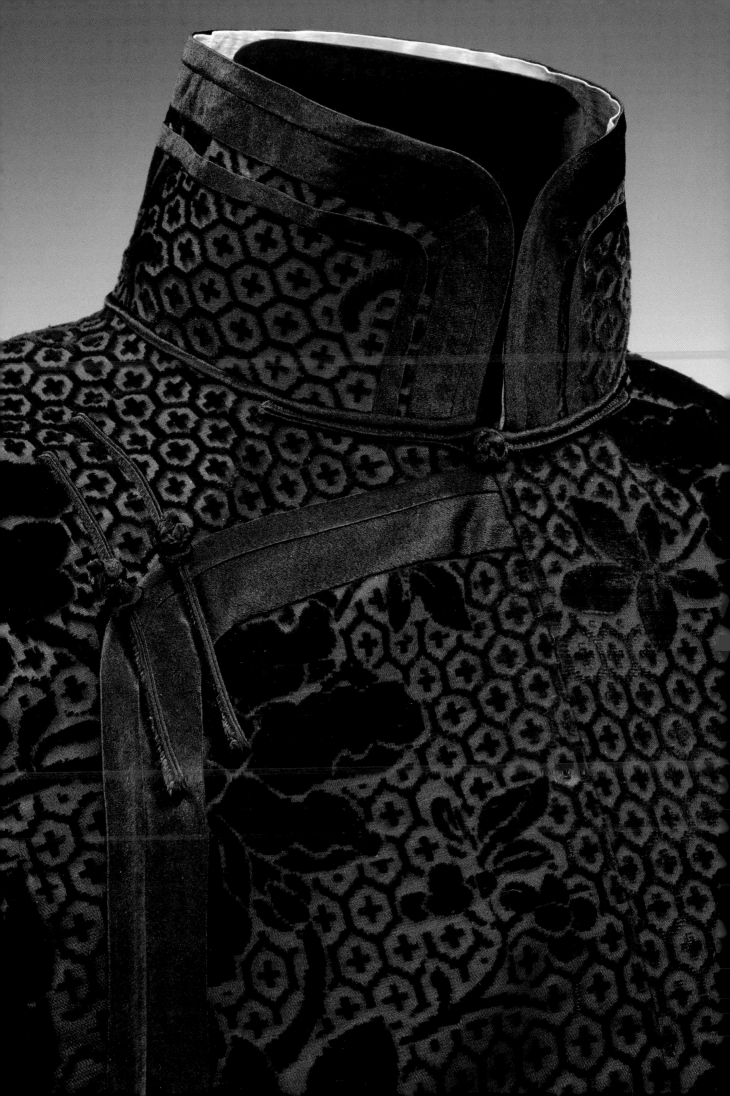

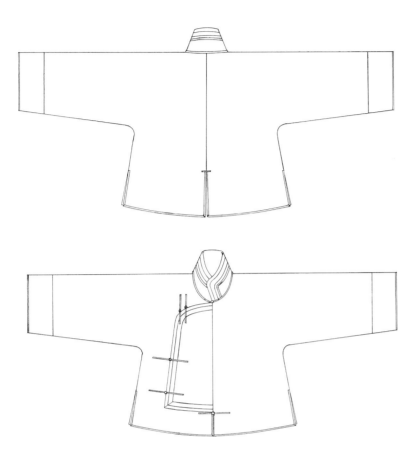

The stiffened high collar, made from the same fabric as the garment, only emerged as a standard feature for men's and women's dress in the early 20th century. This jacket would have been worn by a Manchu woman over an ankle-length robe in winter. The L-shaped overlapping flap, closing the garment from left to right, is a style of closure known as *pipa*, as it resembles the traditional four-stringed Chinese musical instrument of the same name. The maroon velvet fabric is richly woven with cut pile flowers and a tortoiseshell pattern on a satin ground. The whole garment is framed by bias-cut black satin edgings and elongated loops with knot buttons, and lined with pale-blue silk.

The V&A acquired the jacket from the Japan–British Exhibition held in London in 1910. This event was a showcase for Japanese imperialism, demonstrating Japan's determination to widen its spheres of influence in emulation of European powers. At the time, the Liaodong Peninsula (modern Dalian) in northeast China was a territory leased to Japan, and it is possible that the velvet fabric was made there.

Jacket for a Manchu woman (*magua*)
Voided silk velvet; satin-weave silk Dalian, c. 1909
Given by the Imperial Commissioners of the Japan–British Exhibition
T.5-1911

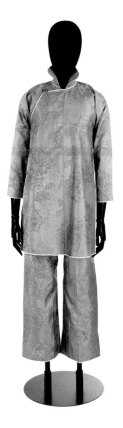

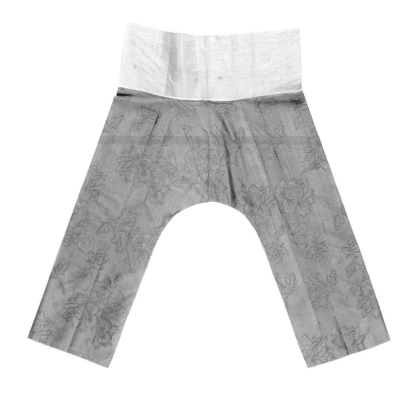

Jacket and trousers ensemble (ao ku)

Figured gauze-weave silk
Hong Kong, 1911–15

Supported by the Friends of the V&A
FE.53:1, 2-1995

After the fall of the last imperial Chinese dynasty (Qing) in 1911, wearing a jacket and trousers ensemble (ao ku) like this example signified modernity and liberation for women. Such outfits became fashionable among schoolgirls, women from educated families and fashion-conscious courtesans. The close-fitting, thigh-length jacket has an exceptionally high flaring collar shaped like an ingot, known as a *yuanbaoling* ('ingot collar'). Often left unbuttoned, the collar serves as a framing device to enhance the oval shape of the wearer's face.

The ensemble is made of gauze-weave silk in light grey with a floral design, suitable for spring and summer wear. All edgings are trimmed in white ric-rac, a flat, wavy braided trim developed in Europe in the 19th century, initially to finish seams and hems, rather than as an embellishment. Compared to the embroidered borders seen on the looser-fitting, wide-sleeved jacket (see p. 64), ric-rac trimmings are much narrower and less dominant. The neat, streamlined cut of these garments allowed women maximum ease of movement as they began to lead more active lives.

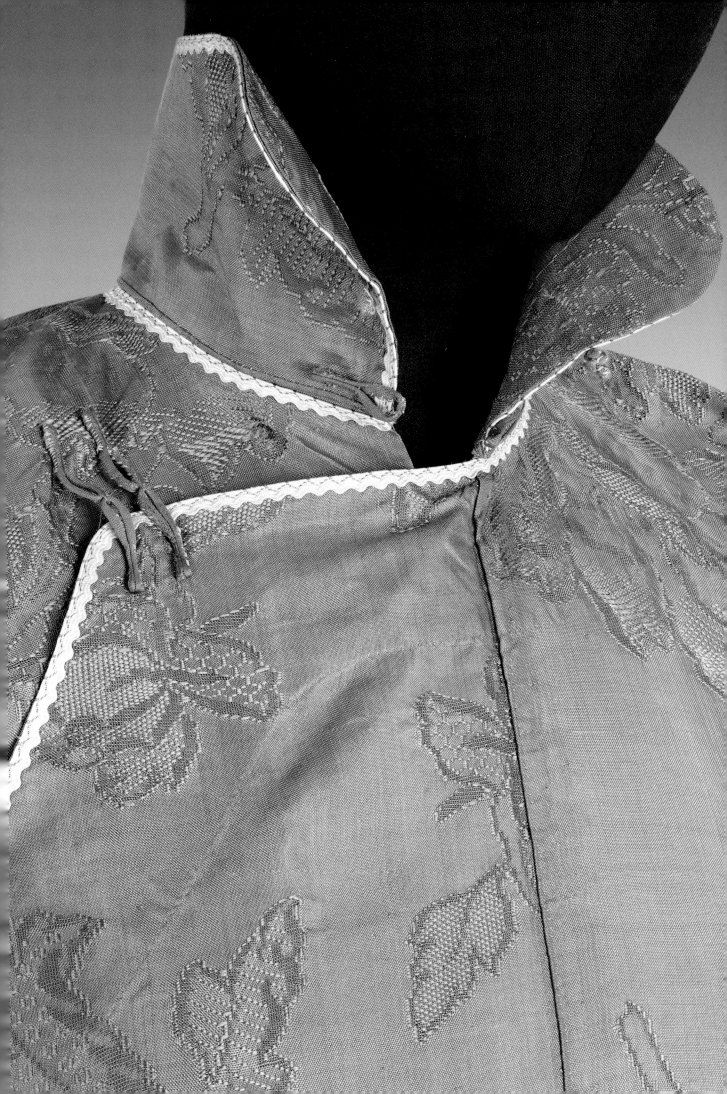

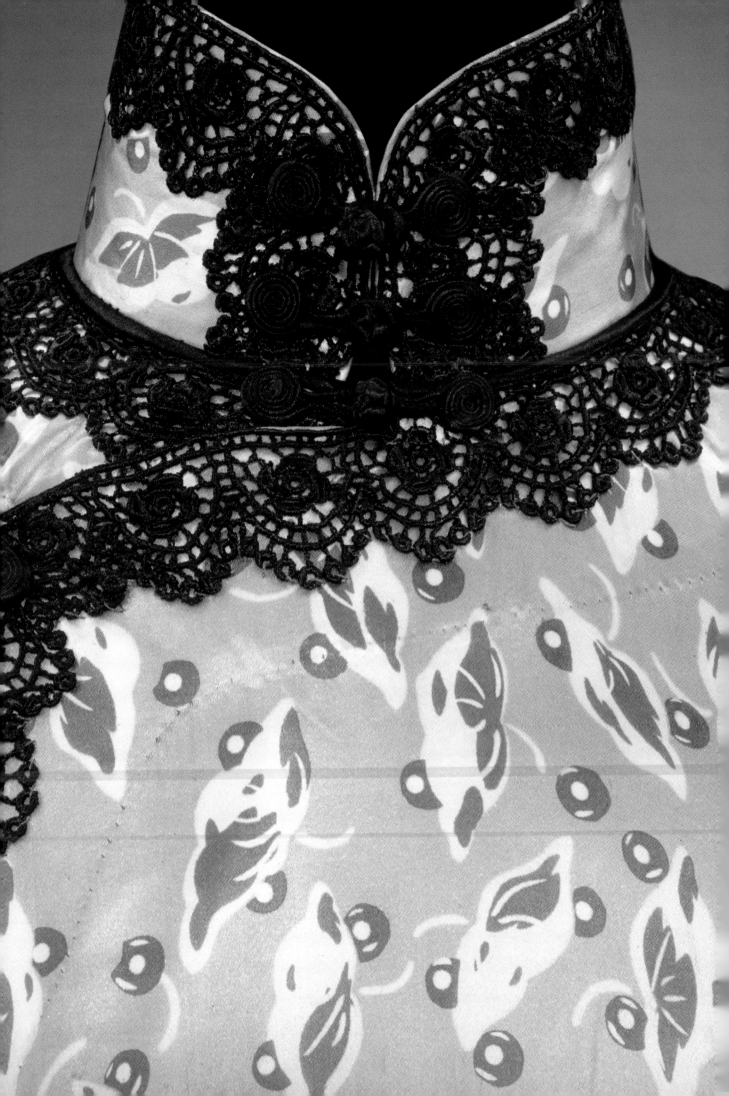

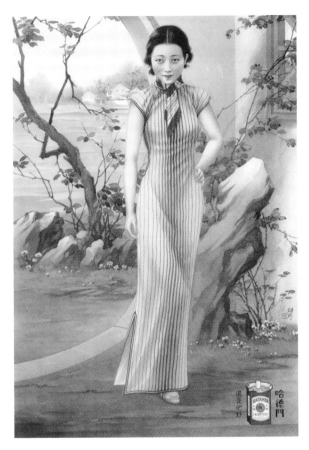
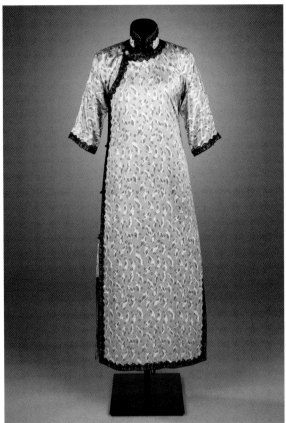

The exceptionally high neck on this one-piece dress is a characteristic feature of the 20th-century garment style known as a *qipao*, or *cheongsam* in Cantonese. Developed in Shanghai in the 1920s, it is a modernized version of the robe worn by the Manchu people during the Qing dynasty. It was heavily promoted in magazines and advertisements as a fashionable dress for young urban women, who wore it with modern permed or bobbed hair, silk stockings and high-heeled shoes.

The neckband has a stiff interlining to ensure it sits upright when the dress is worn, with a black lace trim sewn all around the neck to frame the wearer's face. Black knot buttons and loops, arranged in a trio up the collar opening, further accentuate the neck and chin, which would nestle into the space between the sides of the neckband. The lace trim, an import from Europe, continues along the collarbone closure, down the side and across the hem and cuffs of the dress. The full-length *qipao* is tight-fitting, with slits up the side that allow for easy movement, but also add to the gown's seductive allure.

Dress for a woman (*qipao*)
Printed silk satin; lace
China, 1930–40

Given by Christer von der Burg
FE.16-1994

Advertising poster for Hatamen cigarettes
Coloured lithograph on paper
China, c. 1930
Ni Gengye (active 20th century)

FE.482-1992

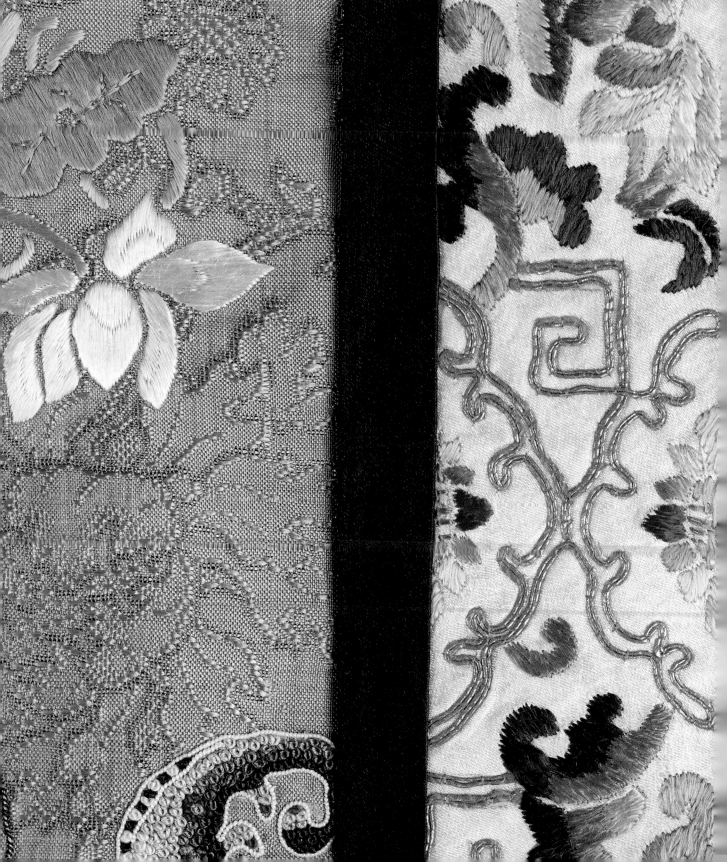

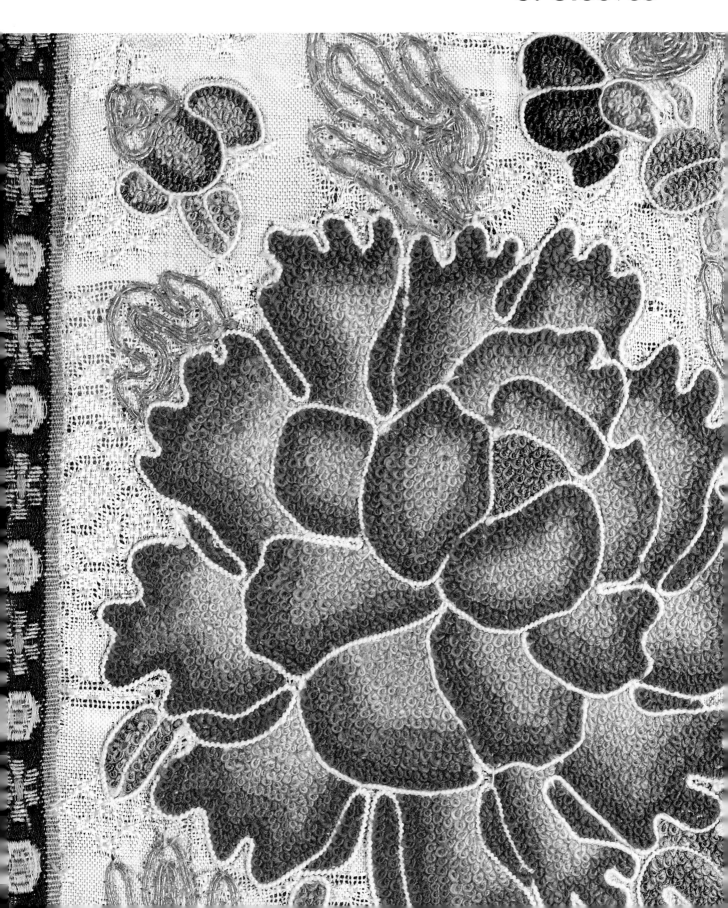

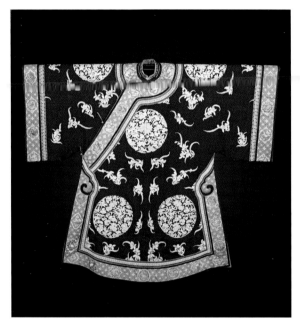 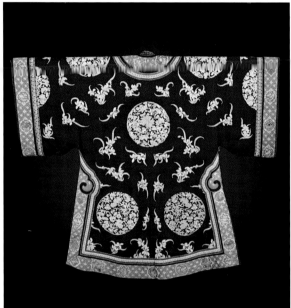

Jacket for a Han woman (ao)
Silk satin damask; embroidery
in silk and metallic threads
China, 1870–1900

Given by Mr F. Twyman
T.26-1958

This woman's jacket (ao) is cut generously with wide sleeves, a recurring feature of Han Chinese dress, signifying status and wealth. The back of the sleeve is gracefully shaped where it joins the body of the jacket. The cuff is decorated with an applied band of embroidery. Sleevebands vary in style, but always provide a contrast to the garment in terms of colour, technique or motifs.

Here, white floss silk and gold threads are used for much of the embroidery on the cuffs and for the flowers that adorn the main body of the jacket, giving the garment a visual unity. The sleeveband, in bright-blue satin, is also embroidered with multicoloured vignettes of animals and birds in knot stitch, providing a contrast to the predominantly monochromatic palette (see opposite). Along with the embroidered band, there are three narrow, warp-patterned ribbons and a black satin bias-edging. Cut to three-quarter length, the sleeves are designed to reveal further decorative trimmings on the cuffs of garments worn beneath the jacket.

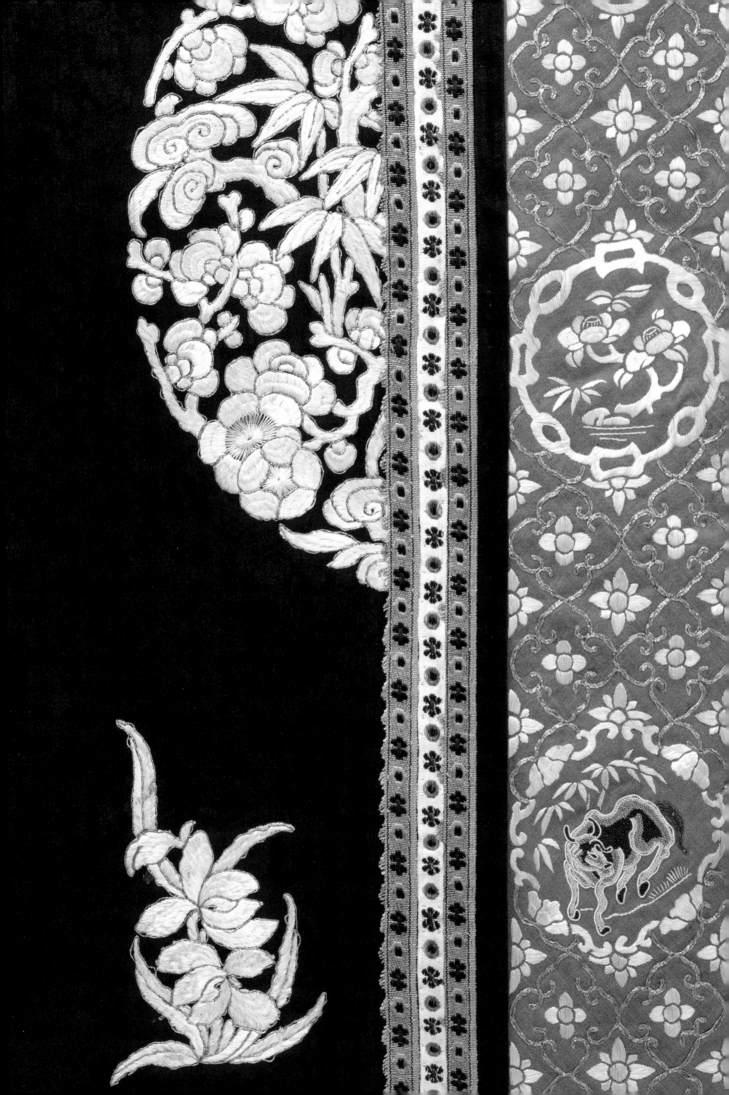

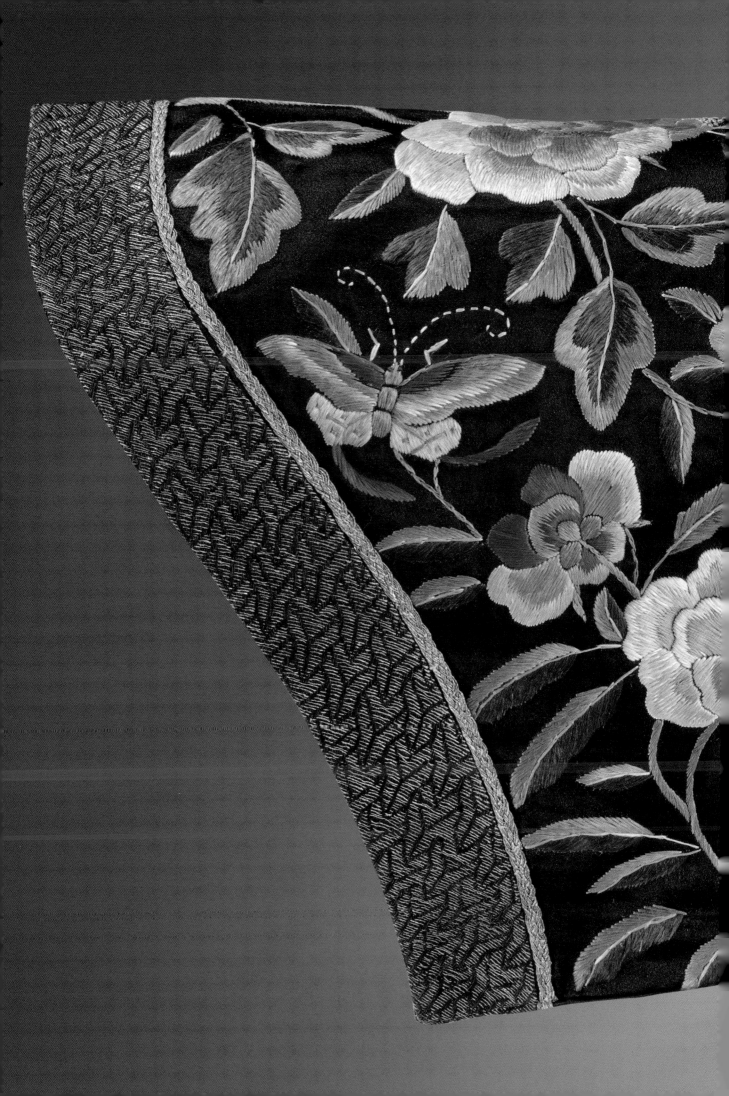

This type of embroidered and edged cuff was introduced to China when Manchu leaders established the ruling Qing dynasty in the 17th century. The shape of the cuff – known as *matixiu* ('horse-hoof cuff'), a fitting term as the Manchu were skilled horse riders – allowed for both holding the reins and protecting the hands.

In this example, the cuff is in a contrasting material to the rest of the garment. It features two bands of coloured silk embroidery on black satin, both with the same design of butterflies and peonies, but on a slightly different scale. The bands are edged in a braid of gold-wrapped thread and a strip of woven gold silk. The rest of the robe is made from a soft yellow satin, embroidered in pale blues and white, and has a floral theme, echoing the cuffs. The lower border is covered with diagonal lines (*lishui*, or 'standing water'), rising into a rolling sea and mountain rocks. The shaped cuffs and striped hem were features of court attire for men and women throughout the 18th and 19th centuries.

Festive robe for a Manchu woman (*jiapao*)
Satin-weave silk;
embroidery in silk threads
China, 1736–1820

Bequeathed by Dame Ada MacNaghten
T.52-1970

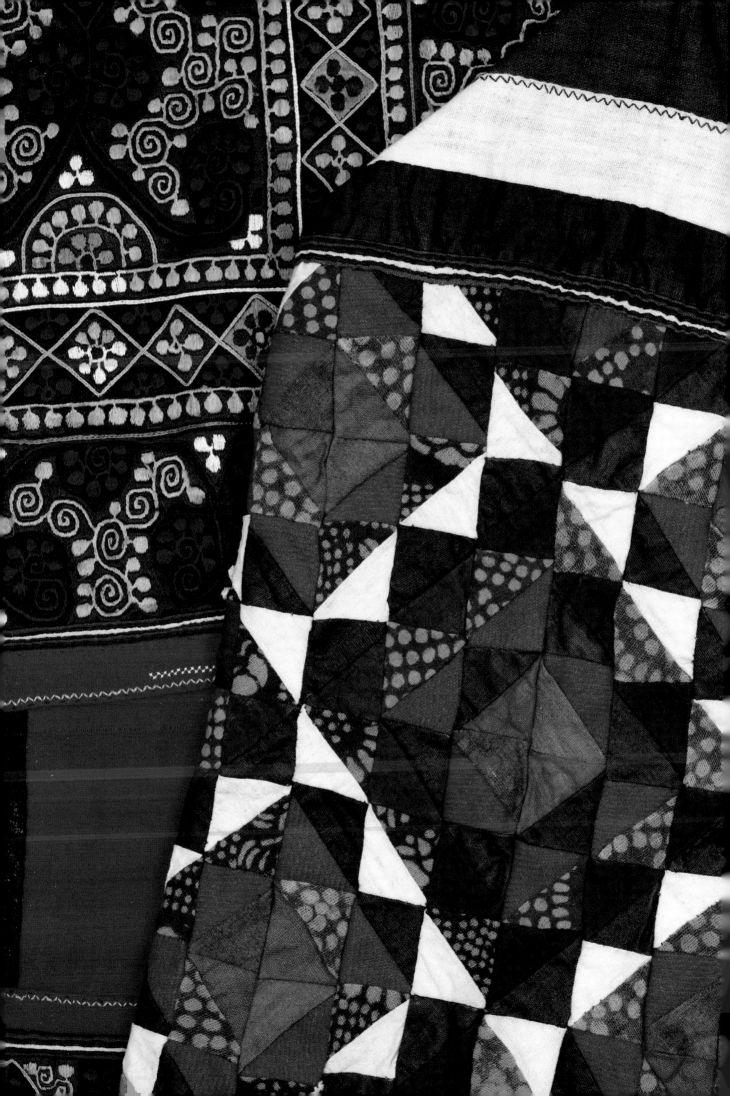

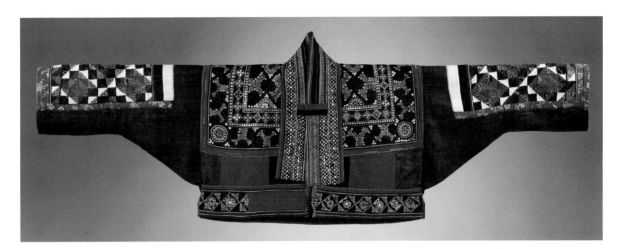

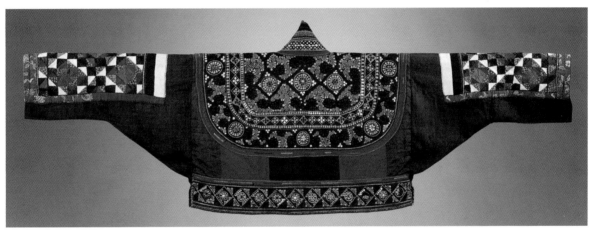

The detail opposite shows the sleeve of a jacket made and worn by the Miao people of southwestern China. The entire garment is fashioned from pieces of silk, cotton and wool, some of which are densely embroidered. Separate pieces of material, to be later made up into jackets, were easier for women to pick up and work on during the day. The section pictured is, in effect, a patchwork within a patchwork. It shows triangles of plain and yellow-spotted resist-dyed cotton, and red wool. Strips of folded cotton (or flat piping) in bands of red, blue and white mark the end of the triangular patchwork section towards the cuff and shoulder. The many different techniques on display in the design attest to the technical virtuosity of its maker.

The donor was Great Britain's consul general in southwest China at the beginning of the 20th century; he acquired it from a woman who had reportedly taken two years to make it.

Festive jacket for a Miao woman
Cotton; silk; wool; patchwork; embroidery in silk threads
Guizhou, 1910–17

Given by Mr B.G. Tours
T.78-1922

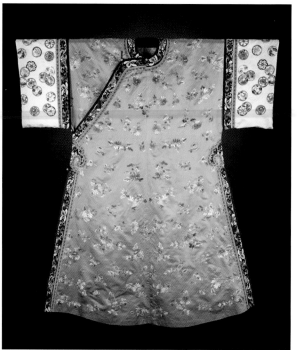

**Outer gown for a Manchu
woman (changyi)**
Satin-weave silk; embroidery
in silk threads
China, 1850–75

T.126-1966

***Emperor Daoguang and His Family
Enjoying Autumn in the Courtyard
(detail)***
Ink and colours on paper
Beijing, 1821–50

The Palace Museum, Beijing

Wide sleeves with replaceable linings that could be folded back to form
cuffs are called *wanxiu* ('rolled sleeves'). Originally a feature of Han
Chinese women's dress (see p. 87), Manchu court ladies adopted these
turnback cuffs for the *changyi*, an informal outer gown that developed
in the 19th century. It featured two long side slits extending from
underarm to hem, often trimmed with decorative borders, and would
have been worn over another full-length robe (*chenyi*).

In this example, the cuffs in white satin-weave silk are embroidered
with a whimsical pattern of floral roundels ('flower-balls', or *piqiu
hua*). This was a new design that first became fashionable on imperial porcelain
in the Yongzheng (1723–1735) and Qianlong periods (1736–1795).

The *changyi* could be worn year round. This outer gown in teal satin,
embroidered with sprays of chrysanthemums scattered across the main
body, would have been worn in autumn. The detail of the painting
(above left) depicts a concubine of the Daoguang emperor (r. 1821–1850)
holding the hand of a young prince, who is wearing a *chenyi* with similar
designs. At one point, the emperor attempted to ban the widening
of the sleeves, which he saw as an abandonment of Manchu tradition,
but to no avail.

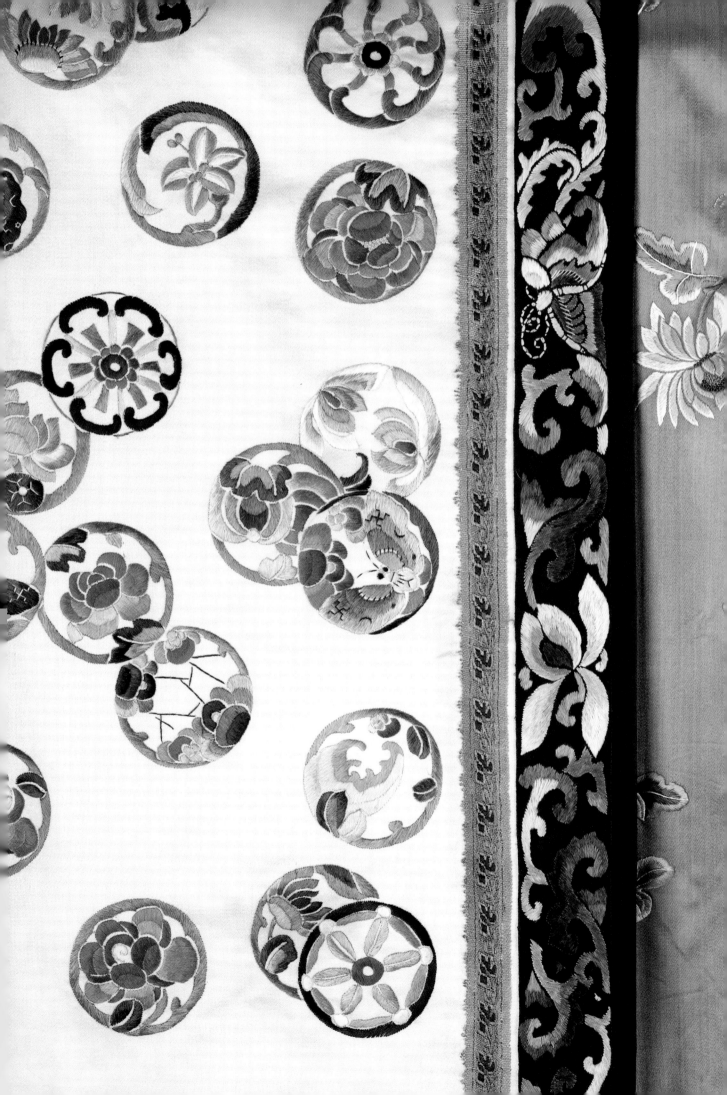

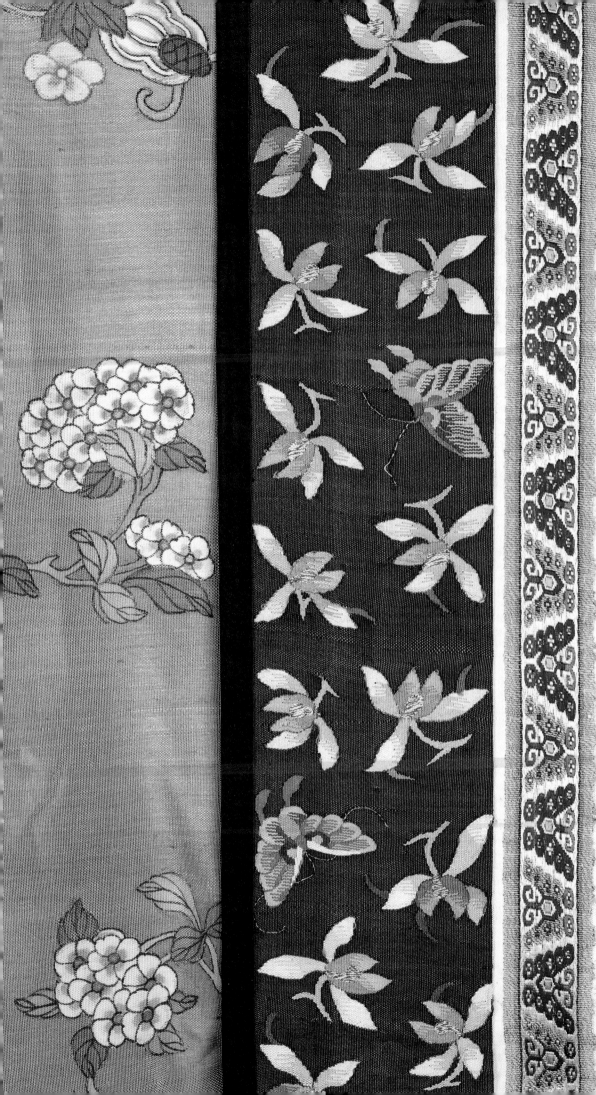

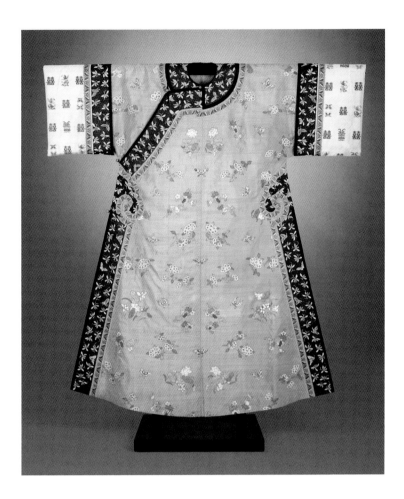

This pea-green outer gown of tapestry-weave silk features butterflies and floral imagery, including hydrangea, lotus and gourds. It was probably made to be worn in the summer. The white cuffs are decorated with 'double-happiness' (*shuangxi*) characters in blue, signifying wedded bliss for the wearer. These delicately rendered ornaments are woven in the slit tapestry technique (*kesi*), using raw silk as warp threads and coloured silks, carried by tiny shuttles, as weft threads. A key feature of tapestry weaving is that the small shuttles carrying the coloured weft threads do not pass across the width of the cloth, but run back and forth along the pattern area.

This gown, decorated as weaving progressed, would also have been woven to shape according to the measurements of its eventual wearer. The tailor would then have cut around the pre-woven shapes and sewed them together. Silk tapestry was an extremely labour-intensive process, and creating a luxurious robe such as this example could take a year, even for the most experienced of weavers.

Outer gown for a Manchu woman (*changyi*)
Tapestry-weave silk (*kesi*)
China, 1850–75

Given by Mrs G. Knoblock
T.53-1951

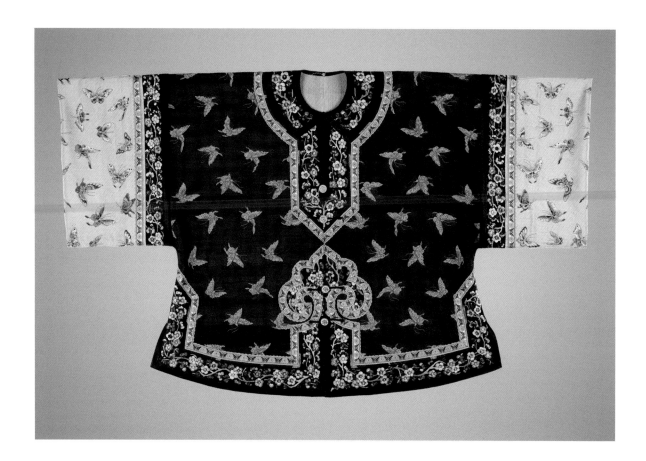

Jacket for a Manchu woman (*magua*)
Tapestry-weave silk and metallic threads; embroidery in silk threads
China, 1850–65

Purchased with Art Fund support
T.210-1948

The vivid yellow cuffs of this predominantly dark-blue jacket for a Manchu woman might look like a strong fashion statement. In fact, the choice of colour for the fabrics was determined by the rank and age of the wearer. The bright yellow seen in this example was the prerogative of the empress dowager and the empress, while deep blue was customarily worn by elderly women or widows. The subtly orchestrated butterfly patterns on the main body, woven in gold and silver threads on a dark-blue ground, were particularly popular among older women.

The 'one hundred butterflies' design symbolized the desire for long life, as the word for 'butterfly' (*die*) is homophonous with another Chinese word meaning 'eighty years of age'. The metallic threads used to weave this jacket are extremely fine, less than 0.25 mm in diameter, made from gilt-paper wrapped around a red silk core or silvered-paper wrapped around a white silk core. By contrast, the fluttering butterflies shown on the yellow cuff have added painted details and shading to enliven the colour – a cost-cutting method that was regularly incorporated into tapestry silk in the late 19th century.

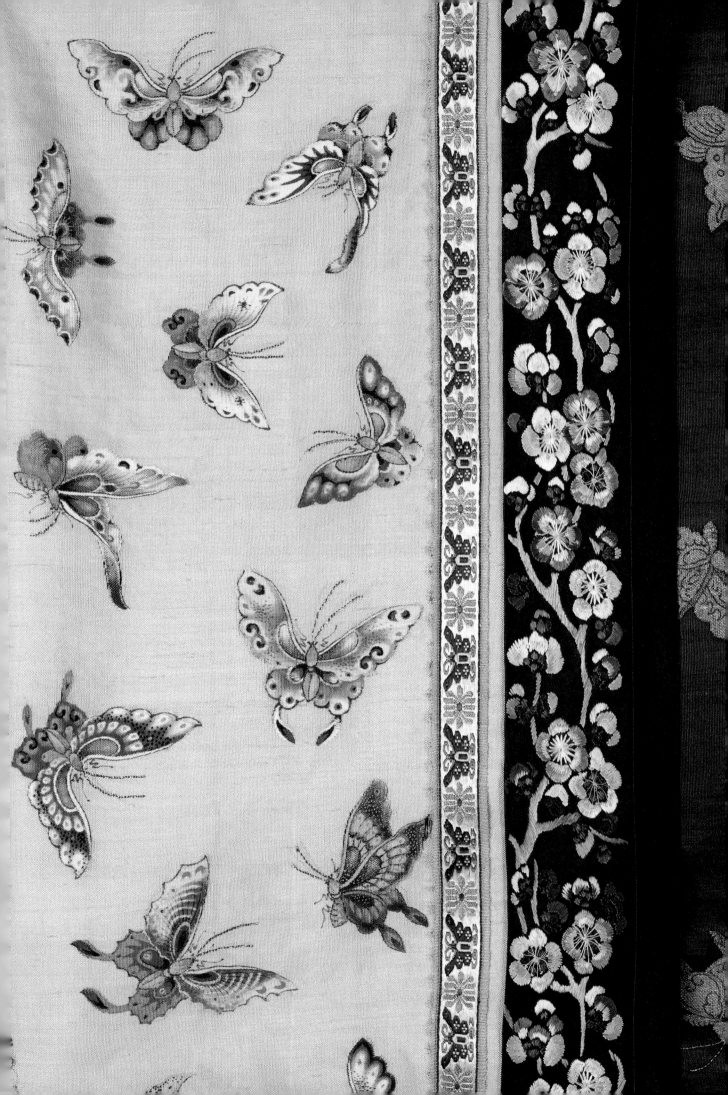

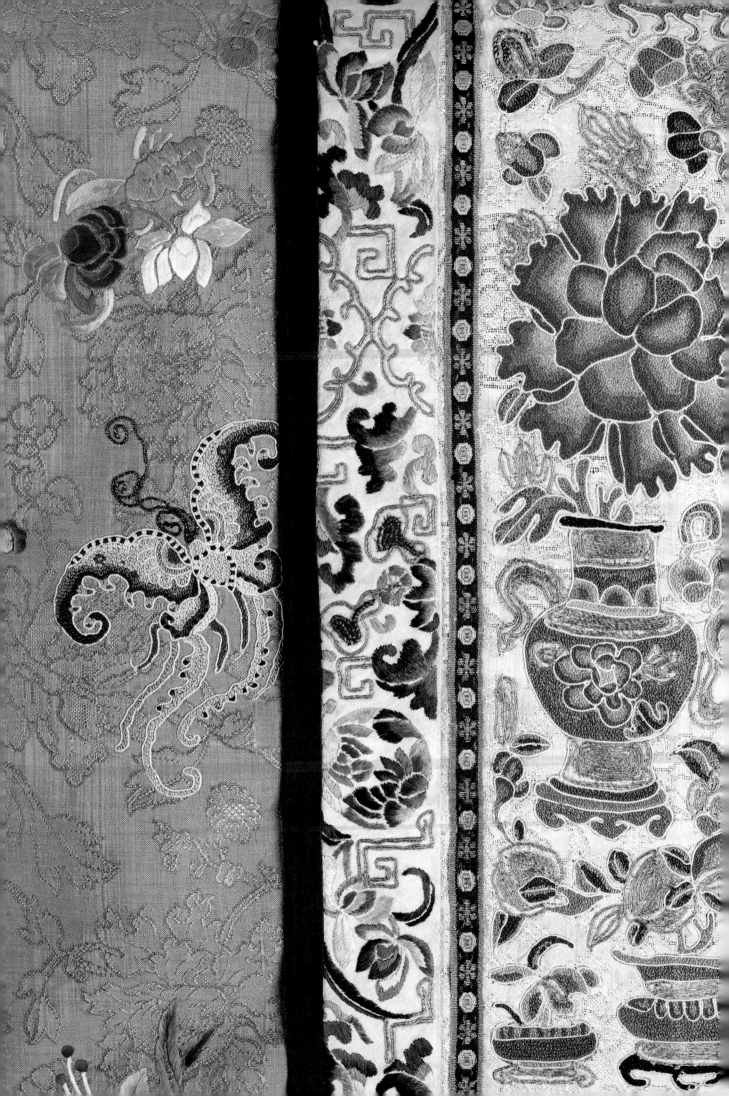

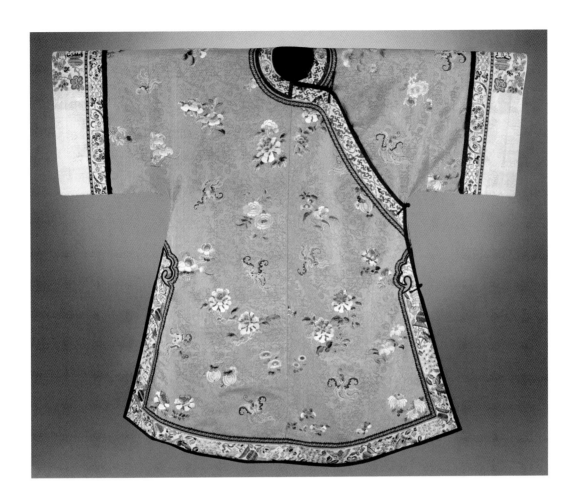

The cuffs of outer garments for Han women were often elaborately decorated with embroidered bands and applied ribbons, which would be visible when the wearer placed her hands in front of her body in the customary polite and demure posture. Auspicious ornaments were usually chosen to convey wishes for good luck.

On this jacket of pale-blue figured silk gauze, two embroidered white sleevebands have been added to the cuff. The peaches and peonies in vases on the wide sleevebands are traditional motifs symbolizing a wish for longevity, prosperity and peace. The gourds on the narrow bands symbolized progeny and the desire for male descendants, and were popular among young women. The centre of each gourd is couched with iridescent peacock-feather threads (bluish-green silk threads entwined with peacock-feather filaments), a rare material only occasionally found on court garments. A warp-patterned ribbon has been added to conceal the seam between the two sleevebands, while a black satin bias binder provides a crisp finish.

Jacket for a Han woman (ao)
Gauze-weave silk; embroidery in silk, metallic, and peacock-feather threads
China, 1850–1900

Bequeathed by Dame Ada MacNaghten
T.53-1970

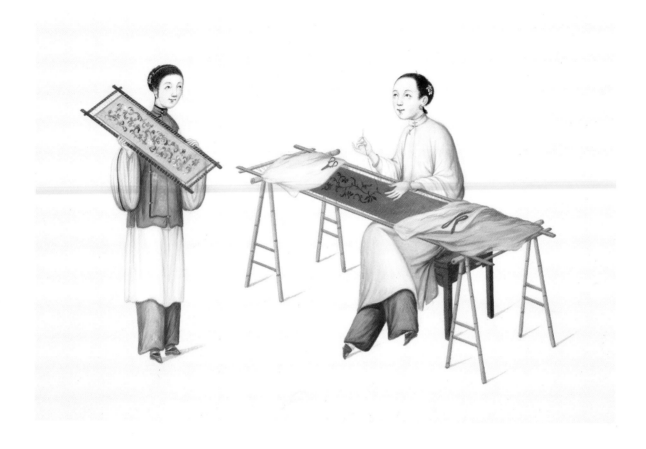

Sleevebands for a woman's robe
Satin-weave silk; embroidery
in silk and metallic threads
China, 1800–1900

Purchased with Art Fund support
T.120-1948, T.151-1948, T.157-1948

Two Female Embroiderers
Watercolour and ink on paper
China, 1880–85

D.83-1886

The production of smaller pieces such as these embroidered sleevebands was principally the work of women or young girls, and was carried out in the home. Some of the most popular designs were drawn from the natural world, with insects or plants rendered realistically or in a stylized manner, often combined to provide strong associations with specific seasons.

The white sleeveband shown opposite features grasshoppers, dragonflies, butterflies, gourds and pea pods, each symbolic of summer and ideal for embellishing a garment to be worn in the summer months. Plum blossoms and peonies, embroidered in knot stitches, which bloom from early to late spring, adorn the red sleeveband. The blue sleeveband, with couched embroidery in metallic threads, features two dragonflies flying towards a chrysanthemum plant, a favourite autumn flower of the Chinese, who sometimes organize gatherings to better enjoy its beauty. All of these images evoke poetic ideas that appeal to the senses or capture the transitory nature of a moment in time.

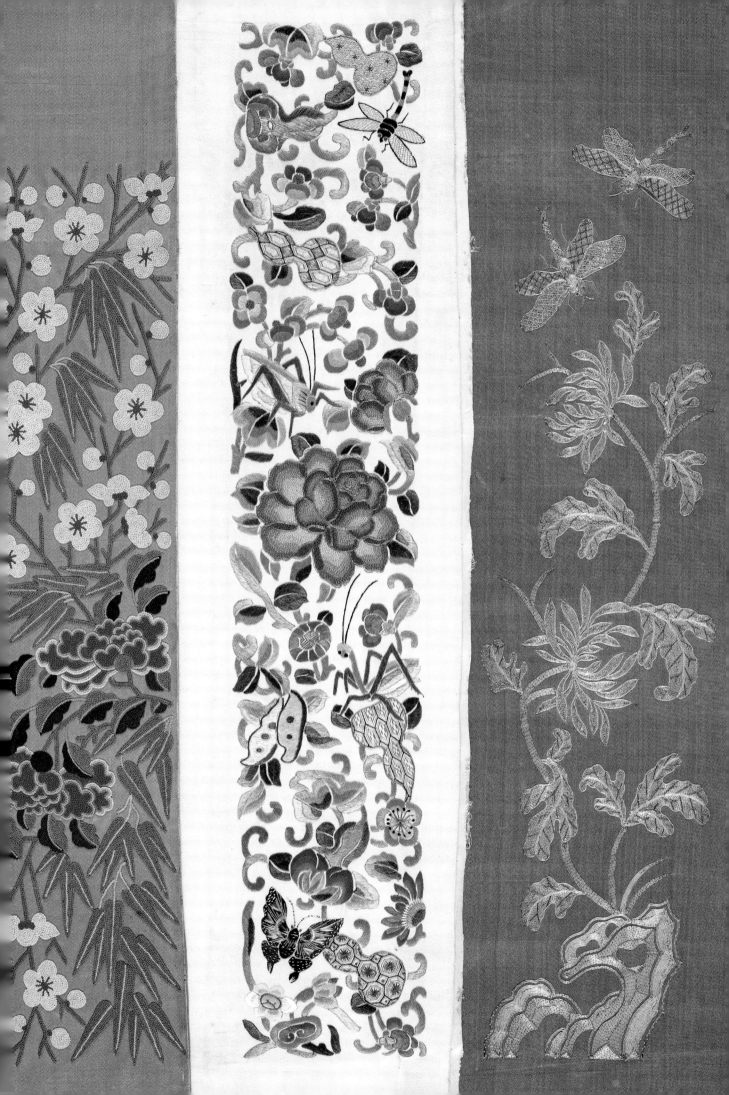

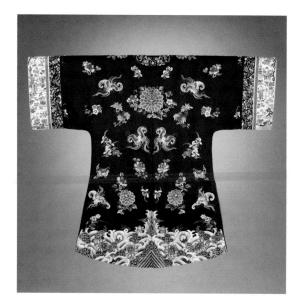

Coat for a Han woman (*gua*)
Satin-weave silk; embroidery
in silk and metallic threads
China, 1825–75

Given by Dame Kathleen Lonsdale
T.27-1964

Decorating garments for Han women with narrative
imagery from plays, novels and prints was popular
in the 19th century. On this coat, the embroidered cuffs
feature two scenes from *The Peony Pavilion* (*Mudan ting*),
an opera written in 1598 by Tang Xianzu (1550–1616).

The opera tells the story of a sixteen-year-old beauty,
Du Liniang, daughter of the local magistrate. One day,
she falls asleep underneath a plum tree and dreams that
she meets a handsome young scholar, Liu Mengmei.
Together, they admire the beautiful flowers, but when
she wakes up, he is gone. The lovestruck girl soon falls
ill and dies. Three years later, Liu wanders into a garden
and falls asleep. He dreams about a romantic encounter
with Du Liniang, even though he has discovered that
she is a ghost. At the end of the opera, she wins over
the Judge of Hell and comes back to life to marry Liu.

The story resonated with many young women who
dreamed of finding true love, instead of submitting
to an arranged marriage. This calf-length coat (*gua*)
would have been worn as informal dress by the wife
of a Chinese official.

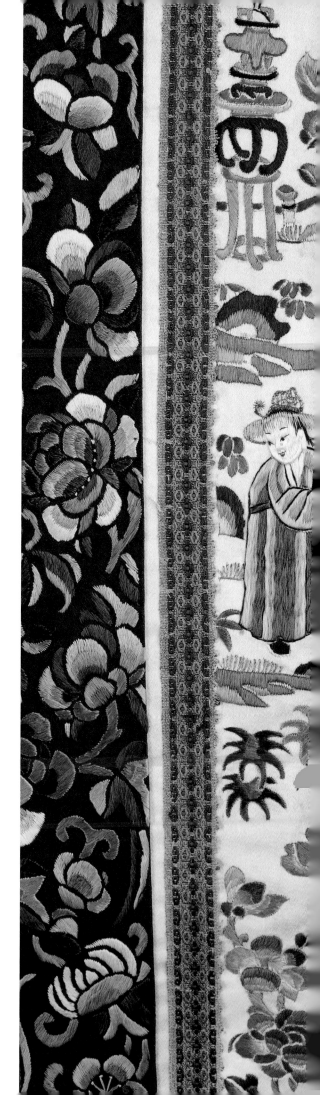

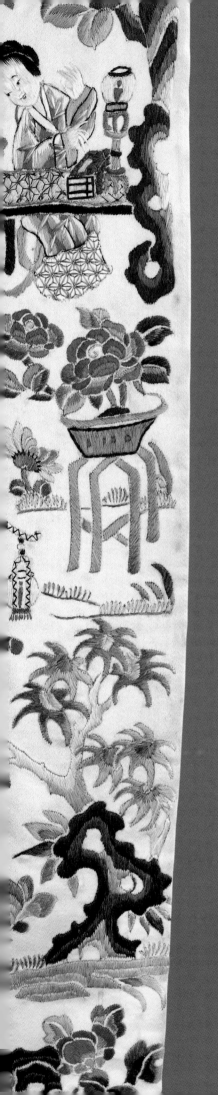
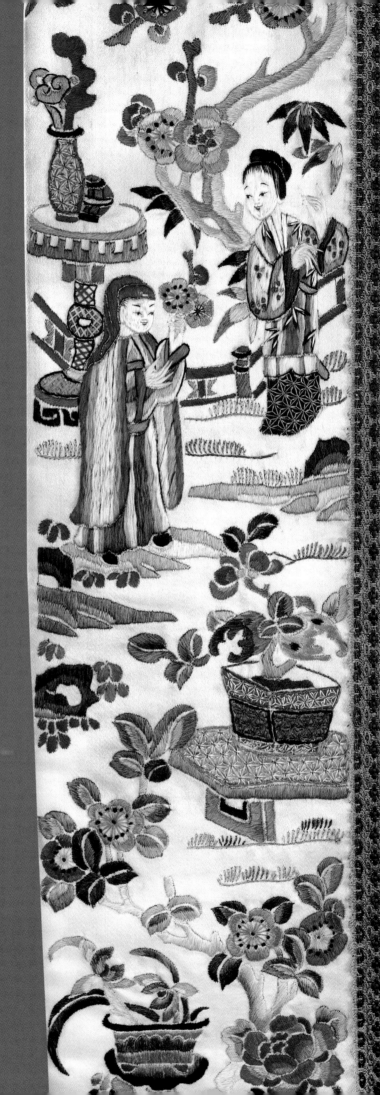

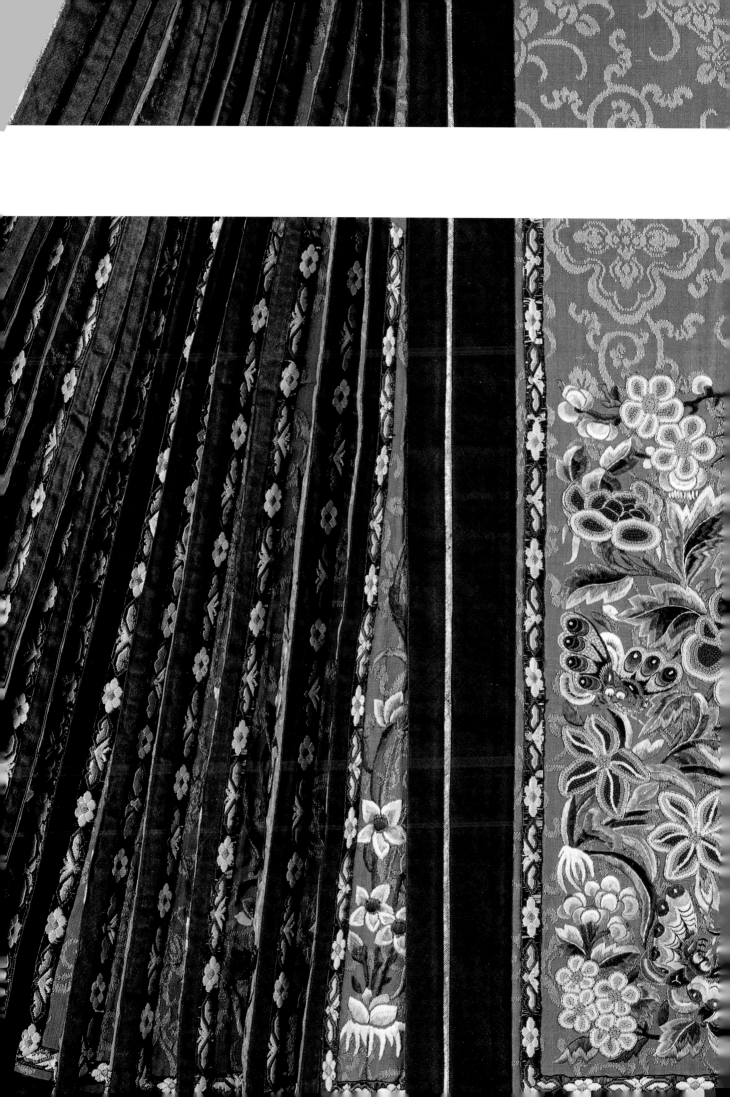

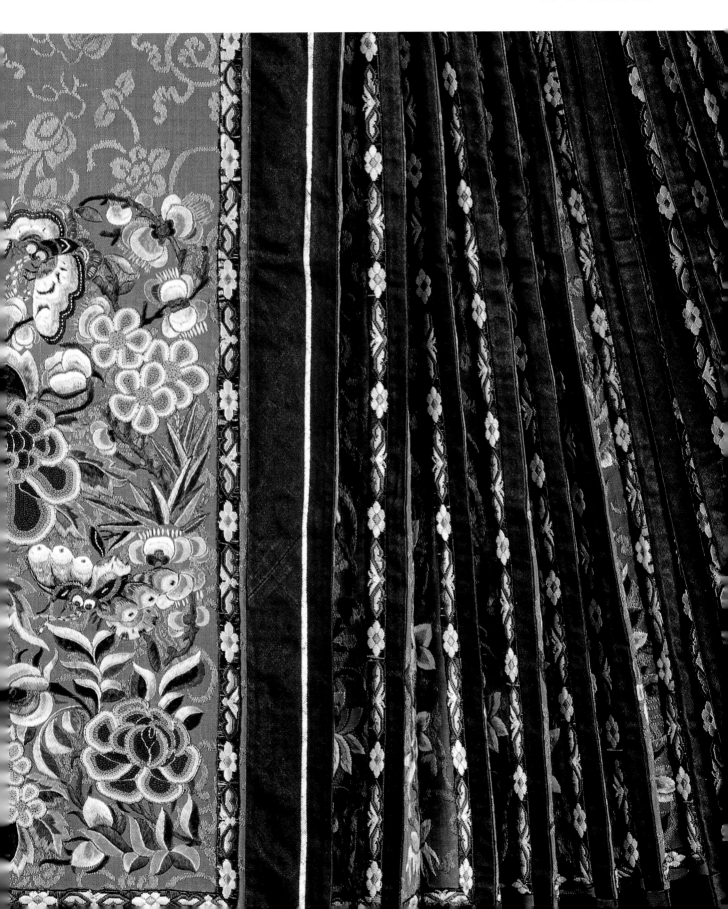

4. Pleats

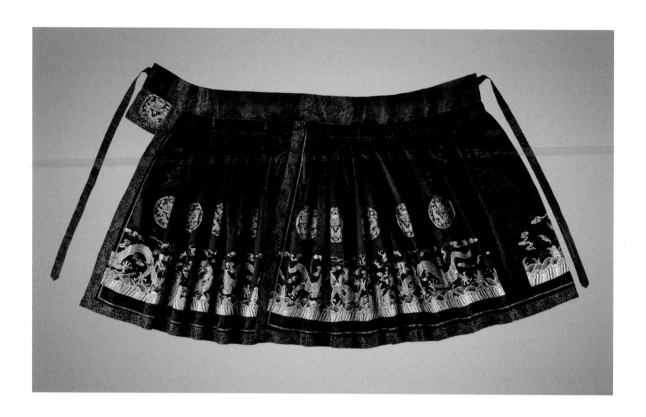

Court skirt for a man
Satin-weave silk; embroidery
in silk and metallic threads
China, 1700–50

T.251-1966

The pleats of this blue satin court skirt are evenly arranged along the entire length of the waistband. In Chinese, this style of box pleat is called *biji* ('piled-up pleats'). A double row of running stitches secures the pleats to a depth of 6 cm (just over 2 in.) from the top. Above these stitching lines, the pleats lie flat; below, the pleats flare out, adding bulk around the wearer's hips. The skirt is fashioned from two overlapping sections in a wraparound style, with embroidered decoration featuring a dragon pattern on the lower section.

The skirt formed part of the court dress (*chaofu*) of a noble or high-ranking official. It would have been worn on formal occasions over a plain long robe, underneath an outer coat (*bufu*) with embroidered rank badges. The waistband, although unlikely to be seen, is nevertheless woven with a dragon roundel design. It is made from an extremely stiff silk, with ties at each end made from the same material.

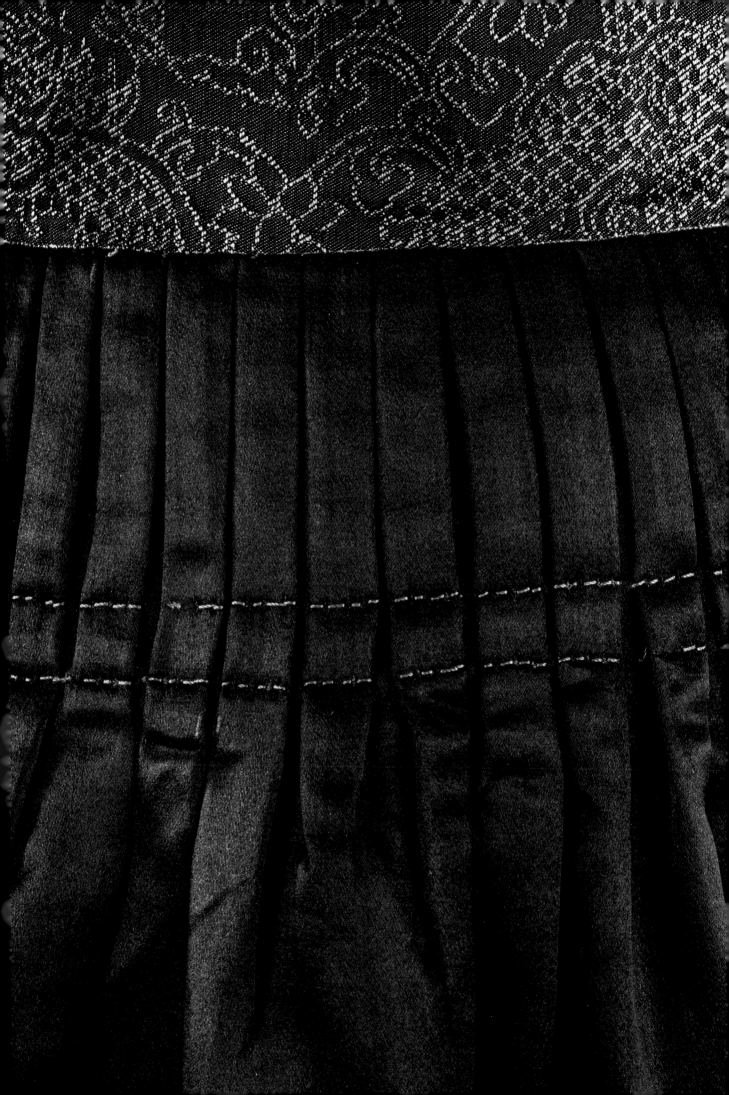

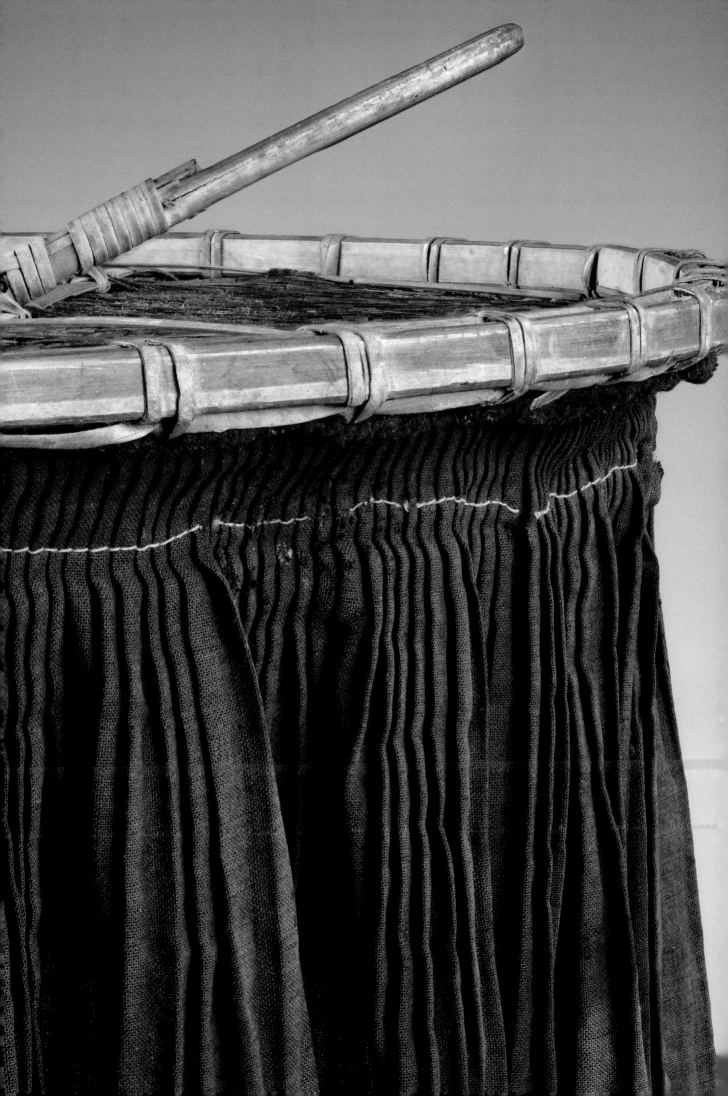

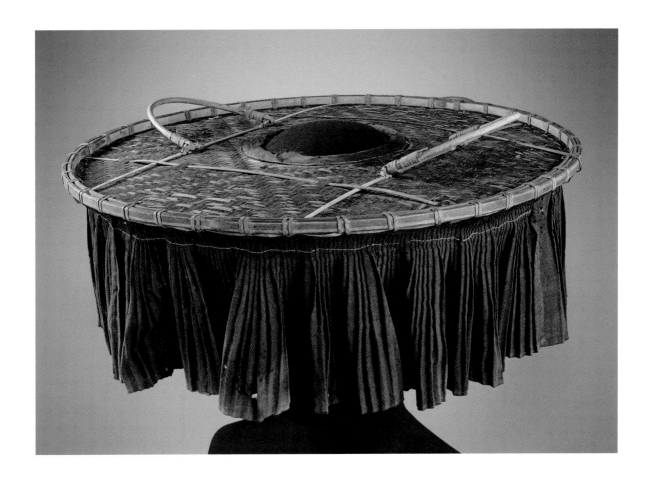

In Hong Kong, Hakka women wear these distinctive hats, known as *liangmao* ('cool hat'), when working outdoors. Originally from northern China, the Hakka people migrated south with some eventually settling in the rural areas of Hong Kong at the turn of the 20th century. The term 'Hakka' means 'guest people', a reference to their history of continual migration and resettlement.

Hakka women prefer simplicity and comfort when it comes to clothing, with black a favourite colour for workwear. This hat is made from woven bamboo in the shape of a flat disc with a hole at the centre for the head. Along the outer edge is a veil, fashioned from two lengths of black plain-weave cotton, neatly arranged in tight, narrow knife pleats. The pleats are held in place at the top with a row of simple running stitches, allowing the veil to swing gracefully when the wearer moves, creating a cooling breeze. As well as being visually striking, the hat would also have shielded the wearer's face and shoulders from the sun.

Hat for a Hakka woman (*liangmao*)
Woven bamboo; rattan; plain-weave cotton
China, 1950–80

Supported by the Friends of the V&A
FE.186-1995

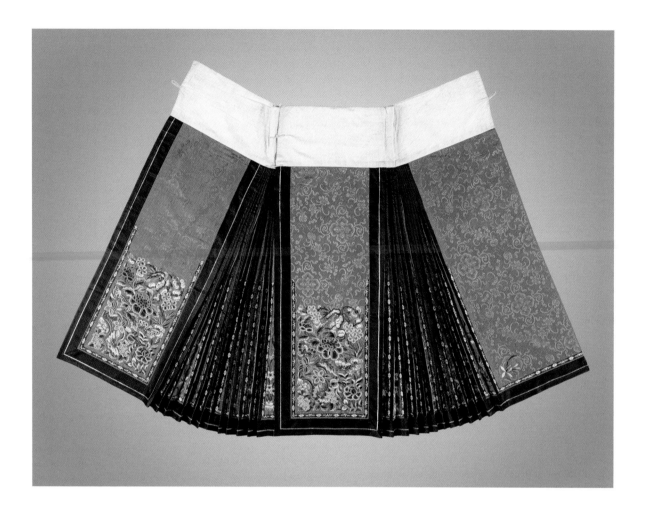

**Skirt for a Han woman
(*ma mian qun*)**

Silk damask; embroidery in silk and
metallic threads; plain-weave cotton
China, 1850–1900

Bequeathed by Lt, Col, G.B. Croft-Lyons
T.137-1926

The detail opposite shows one pleated section of a panelled skirt, known
as *ma mian qun* ('horse-face skirt'), a reference to the shaped panels.
The skirt is made from two segments of pale-blue silk damask, secured
into a white cotton waistband, overlapping each other. Each piece
comprises a straight, densely embroidered panel and a pleated panel.
When the skirt is worn in a wraparound style, the decorated panels form
the front and back, with the pleats flaring out at the sides.

Each individual pleat is defined with narrow bias-cut black satin,
embroidered with floral and butterfly motifs at the bottom in white
and shades of blue. The recessed space between each pleat is similarly
embroidered with further stems and branches of flowers, offering
glimpses of the pattern when the wearer moves. A three-quarter-length
jacket or gown would have been worn over the skirt, so the embroidered
details have been kept to the lower section, where they would have
been visible.

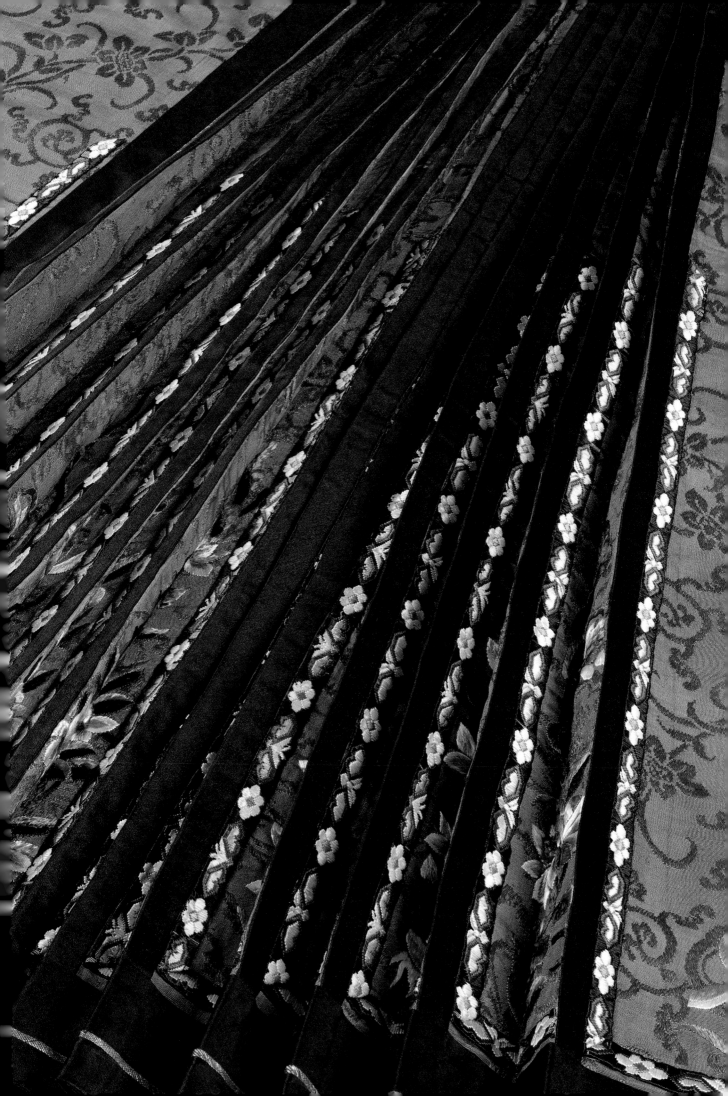

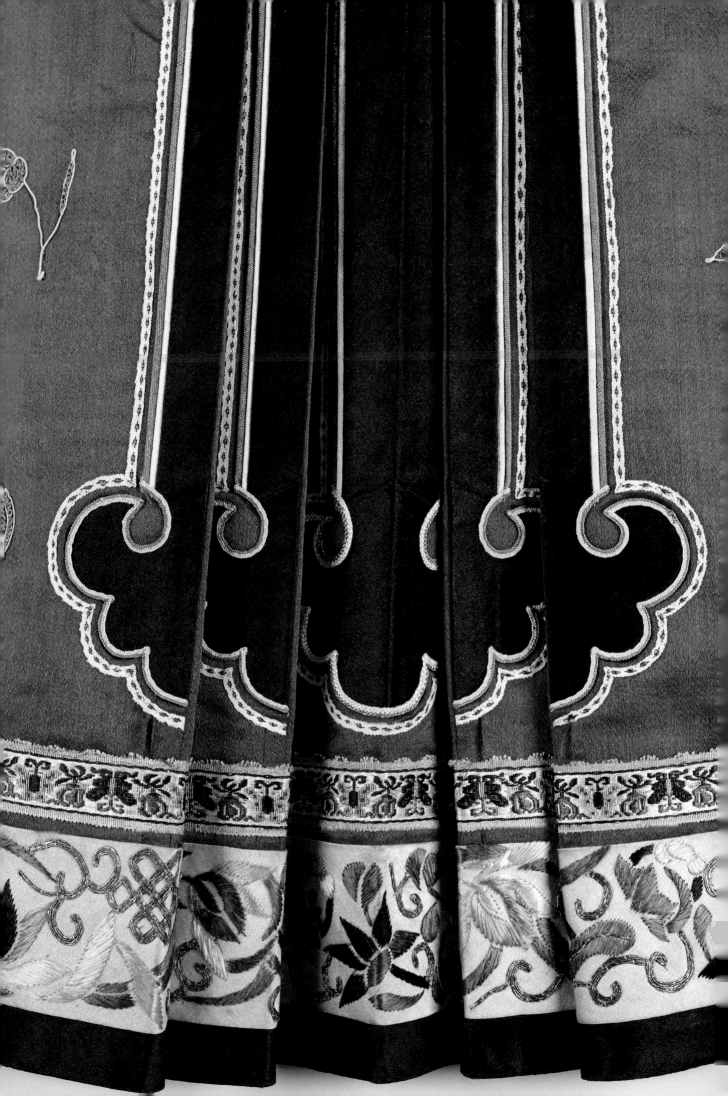

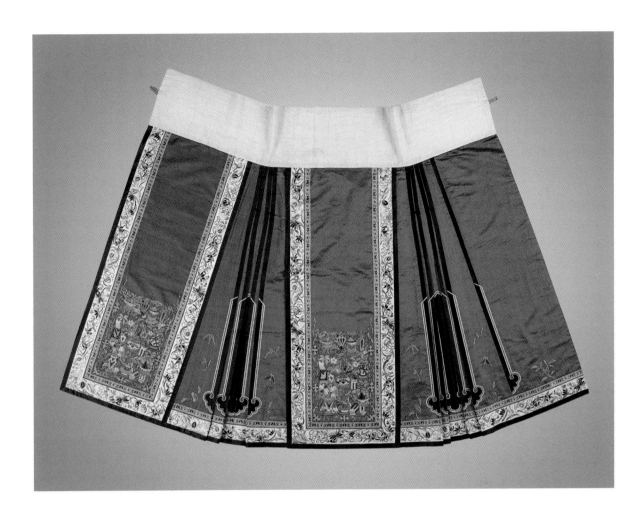

Like a film capturing the fleeting moments of the swish and sway of a skirt, the pleats of this Han woman's skirt are edged with black satin to imbue it with a sense of movement and grace. The pleats are simple, but the visual effect is bold and dramatic.

The construction of the pleats would have begun after the hems were completed. When the skirt is worn, five pleats would be visible on each side, with two folded over one way and two the other, with each pair facing the central pleat. The bottom is decorated with the wish-granting *ruyi* design. This red satin skirt would have been worn on special occasions, as red is a joyous colour for the Chinese.

Skirt for a Han woman
(*ma mian qun*)
Satin-weave silk; embroidery in silk and metallic threads
China, 1850–1900

T.290-1960

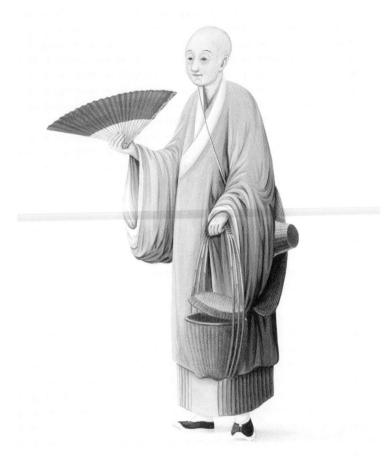

Skirt for a woman
Plain-weave hemp
China, 1900–30

Supported by the Friends of the V&A
FE.213-1995

A Buddhist Nun Delivering Soup
Watercolour and ink on paper
Guangzhou, c. 1790

D.110-1898

Hemp is not a material that lends itself easily to the fashioning of pleats, and this type of wraparound skirt would be more often made from silk. Plain pleated skirts made from hemp were worn by female labourers or Buddhist nuns. The detail opposite shows one set of six pleats, arranged in two groups facing the centre of the panel. Each pleat is stitched vertically along its folded edge like a French seam, with all of the pleats held in place with a horizontal line of long, light-blue stitches, which would have been removed before wear. The fact that they remain in place reveals that this skirt has never been worn.

There is no ornamentation, and the skirt's aesthetic quality derives solely from the pleats and rich indigo-blue colour. Historically, hemp was a major textile fibre that was cultivated and processed in China. It was replaced by cotton as the primary material for everyday wear, but is occasionally used today to make garments for attending funerals.

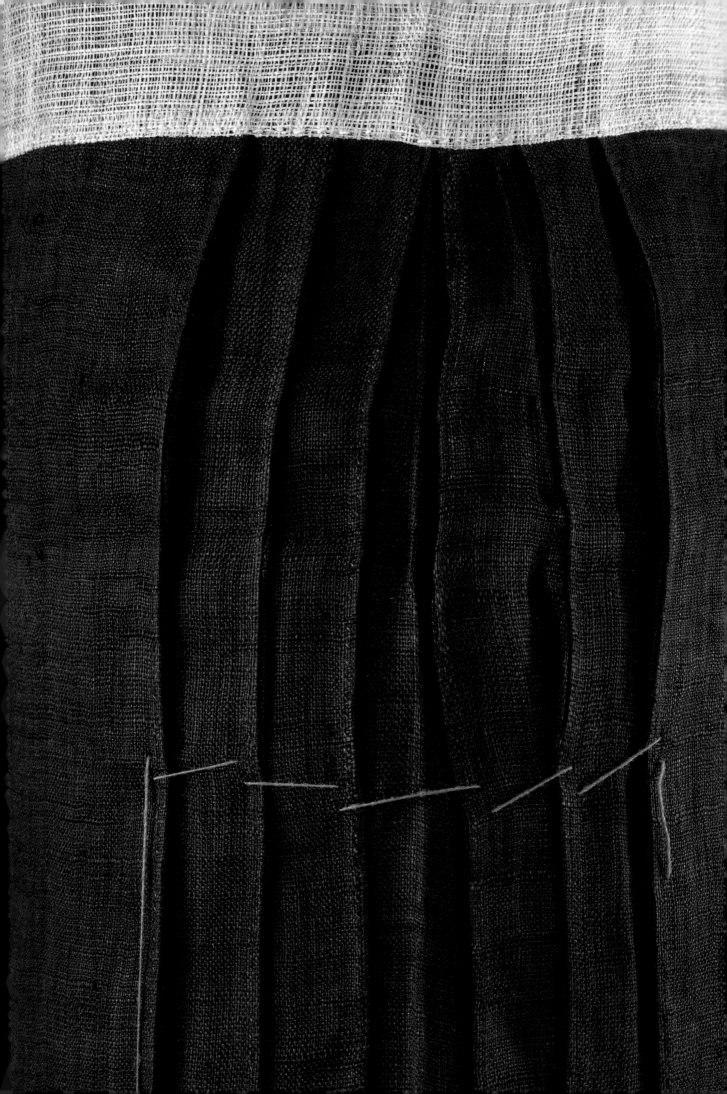

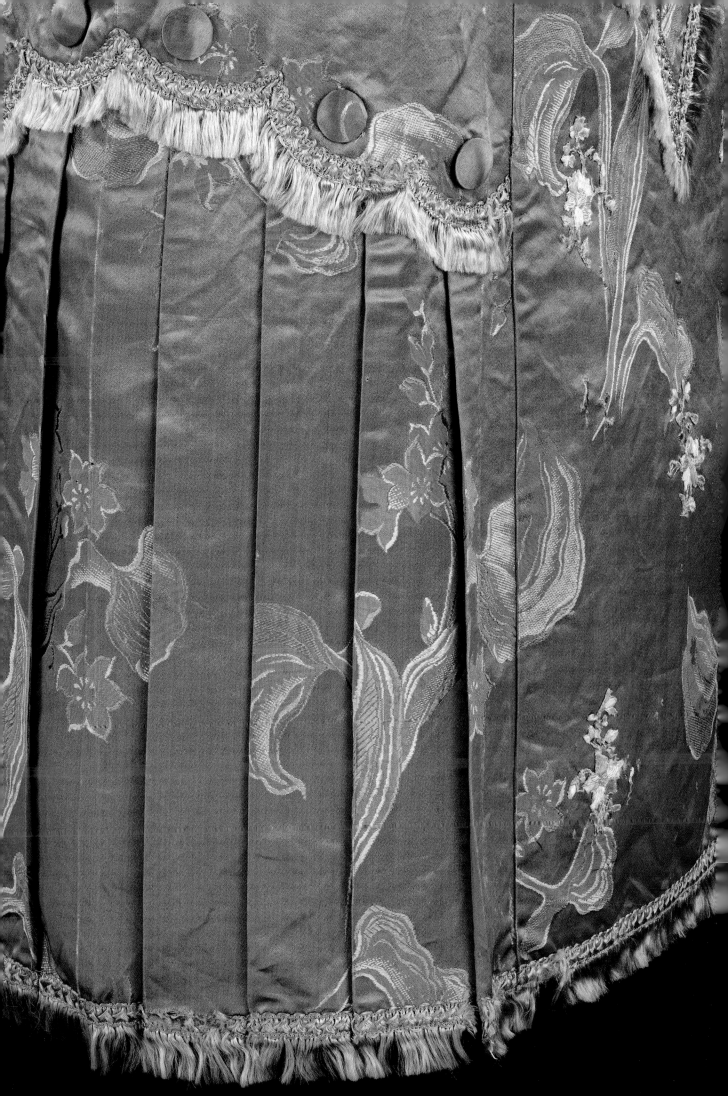

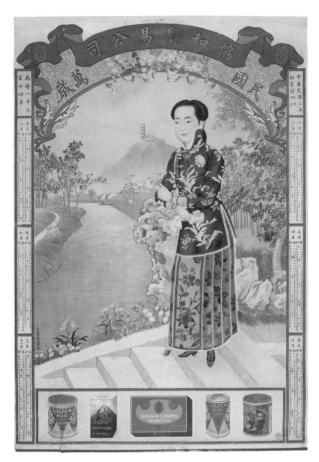

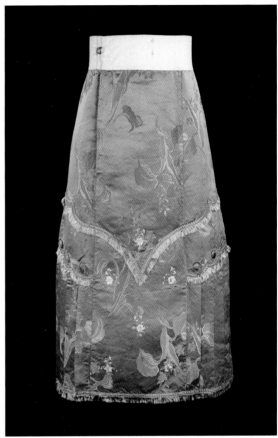

The collapse of the Qing dynasty in 1911 brought noticeable changes to the dress of Han women. Leaving behind the fashion for bulky robes and skirts with elaborate trimmings, young urban women now embraced a modern style that celebrated simplicity and muted colour schemes. This panelled skirt, with crisp knife-pleats on the lower sides, is fashioned from French jacquard-woven silk with large floral patterns. Simple, understated trimmings such as these grey silk fringes, also French, together with purely decorative fabric-covered buttons, enliven the lower part of the skirt.

After 1911, Han dressmaking became increasingly influenced by western styles and regularly incorporated haberdashery that was in vogue in Europe. Although the cut of this skirt alludes to an older style, it is not wrapped around the body, but is stepped into and pulled up. The traditional fastening method, with tape threaded round the waistband, has been replaced by western metal fastenings, including a hook and eye, pressed studs and a buckle that allowed the skirt to be adjusted to the size of the wearer. This skirt would have been worn with a fitted hip-length jacket, silk stockings and leather heeled shoes, similar to the style shown on the advertising poster above.

Skirt for a Han woman
Jacquard-woven silk; plain-weave cotton
Hong Kong, 1910s
Supported by the Friends of the V&A
FE.50-1995

Xiehe Trading Company Calendar Poster
Coloured lithograph on paper
China, 1913–14
Zhou Muqiao (1868–1923)
FE.478-1992

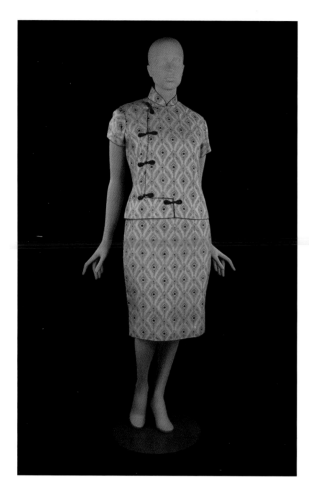
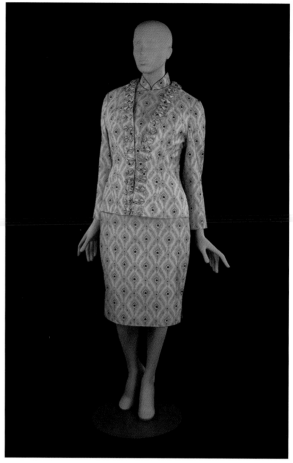

**Dress for a woman (*qipao*),
waistcoat and jacket**
Printed silk
Hong Kong, 1950s

Given by Richard and Janey Cheu
in memory of Dr Henry Cheu
FE.55:1 to 3-1997

A band of ruching trims the front opening and around the neck of the collarless jacket, adding depth and interest to this ensemble. A total of thirty-seven ruches were made from a long strip of the same patterned silk used for the rest of the garment, cut on the bias and fashioned into evenly spaced box pleats. The two open ends of each pleat were then folded towards the middle and fixed together with a small stitch. The jacket is waisted and tailored to the body, and can be fastened with hooks and eyes sewn discreetly just inside the garment.

As part of a three-piece suit, the jacket would have been worn with a matching waistcoat with decorative frogging in dark red, and a tight-fitting *qipao* (or *cheongsam*, in Cantonese). The style of this ensemble was an early adaptation of a western dress suit and would have been worn on formal occasions. This style of dress became even more popular with the introduction of air-conditioning in offices and public spaces in Hong Kong during the 1950s.

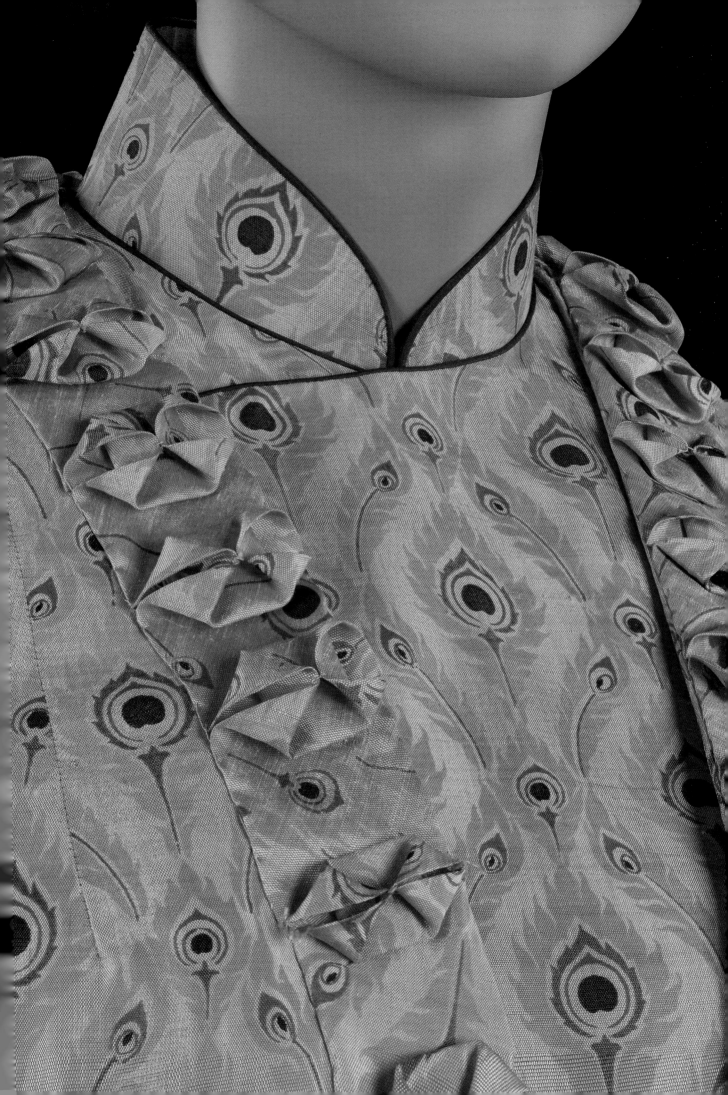

Folding fan (*zheshan*)
Ink and colours on paper;
stained bamboo
Hangzhou, c. 1935

Given by Pamela Marchant
FE.591-2007

Hand-held folding fans (*zheshan*) such as this example were painted
before being pressed into concertina pleats and mounted onto bamboo
sticks. The folding fan was an import from Japan, and not widely used in
China until the 16th century. The paper surface was often decorated with
small-scale paintings, which led to a new pictorial format popularized by
the literati class. Depicted on the central panel is an autumnal scene
showing two freshwater hairy crabs (an autumn delicacy for the Chinese)
crawling ashore towards a cluster of chrysanthemums.

Folding fans were essential accessories for both sexes, and ideal as
gifts or commemorative pieces. During a wedding in Chongqing, held
in August 1935, the chapel was filled with the humming of two hundred
hand-held fans as guests tried to keep the heat at bay. According to the
donor, this folding fan was a wedding present for the bride and groom
on that day, Robina Bookless and Lt. Tom Marchant, both from Scotland
but living in China at the time.

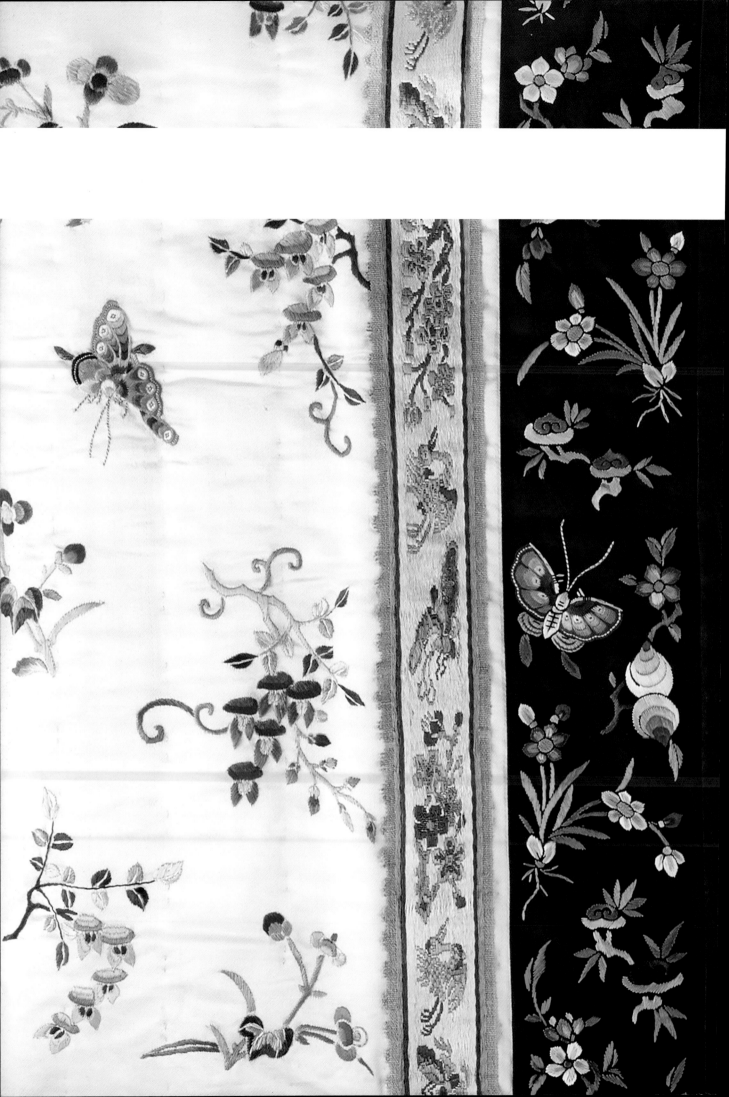

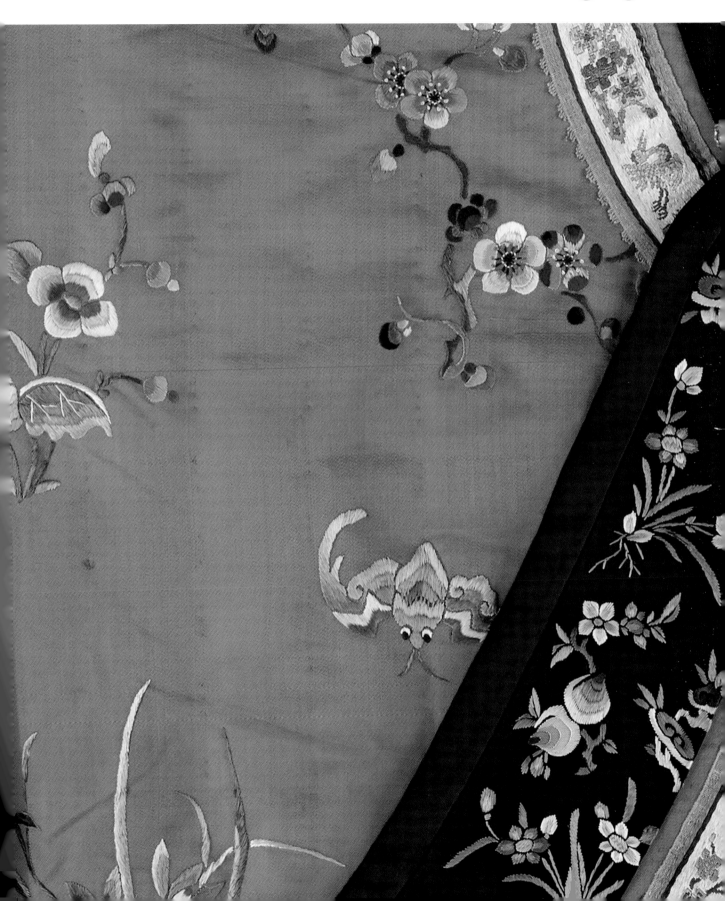

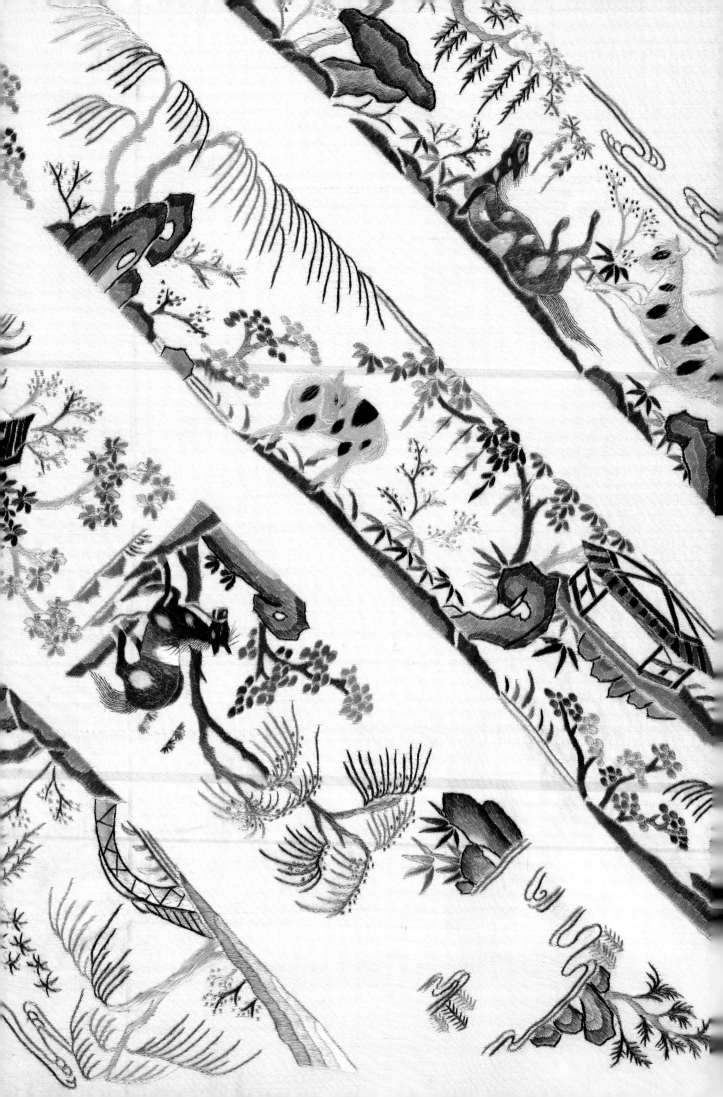

In these uncut edgings for embellishing the collar, overlap, hem and side vents of a jacket, bands showing horses and pavilions in a landscape setting have been finely embroidered on the bias on ivory satin. Decorative trimmings were a distinctive feature of Han women's dress since the 4th century BCE. Woven, embroidered or resist-dyed, they initially served to strengthen the raw edges of garments to prevent them from fraying; over time, they became wider and more ornate. By the mid-19th century, ready-made embroidered sets of borders like this example were popular and widely available from silk shops.

Chinese dress rarely features horses as a decorative motif, but borders featuring zodiac animals became more sought after in the late 19th century, when unique and complex designs were fashionable. The horse, associated with speed, power and success, is the seventh animal in the Chinese zodiac. These uncut edgings would have appealed to a woman born in the Year of the Horse.

**Uncut edgings for
a Han woman's jacket**
Satin-weave silk; embroidery
in coloured silks
China, 1850–1900

Given by Miss Winifred Ardley
T.134-1962

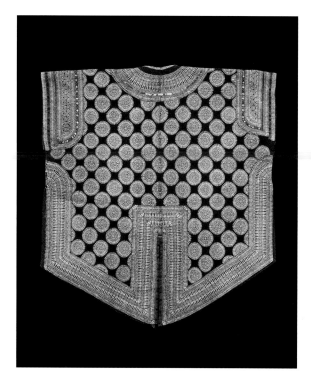 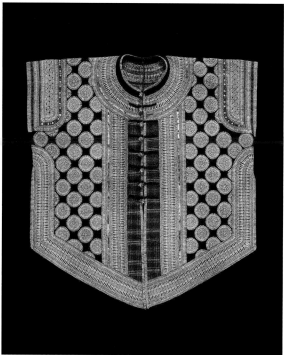

Festive jacket for a Yi man

Plain-weave cotton; wax-resist
dyeing; appliqué; silver
Yunnan, 1940–60

Given by Lady Keswick
FE.263:3-2018

Finely executed wax-resist dyed patterns adorn the front and back
of this sleeveless jacket, which would have been worn by a Yi man over
two long-sleeved cotton jackets as an ensemble at festivals or weddings.
The Yi people live in a mountainous area of southwest China. Because
of the high altitude, their primary concern when it comes to clothing
is warmth. They protect themselves from the cold by wearing multiple
layers that can be added or removed, depending on the conditions.

The jacket was probably made by a bride and given to her soon-to-be
husband on the occasion of their wedding. Yi women use copper
needles to apply melted beeswax as a resist agent to cotton textiles,
before dyeing the fabric in indigo to produce various geometric motifs
associated with nature. These designs have profound meaning for
the Yi people, and serve as a medium for showing gratitude to their
ancestors for blessings. In this example, the large, circular motifs are
thought to represent the sun. Other patterns depict thunder, moonlight,
stars and buckwheat, which carry wishes for good harvests. Fabric
strips in vivid colours and edged with gold foil add interest to the
otherwise monochromatic palette.

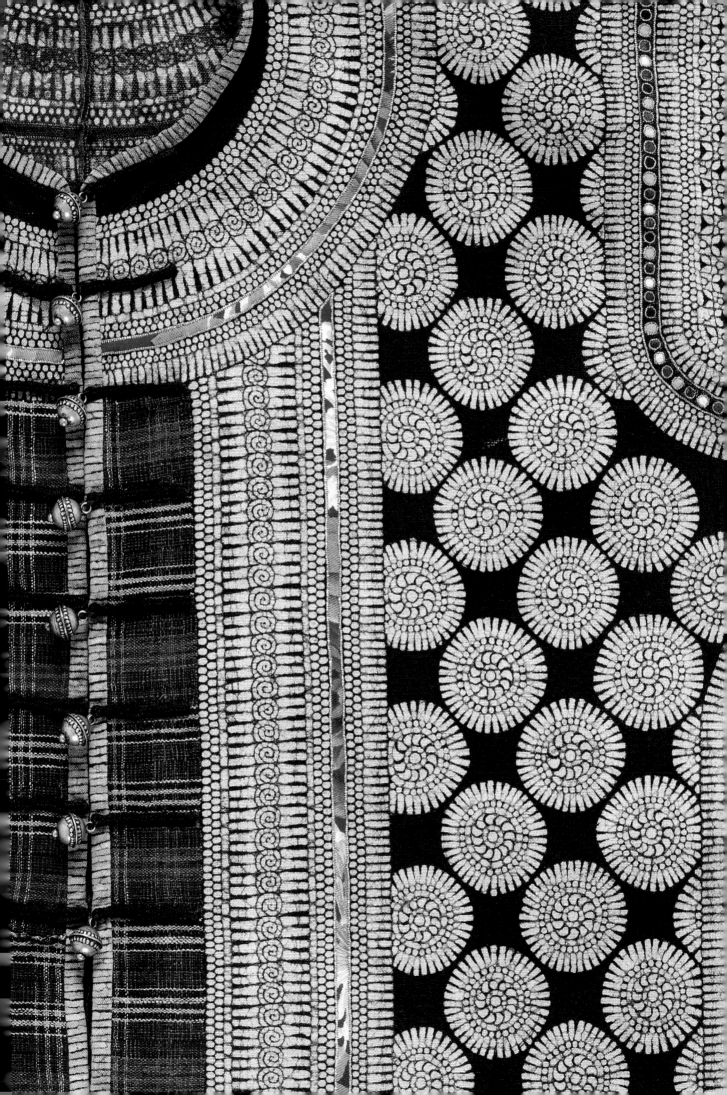

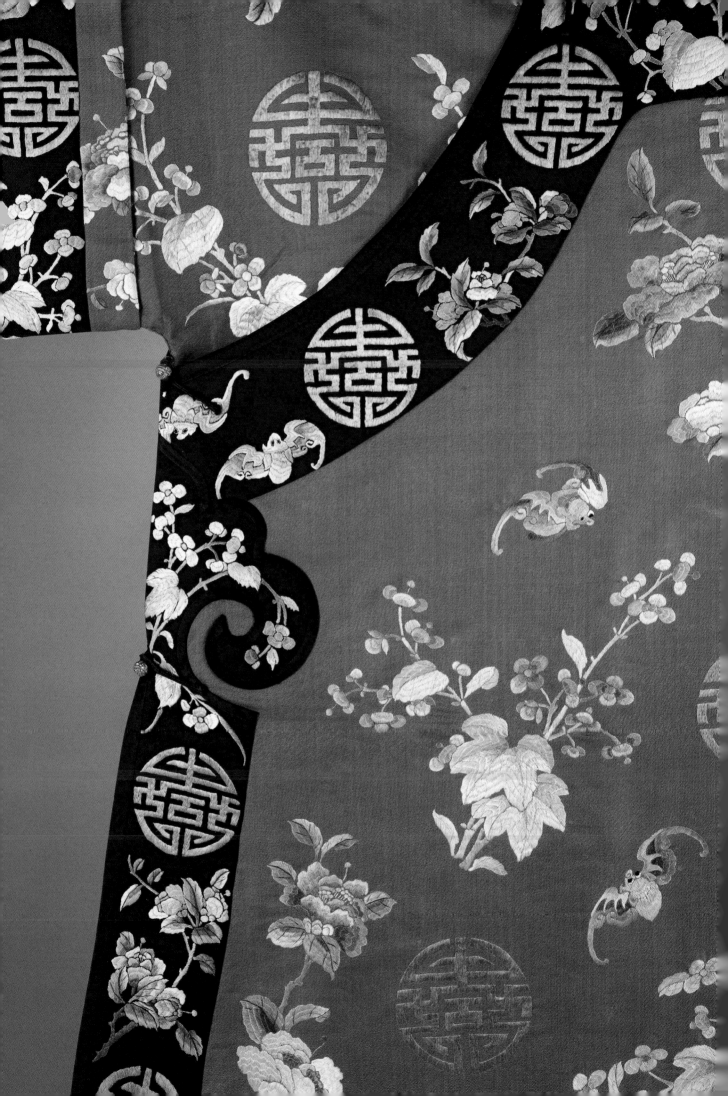

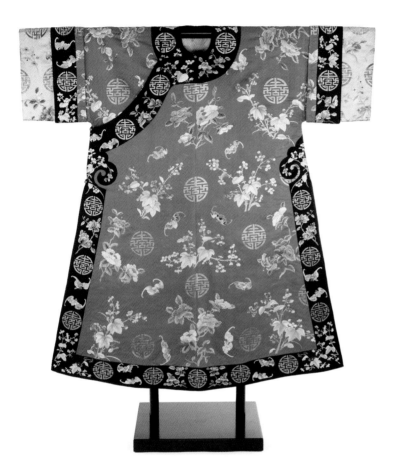

In the 19th century, Manchu noblewomen favoured lavishly decorated robes, trimmed with bold borders, for informal wear. This full-length outer gown is known as a *changyi* ('wide dress'), and has a distinctive broad cut, rolled sleeves and slits at the sides rising to the armpits, with *ruyi* heads on top, elements that were all heavily influenced by contemporary Han women's fashion.

The *changyi* often displayed striking and sophisticated craftsmanship, and could be worn in all seasons. Here, the main body of the garment features a pale-blue silk – known as 'moon white' in Chinese, a colour often worn by middle-aged women – embroidered with bats, scattered medallions of *shou* ('longevity') characters, and sprays of peonies and begonias in silk threads of pastel tones. All of these motifs are auspicious, but together they represent a wish for longevity, happiness and wealth. The same motifs are repeated on the layered cuffs and black satin borders. Fastened with four gilt-brass buttons, cast with *shou* characters, the gown would have been worn at a birthday celebration to bestow long life on its wearer.

Outer gown for a Manchu woman (*changyi*)
Twill-weave silk; embroidery in coloured silks
China, 1875–1908

Purchased with Art Fund support
T.231-1948

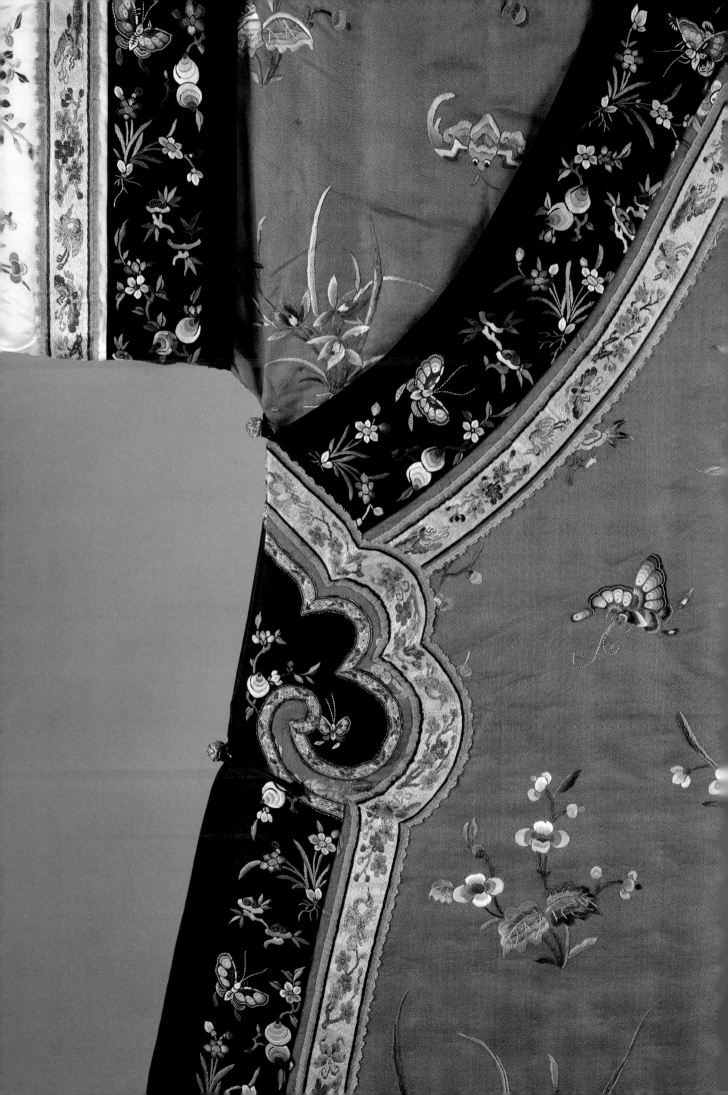

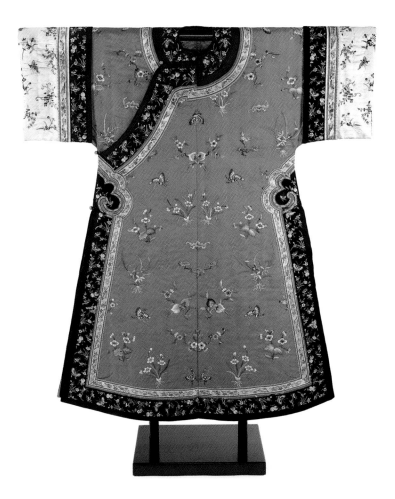

Figured silk ribbons provide a striking finishing touch to this red satin outer gown (*changyi*). Such features were originally foreign imports, but by the 1850s Chinese weavers were able to produce patterned silk ribbons decorated with auspicious designs to suit local taste. In this outer gown, a white-ground ribbon with a woven pattern of plum blossoms, cranes and butterflies – symbols of beauty and marital bliss – runs parallel to an embroidered black satin border. At the armpits, two ribbons – one thick, one narrow – have been skilfully pleated to ensure a smooth application in delineating the scalloped *ruyi*-head.

Red silk robes like this were typically worn by young Manchu noblewomen on joyous occasions. The garment is padded for wear in winter and early spring. The silk is embroidered predominantly with botanical motifs, some representative of the season when the robe would be worn, and others symbolizing a wish for all good things in life. Plum blossoms, orchids and wisteria symbolize eternal prosperity and an enduring spring, while peaches, narcissus and lingzhi are associated with immortality, signifying birthday wishes for a long life.

Outer gown for a Manchu woman (*changyi*)
Twill-weave silk; embroidery in silk and metallic threads
China, 1875–1908

Given by Sir Richard Tottenham
T.241-1963

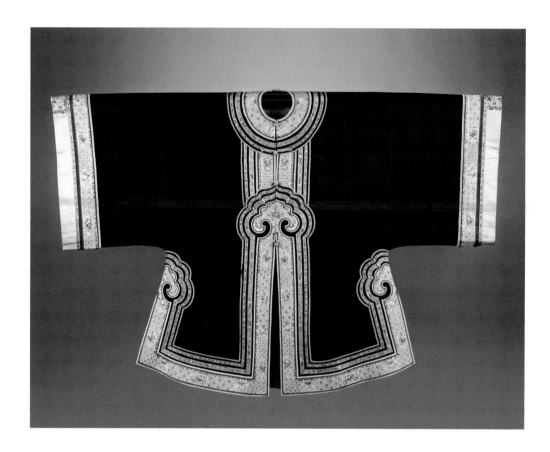

Jacket for a Han woman (ao)
Satin-weave silk; embroidery
in silk and metallic threads
China, c. 1875

Given in memory of Margot Miller
FE.109-2009

The detail opposite shows the trimming for the side slit of a jacket
for a Han woman, demonstrating the trend for heavily ornamented
edgings. The garment is bordered with a variety of trims: gold braid;
two polychrome ribbons, decorated with the Eight Daoist Emblems
and Treasures; two bias-cut strips in pale-yellow and blue satin; and
an ivory satin band, densely embroidered with vignettes featuring
a phoenix, a peacock, a deer and a crane under a pine tree, all on
a ground of fret pattern and floral motifs. The plainness of the main
body of the jacket contrasts with these colourful edgings, giving it its
striking appearance.

Decorative borders like these, called *langan* ('baluster') in Chinese,
add interest and texture to a garment. Prompted by their popularity,
the production of woven and embroidered edgings increased
exponentially in the late 19th century. One urban legend has it that
the excessive use of borders and edgings on a woman's jacket was
ridiculed as 'eighteen trimmings'.

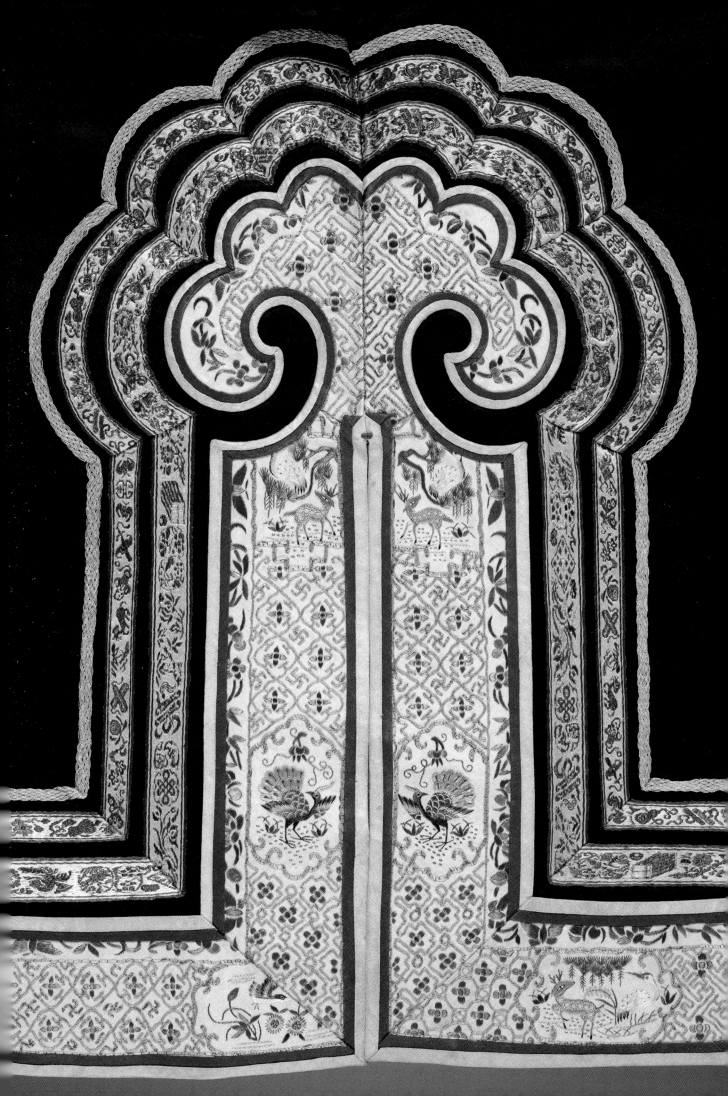

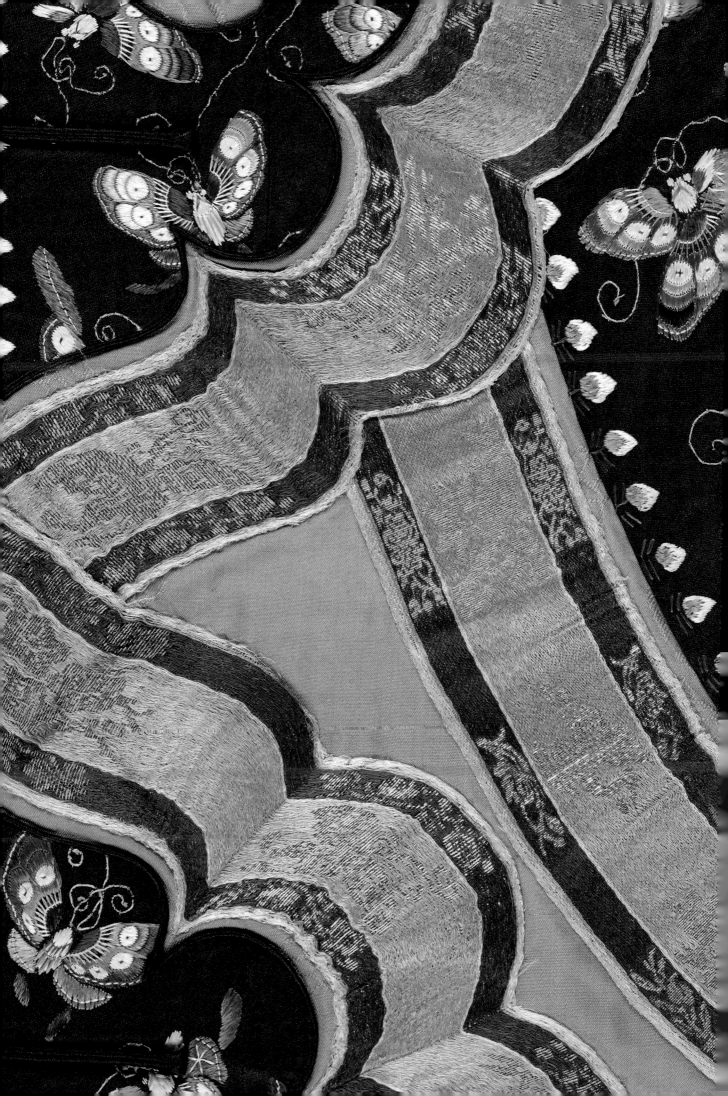

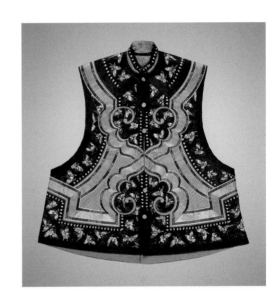

This hip-length, sleeveless jacket with a stand-up collar and deep armholes (*kanjian*) would have been worn over a long robe, as depicted in the painting above left. This garment style is also known as *beixin* or *jinshen* ('close-fitting'), and was popular for men and women from the mid-19th century to the early 20th century.

The decoration on this striking example exemplifies the fashion for applied edgings. The bright-pink silk is smothered with broad black satin bands, embroidered with fluttering butterflies, and wide turquoise silk ribbons with magenta edges and woven patterns in gold and silver. These embellishments have been laid on the surface with meticulous precision and secured with tiny, almost invisible stitches.

Sleeveless jacket for a woman (*kanjian*)
Satin-weave silk; embroidery in coloured silks
China, 1875–1908

Given by Mrs Muriel Carpenter in memory of Ebenezer Mann
FE.15-2006

Girl Selling Her Silver Hair Ornament
Watercolour and ink on paper
Beijing, 1885
Zhou Peichun Workshop
(active c. 1880–1910)

D.1653-1900

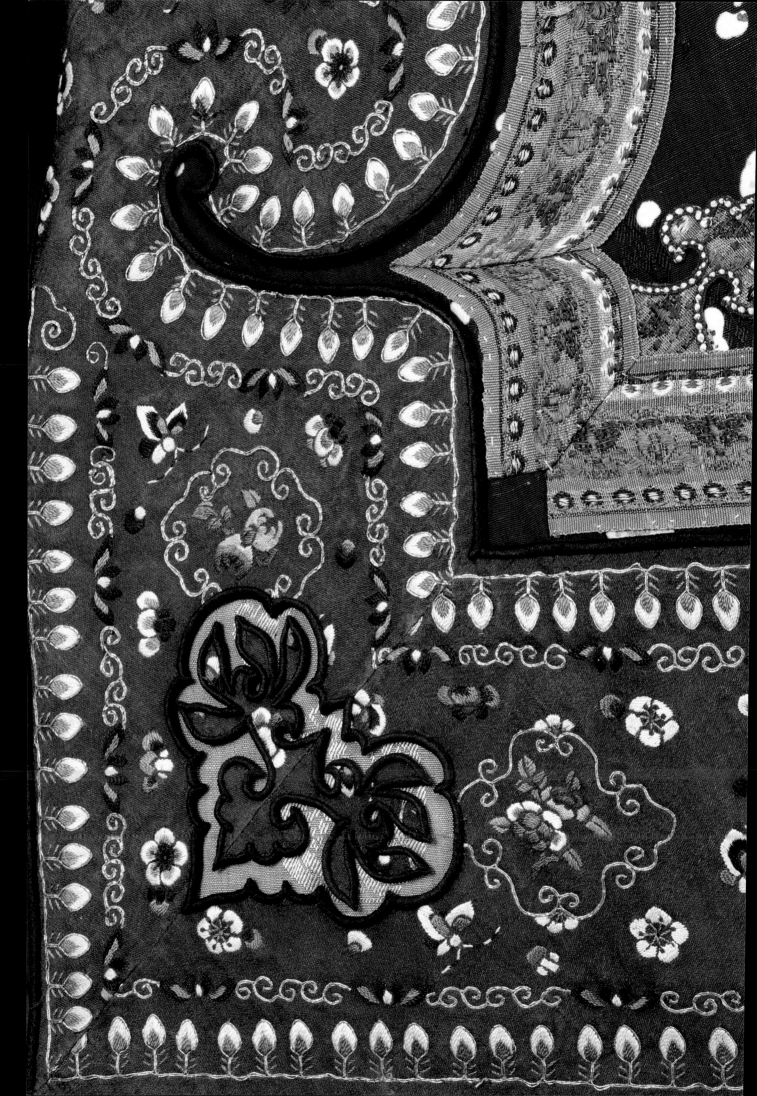

The detail opposite illustrates a carefully executed example of cutwork, a technique known as *wa yun*, which refers to the edging being cut into the shape of a *ruyi*-cloud. *Wa yun* was mostly used to embellish the edgings of jackets and pleated skirts. On this jacket for a young girl, it appears at each corner of the hem. The cutaway and filled-in section are both in the shape of a *ruyi*-cloud, connected to two orchid blossoms and sewn down onto an insertion of pale-mauve silk underneath. The edges have been skilfully neatened with black piping, and the wide band of blue silk, decorated with embroidered butterfly, floral and leaf motifs, turns the corner with a neat mitre.

The detail, while decorative, also adds some weight to the garment's edge, preventing the jacket from riding up while worn. The jacket is part of a suit, and would be teamed with matching trousers. Matching suits were a feature of the late 19th and early 20th centuries. After marriage, women tended to wear a wraparound skirt over the top of the trousers.

Jacket for a young girl
Resist-dyed silk; embroidery in silk and metallic threads
China, 1880–1920

T.124-1961

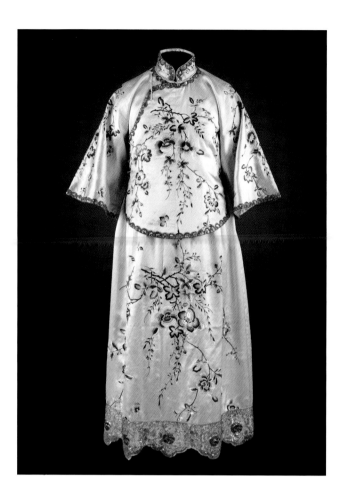

Jacket and skirt for a woman
(ao qun)

Satin-weave silk; cotton tulle; embroidery
in silk, glass beads and gelatine sequins
Shanghai, 1920s

Supported by the Friends of the V&A
FE.54:1, 2-1995

This ensemble from the 1920s, comprising a jacket and matching skirt,
was based on a revolutionary clothing style known as *wenming xinzhuang*
('civilized new dress'). It was associated with the contemporary image
of the modern woman, popularized by female intellectuals. By shortening
the sleeves to elbow-length, and the hemline of the skirt to calf-length,
this new fashion allowed women to reveal more flesh, a trend that was
seen as avant-garde and signified liberation.

Floral sprays, worked in pink and grey silks, adorn the cream silk
of the jacket and skirt. Glistening sequins and bugle beads on the
edgings give the ensemble the luxurious and flamboyant look that
characterized the so-called 'Shanghai style'. The scalloped hem has
been tamboured (chain stitch worked with a hook on tulle) in a pattern
of flower heads with iridescent gelatine sequins and glass beads.

Although gelatine sequins might seem unusual for embellishing
a delicate silk dress, this new and innovative material, produced
in Europe, was extremely effective in giving a lustrous appearance.
The ensemble could have been worn as a wedding dress with a western
white veil and a pair of white gloves. The previous owner bought it from
an antiques shop in Shanghai.

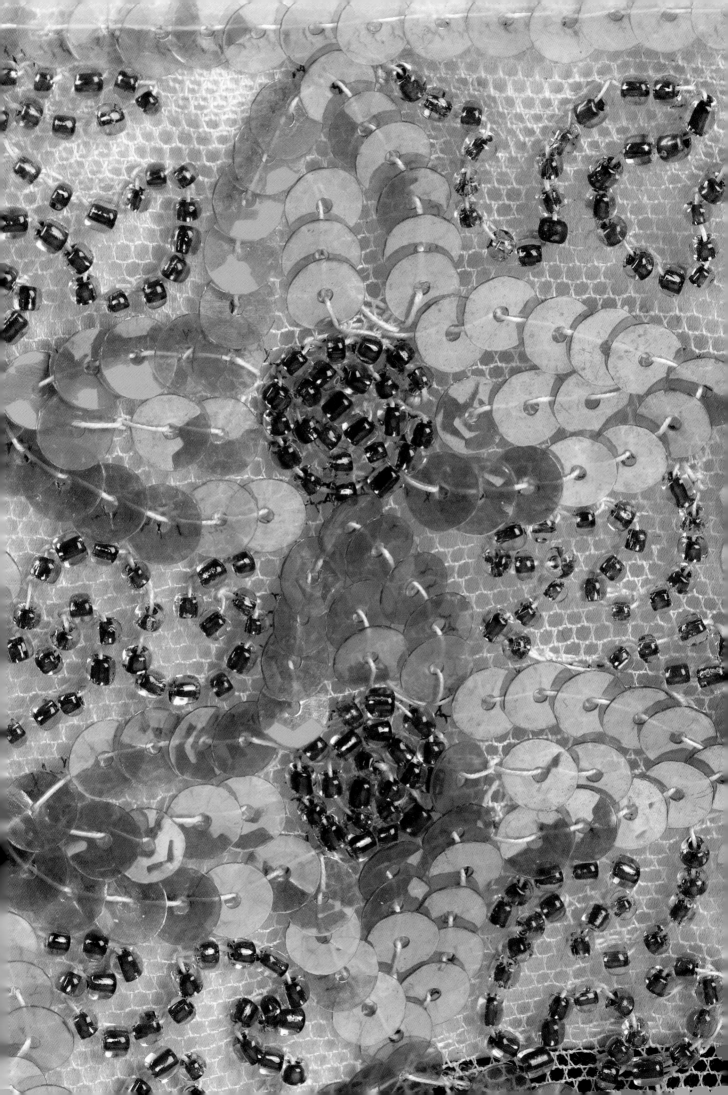

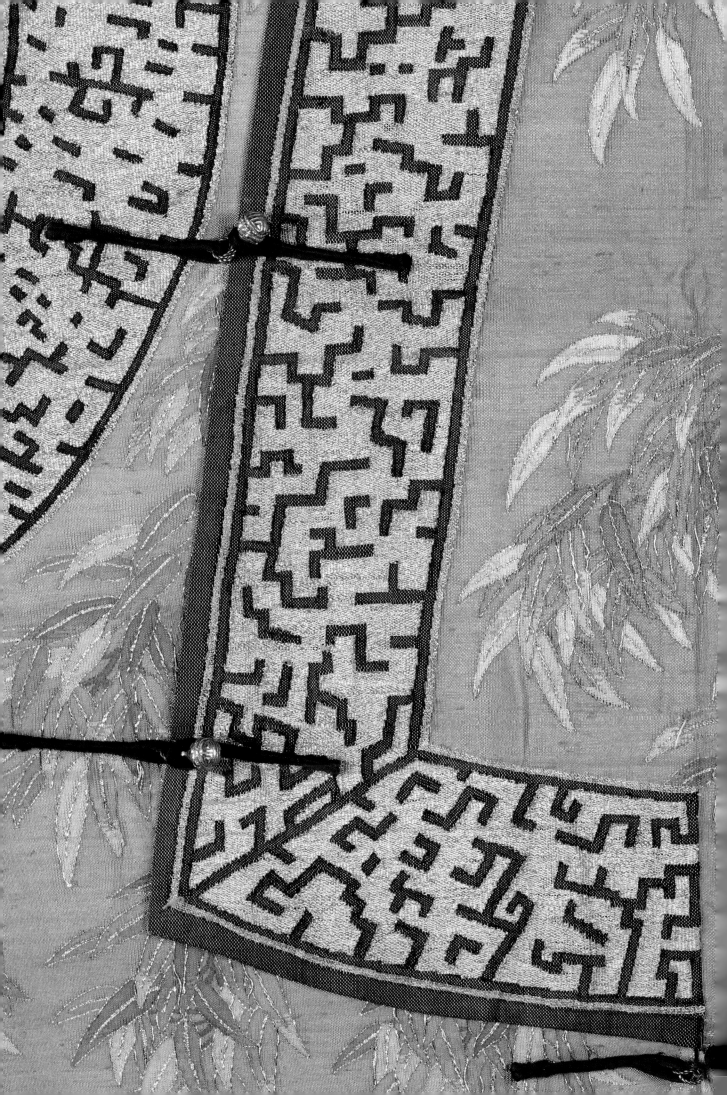

The design of this *kanjian* features bamboo on a ground of *xue qing* ('snow blue'), with edges patterned with fretwork. The borders, including mock-mitre corners, were all patterned on a tapestry-weaving loom using black silk and gold threads, and the collar's gilt edge was scaled down to ensure it remained in proportion with the jacket. On the main body of the jacket, slender bamboo designs are woven in shades of green with outlines of gold threads. Bamboo is one of the most popular evergreen plants in China, traditionally associated with integrity and winter. Being naturally flexible, it bends but does not break, representing the moral character of a gentleman (*junzi*).

This ornate yet elegant jacket is almost identical to the 'sauce-coloured green bamboo' pattern, one of a set of six designs produced to commemorate the seventieth birthday of the Empress Dowager Cixi (1835–1908) in 1904. These were the work of the court painters at the Ruyiguan studio, one of the workshops under the Imperial Household Department. The designs would then have been forwarded to the imperial silk factories in Suzhou and manufactured to specifications.

Sleeveless jacket for a woman (*kanjian*)

Tapestry-weave silk and metallic threads
China, 1904–10

Given by Mrs G. Knoblock
T.51-1951

Sleeveless Jacket Designed for Empress Dowager Cixi

Ink and colours on silk
Beijing, 1904

The Palace Museum, Beijing

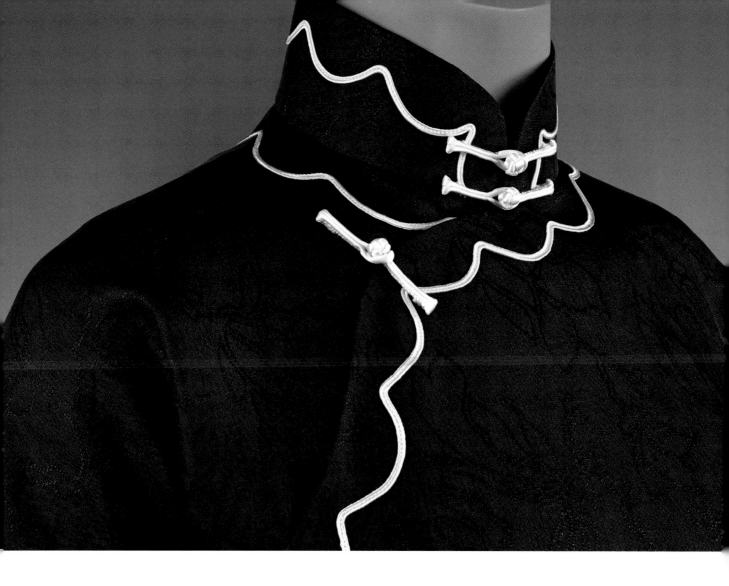

Dress for a woman (*qipao*)

Gauze-weave silk; polyester
Shanghai, 2019
Guo Yujun and Xu Yulin

Given by GUO XU
FE.193-2019

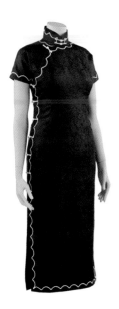

This monochromatic *qipao* takes inspiration from the plain appliqué trim that adorned Han women's dress in the early 20th century. A simple, undulating pattern in white cord is applied along the edges of the stand-up collar, neckline, right overflap, sleeves, sides and hemline. Black silk gauze, decorated with an inconspicuous pattern of magnolia, forms the background to the gleaming trim. Handling the appliqué of slippery, narrow cords on this form-fitting garment would have required great precision by skilled tailors. In keeping with the understated elegance of the dress, the same white cords are used to fashion the unadorned loop-and-knot fastenings.

The design of this *qipao* celebrates a different kind of beauty, one that eschews pictorial ornaments in favour of simple lines and a restricted colour palette. This design style is deeply rooted in one of the traditional Chinese aesthetics: *ya* (elegance), a refined taste that values simplicity and minimalism.

This full-length, sleeveless *qipao* features a double arc-shaped front and symmetrical fastening; the left side is stitched together and is purely decorative. This rounded front emphasizes the shapely curves of the body and was a popular style of *qipao* in the 1940s. It was favoured by the First Lady of the Republic of China, Song Mei-ling (1897–2003), also known as Madame Chiang Kai-shek.

Various techniques were used in edging finishes for traditional *qipao*, most of which required the use of bias-cut strips, ideally made from satin-weave fabrics. Tailors would usually apply a flour-paste mixture to the back of silk fabric with a brush, a technique called sizing, before marking or cutting the strips, thus making the slippery fabric easier to manipulate. Here, the edgings along the collar, sleeves, front opening and side slits are picked out with three narrow bias-bindings in pink and blue satin, and a yellow metallic woven strip. The colour palette was cleverly chosen to harmonize with the jacquard-woven pattern of the fabric. The triple bias-bindings were joined together, and the entire combined strip wrapped around the edges to deliver a clean finish.

Dress for a woman (*qipao*)
Jacquard-woven silk
Hong Kong, 1940s

Supported by the Friends of the V&A
FE.39-1995

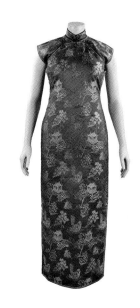

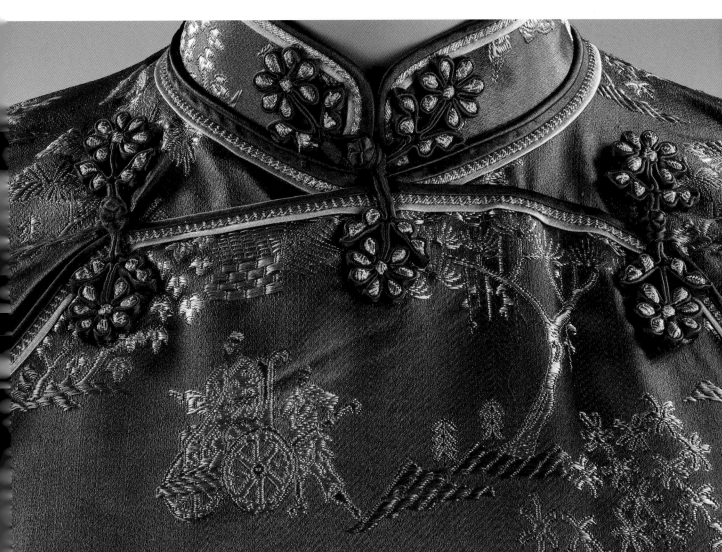

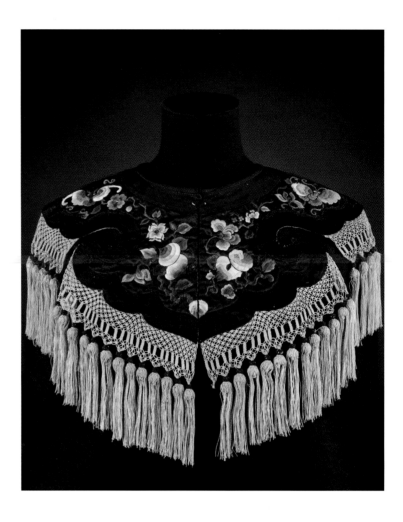

Cloud collar (*yunjian*)
Satin-weave silk; embroidery
in coloured silks
China, 1850–1900

Given by Miss Caroline Nias
and Mrs Isabel Baynes
CIRC.299-1922

Bright-yellow silk macramé fringes serve as the focal part of this blue satin cloud collar (*yunjian*). When the collar was worn, they would have presented a beautiful spectacle in motion. The fringes comprise hand-knotted silk, forming a net of coin-shaped patterns hung with a series of tassels. Chinese craftsmen used the same knotting technique in the 18th and 19th centuries to create luxurious fringing for embellishing embroidered silk shawls or bedcovers for export to Europe and the United States.

This cloud collar is decorated with silk embroidery in shades of blue, and features floral motifs, butterflies and a bat. It would have been worn to complement formal attire on special occasions. Fringes and tassels were associated with dance and theatre costumes, as the loose threads would respond to the wearer's slightest movement. Dancers and actors would wear more elaborate versions in bold designs and colours when performing on stage.

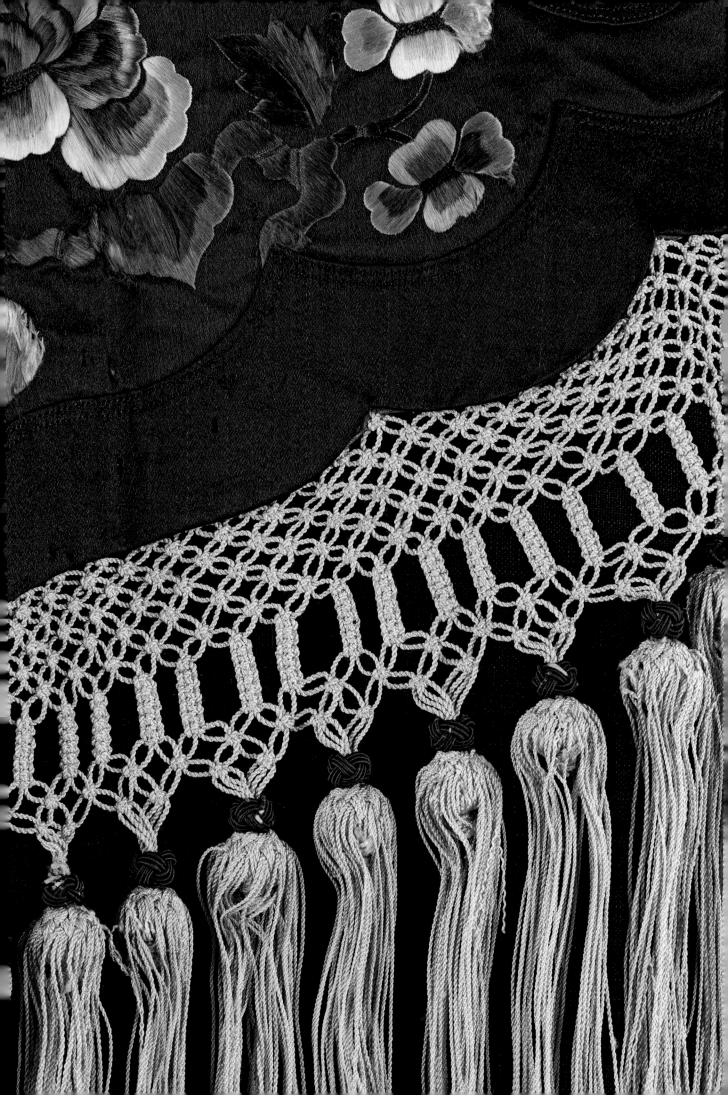

6. Buttons

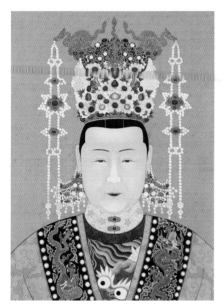

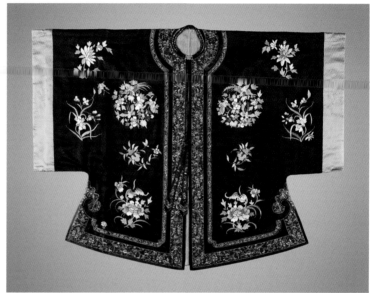

Jacket for a Han woman (ao)
Twill-weave silk; embroidery
in silk threads; gilt brass
China, c. 1875

Bequeathed by Mrs S.G. Bishop
T.2-1957

***Empress Xiao Jing Yi (1492–1535),
Consort of the 11th Ming Emperor
Zhengde (r. 1506–21)***
Hanging scroll painting
Beijing, 16th–17th century

National Palace Museum, Taipei

This navy-blue silk jacket (ao) has a stand-up collar, closed with a metal clasp-like button at the neck, and a central front opening fastened with two satin ties at the chest. A high-necked collar with two horizontal metal clasps, one on top of the other, was a feature of women's dress in the Ming dynasty (1368–1644), a style of fastening that had a fashion revival in the 19th century. Here, the socket-and-disc clasp is made of gilt brass, cast in the shape of a lotus flower.

The main body of the jacket features floral sprays, birds, butterflies, bats and pomegranates, embroidered with coloured silks. Black satin, embroidered with flowers and butterflies in shades of blue silk, is used along the closure, side seams and hem. The wide, elbow-length sleeves have straight cuffs trimmed with wide bands of embroidered green satin, with most of the embellishment appearing on the back. Some areas of embroidery on the sleevebands are now lost, leaving inked outlines that show the embroidery process.

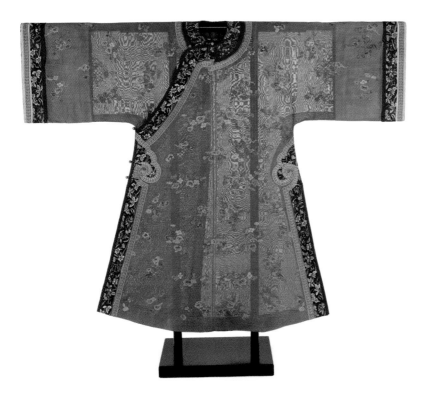

As summer approached, this open-weave, lightweight teal silk gauze would have been the ideal choice of fabric for making an unlined outer gown (*changyi*). The openwork lattice gilt-brass buttons also add a summery touch. The granulation effect on the buttons was not added by hand, but created during the casting process. Brass shanks were then attached to the buttons, and black satin loops passed through them.

Outer gown for a Manchu woman (*changyi*)
Gauze-weave silk; embroidery in silk threads; gilt brass
China, 1850–1900

Given by Mrs Elsbeth Fuhrop
T.387-1967

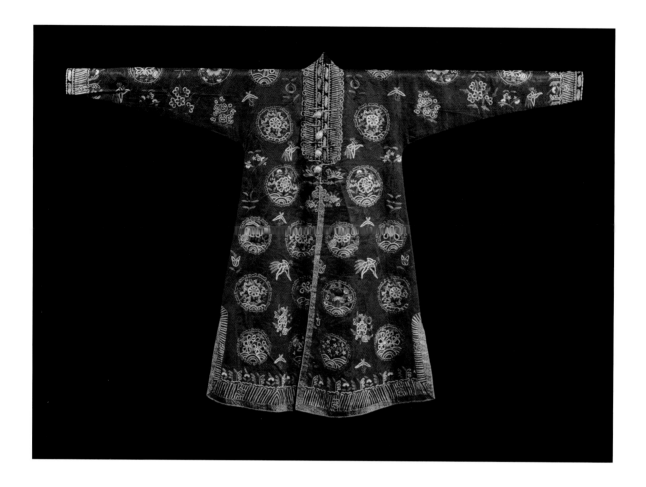

Outercoat for a Uygur woman (*chapan*)
Silk satin damask; embroidery in silk and metallic threads; gold; coral; turquoise; pearls
Khotan (Hetian), Xinjiang, 1850–1900

Given by Captain George Sherriff
T.31-1932

Four large buttons decorate the front of this magenta silk outercoat, known as a *chapan*. The handcrafted gold filigree work of the buttons, set with turquoise and pearls, is finished with a coral bead, and the buttons are secured with twisted wire threaded through a small loop. Apart from their primary function as fasteners, large buttons such as these were also worn as decoration in the same way as jewelry.

Embroidered with floral designs in chain stitch, the outercoat is made of expensive Chinese silk that would have been reserved for special occasions. The chevrons, embroidered in multicoloured silk threads around the neckline and fastenings, signal that the outercoat belongs to a married woman in Khotan (Hetian), southwest Xinjiang.

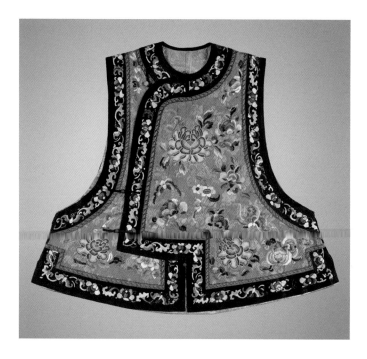

**Sleeveless jacket for a woman
(*kanjian*)**
Silk damask; embroidery in silk
threads; silk crochet; jade
China, 1880–1910

Given by HM Queen Mary
CIRC.33-1936

This hip-length sleeveless jacket for a woman (*kanjian*)
features an L-shaped *pipa* overlapping closure. There
are five closures in the form of black satin loops, with
one button of white jade and four buttons covered in
red silk crochet, matching the colour of the embroidered
peonies.

The technique of crochet, a form of lace worked
with a hook and a continuous thread, was introduced
to China by Christian missionaries, who trained orphaned
children in needlework skills to help them earn a living
as tailors or teachers. Crocheted buttons were popular
in Europe and the United States from c. 1860 to 1915.

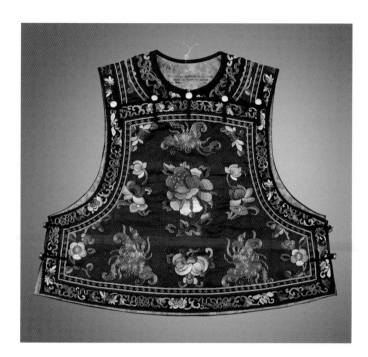

Sleeveless jacket for a child
(*kanjian*)

Twill-weave silk; embroidery in silk
and metallic threads; enamelled brass
China, 1862–74

Given by HM Queen Mary
T.110-1964

This waist-length sleeveless jacket for a child reveals
another style of *kanjian*. Unlike the jacket on p. 142,
it has a completely removable front. The back and yoke
are made from a single piece, with a round neck.
The jacket is fastened by enamelled buttons with black
satin loops: five across the chest and two down
each side.

These exquisite buttons depict clock-faces with
Roman numerals, showing different times of the
day. They were possibly crafted in the capital of
Guangdong province, Guangzhou (also known as
Canton), where there has been a thriving clock- and
watch-making industry, as well as for painted enamels,
since the 18th century. The wearer probably came
from an affluent family who prized this stylish form of
timepiece as a potent symbol of status and influence.

Outer gown for a Manchu woman (*changyi*)

Tapestry-weave silk (*kesi*); gilt brass
China, 1850–75

Given by Mrs G. Knoblock
T.53-1951

Four loop-and-toggle fastenings have been used to finish the pea-green silk tapestry of this *changyi* for a Manchu woman. They are spaced out from the curved front overlap, one arranged horizontally at the neck, another vertically across the collarbone, and two underneath the arm on the right. The ball-shaped toggles, decorated with floral patterns, were cast from brass, then gilded, and the loops are made from narrow strips of black satin.

Gilt-brass buttons such as these were standard fasteners for both formal and informal dress at the Manchu court. By the early 18th century, loop-and-toggle buttons had become the dominant type of fastenings on both Manchu and Han Chinese clothing. The tactility of ball-shaped toggle fastenings has remained a unique and desirable feature of Chinese dress, which does not have European-style buttonholes.

This type of riding jacket (*magua*) was introduced into the informal wardrobes of men and women in the mid-19th century. The short overgarment with a sleeve lining in bright yellow would have been worn by a high-ranking woman at the Manchu court.

Four gilt-brass buttons secured with black satin loops adorn the central front opening. Each bears a winged lion design on the front, the maker's mark 'T.W. & W' and a quality mark 'Double Gilt' encircling the shank on the back. These marks indicate that the buttons were made by Trelon, Weldon & Weil, a company founded in Paris in 1845, and that the buttons were gilded twice.

Jacket for a Manchu woman (*magua*)

Tapestry-weave silk (*kesi*); embroidery in silk threads; gilt brass
China, 1850–65

Purchased with Art Fund support
T.210-1948

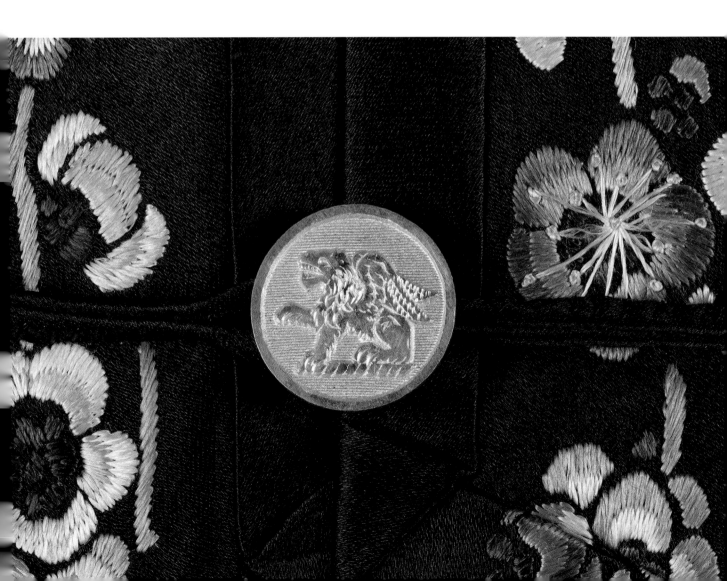

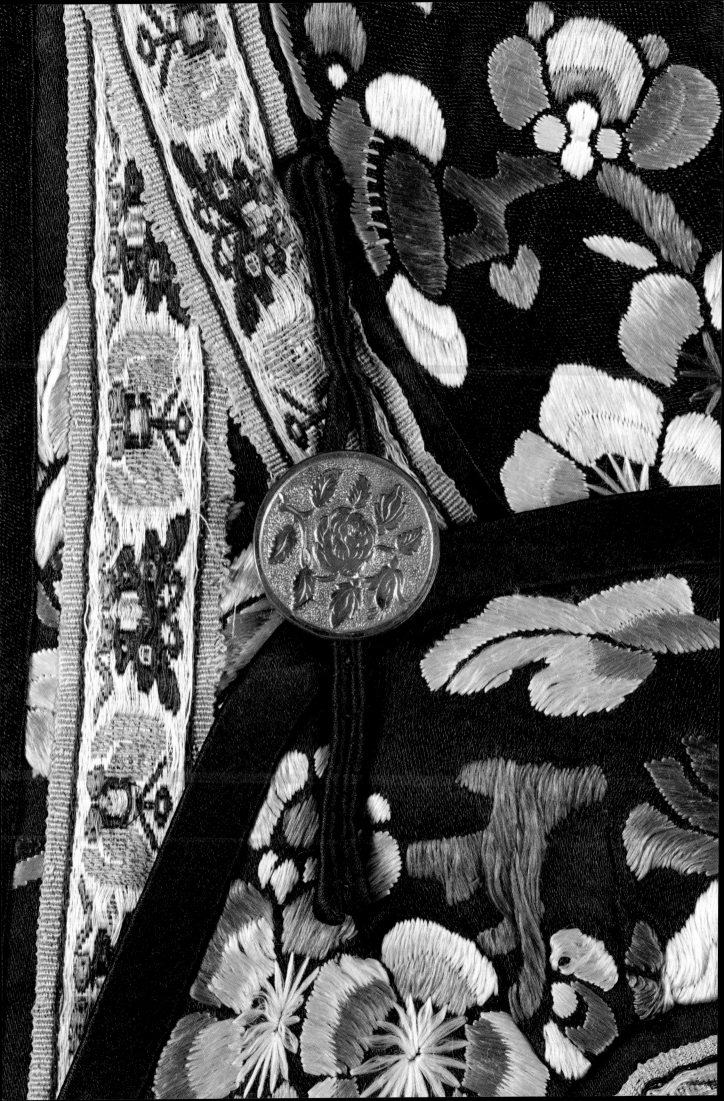

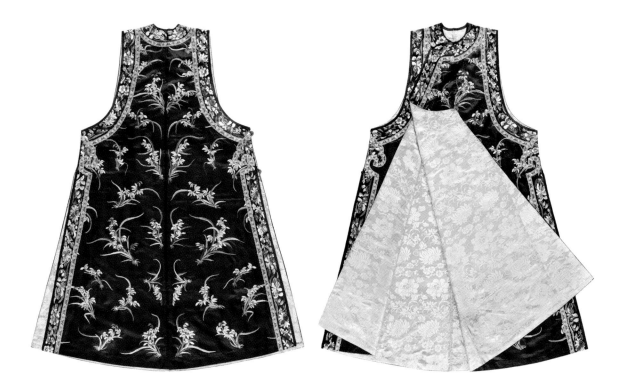

Manchu court women would have worn this style of full-length, sleeveless coat (*gualan*) as informal outerwear, with generously cut armholes to accommodate a long robe underneath. This example is made of dark-blue satin, embroidered with an all-over pattern of orchids. The edges are bordered with black satin embroidered with a floral design, and further embellished with applied ribbons featuring butterfly motifs. The bright-yellow silk lining suggests that it was made for an empress or empress dowager.

The coat is fastened by four gilt-metal buttons with black satin loops: two near the neck, and two on the side. These coin-shaped buttons, cast from copper alloy, were imported from Britain. Each has a floral spray decoration on the front, and a simple brass eye soldered to the back. The quality mark reading 'Standard Rich Colour' on the reverse indicates that the button is gilt. Despite brass buttons, about the size of small cherries, being produced in China, the wealthy were attracted to gilt flat-disc buttons like these, decorated with animals or floral motifs.

Sleeveless outer coat for a Manchu woman (*gualan*)
Satin-weave silk; embroidery in silk threads; gilt copper alloy
China, 1862–74

T.127-1966

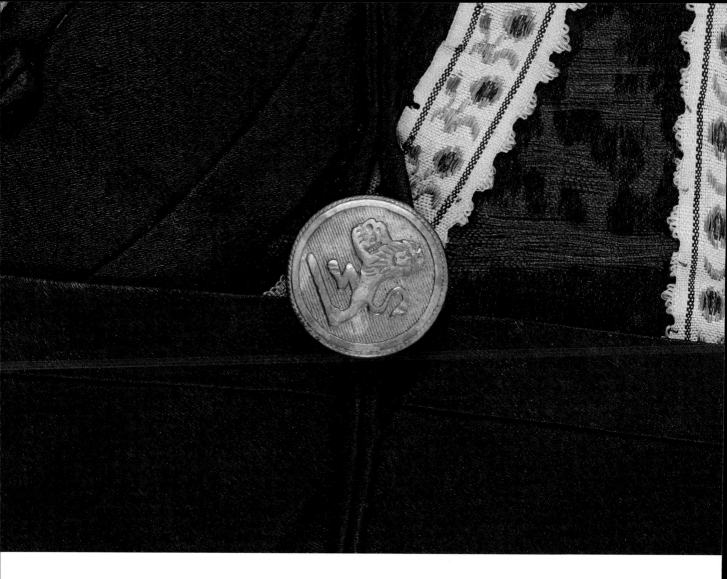

Sleeveless jacket for a child
(*kanjian*)

Satin-weave silk; embroidery in silk,
metallic and peacock feather-wrapped
threads; gilt brass
China, 1850–75

T.84-1965

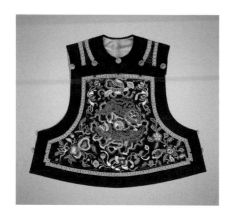

Nine gilt-brass buttons, each decorated with a lion rampant holding
a crown, finish off this sleeveless jacket for a child. The buttons were
originally used for embellishing military uniforms for the East India
Company, founded in London in 1600 and dissolved in 1874. The
inscription on the reverse reads 'Standard Treble Gilt, M.S. & J.D.',
indicating that the buttons were made by Mark Sanders and John
Deykin of Birmingham.

It is unclear how British military buttons ended up on this jacket.
One possible explanation is that the lion design – echoing the two
Buddhist lions, symbols of protection, embroidered on the main body
of the garment – appealed to the Chinese. The lion was also the
insignia of a second-rank military official during the Qing dynasty
and is associated with wishes for the child's future success.

The gilt-brass buttons adorning this sleeveless jacket were mass-produced in China by the 'Shunxing Foreign Company' (順興洋行). Like many of its counterparts, the company was strategic in its domestic production and marketing, having learned the importance of incorporating designs that reflected traditional Chinese culture.

Gilt-metal buttons often featured auspicious motifs that conveyed wishes for happiness, longevity or fertility. Here, the button depicts five bats encircling the character for longevity (*shou*). The bat, pronounced *fu* in Chinese, is a homophone for 'blessings', and symbolizes the 'Five Blessings': long life, wealth, health, love of virtue and a peaceful death, here with an emphasis on longevity.

Sleeveless jacket for a woman (*kanjian*)
Satin-weave silk; embroidery in silk threads; gilt brass
China, 1875–1908

Given by Mrs Muriel Carpenter in memory of Ebenezer Mann
FE.15-2006

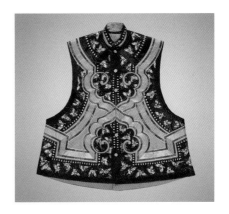

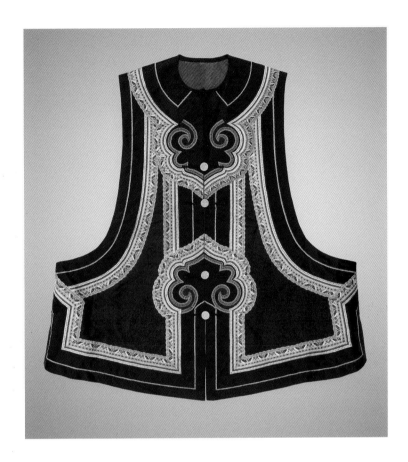

By the 1890s, gilt-brass buttons such as those on this jacket no longer needed to be imported from Europe. Many foreign companies had established factories in China and introduced machinery to produce western-style goods.

The words 'Qianxin Foreign Company' (謙信洋行) on the reverse of the buttons refer to a German trading firm that had an office in Shanghai. The button shown opposite is decorated on the front with six butterflies. The Chinese word for butterfly (*die*) is a homophone for 'eighty years of age', and the design conveys wishes for a long life.

Sleeveless jacket for a woman (*kanjian*)
Silk satin damask; silk ribbons; gilt brass
China, 1890–1910

FE.31-2021

Dress for a woman (*qipao*)
Silk damask
Hong Kong, 1995
Leung Ching Wah of Linva Tailor

FE.313:1-1995

The flamboyant fastening on the shoulder appears to be the only means of closure on this *qipao*. There are, however, press studs along the collarbone, a hook and eye at the neck, and a zip at the right side of the dress. The fastening comprises two parts: the 'eye', which includes a loop and is sewn to the upper side of the dress; and the 'head', which incorporates a button knot and is fixed to the lower side.

To form the flower fastening, strips of bias-cut cloth were passed around a thin wire, which was then twisted into the desired shape and sewn onto the dress. The shape of the fastening echoes the chrysanthemum pattern of the fabric, and incorporates two longevity (*shou*) characters. While most *qipao* tailors were men, women were employed to make buttons and loops. This type of decorative frogging (*pankou*) became a signature of the traditional tailoring of a well-made *qipao*. The V&A commissioned this dress from Mr Leung Ching Wah of Linva Tailor, Hong Kong.

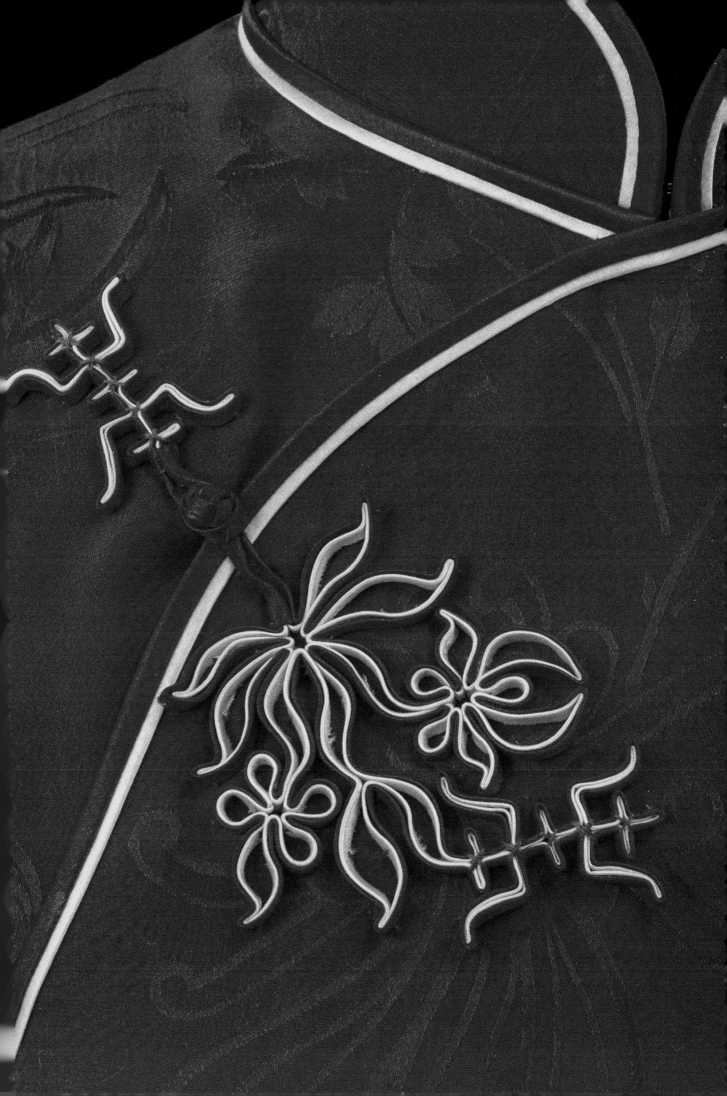

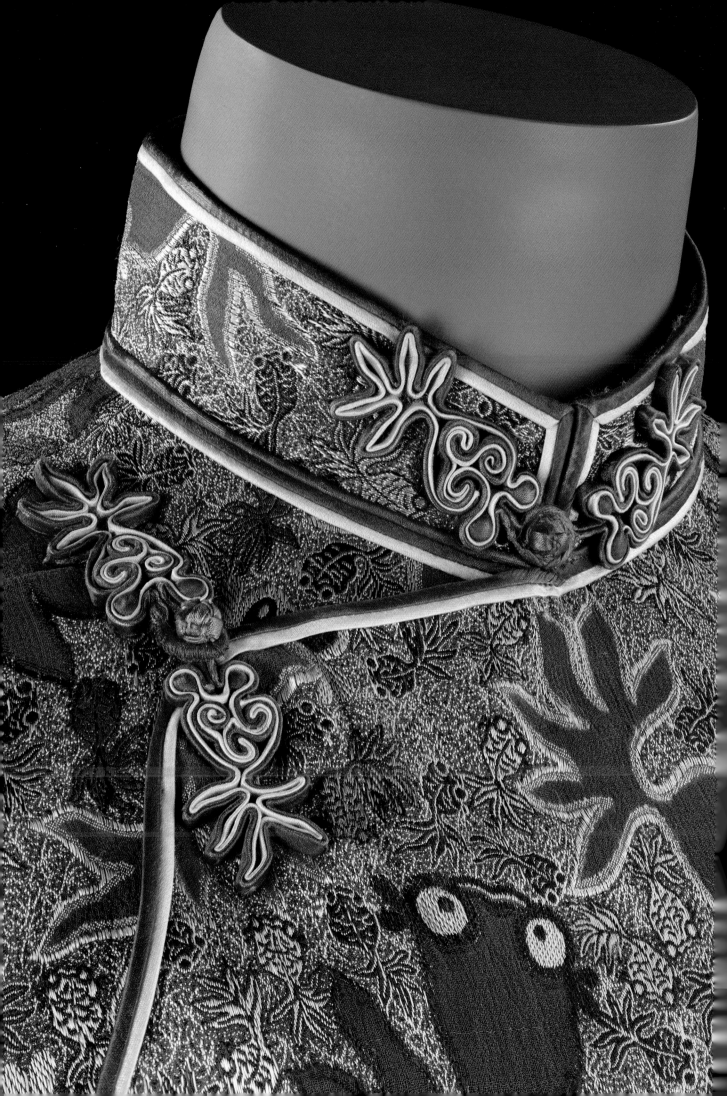

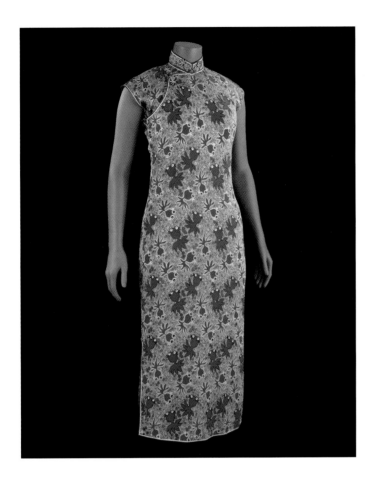

This sleeveless, calf-length *qipao* is made from diaphanous silk chiffon, woven with a pattern of bulging-eyed goldfish (*jinyu*, a homophone for 'gold' and 'jade'), a popular motif in China. The dress has a side fastening and a small squared-off, stand-up collar, and is edged all round with a double-binding of white and red bias-cut satin, which also forms the decorative fastenings.

Two loop-and-knot buttons at the neck and the collarbone were skilfully made in the shape of goldfish to match the pattern of the fabric; the button beneath the arm is shaped in the form of a spiral. These handcrafted fabric buttons evolved from basic loop-and-knot fasteners. By the 1930s, a vast array of new designs were emerging – from floral designs, butterflies and fish to auspicious symbols – demonstrating the creativity of the button-makers.

Dress for a woman (*qipao*)
Figured silk chiffon
Hong Kong, 1940s

Supported by the Friends of the V&A
FE.42-1995

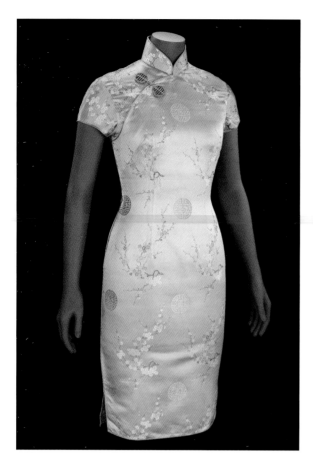 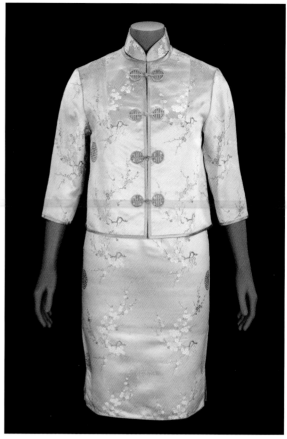

**Dress for a woman (*qipao*)
and jacket**
Figured silk satin
Hong Kong, 1960s

Given by Christine S. Chin
FE.26:1, 2-2004

The minimalist design of this two-piece ensemble, featuring a knee-length *qipao* and a collarless jacket, was probably inspired by the classic Chanel suit of the 1950s, and would have been seen as extremely chic and modern at the time it was made in the 1960s. Both pieces are cut from gold-coloured silk, patterned with plum blossoms and circular longevity (*shou*) characters.

The jacket has a round neck, three-quarter-length sleeves and a central front opening with four decorative loop-and-knot buttons. The form-fitting *qipao* has a stiffened stand-up collar, cap sleeves and side vents, and fastens to the right with the same decorative closure as the jacket. There is also a press stud, and a zipper down the side seam. Both jacket and *qipao* are trimmed around the edges with narrow, bias-cut gold satin. The buttons, made from the same material as the edging, are shaped in *shou* roundels, creating visual unity with the fabric design. This glitzy outfit was designed to be worn on special occasions.

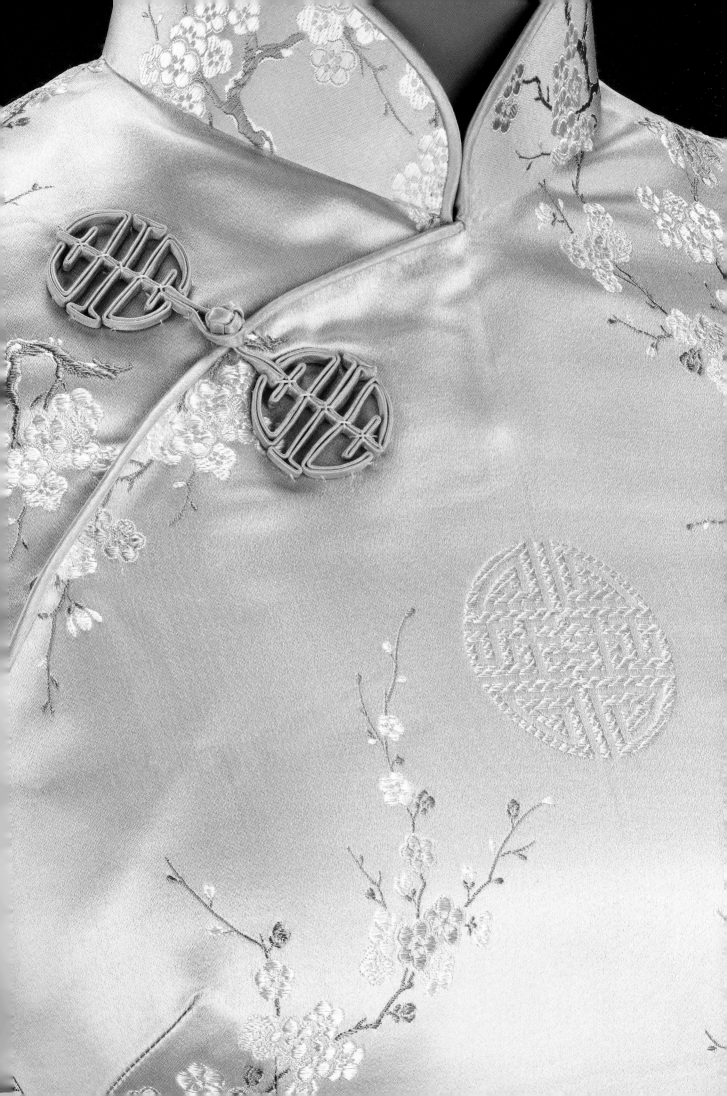

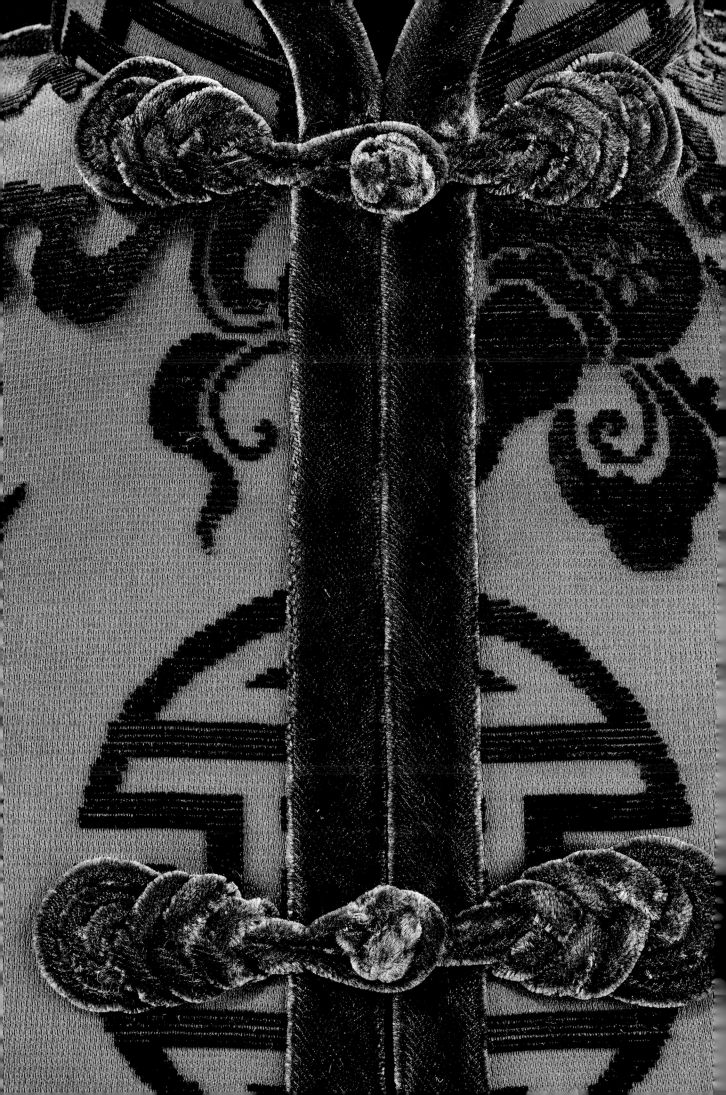

The donor of this jacket, Mrs Victoria Dicks, had it made in Hong Kong around the time of her marriage in 1969. She chose the turquoise velvet, and her tailor suggested the olive-green trim to match the colour of the cut-velvet design of the fabric – an unusual colour scheme that gives the jacket its unique and contemporary appearance.

The tailor meticulously matched the longevity (*shou*) characters across the front opening and on the stand-up collar, and used the thick velvet trim to bind the edges. The same material was also used to fashion the buttons with a unique Chinese knotting technique: the *pipa* knot. The knot itself is based on the shape of the number '8', which is seen in China as the luckiest number because of its associations with wealth, and was thus a popular choice for decorative fastenings. The knot's simple but bold design is a distinguishing feature of this jacket.

Jacket for a woman
Voided silk satin velvet
Hong Kong, c. 1969

Given by Mrs Victoria Dicks
FE.45-1997

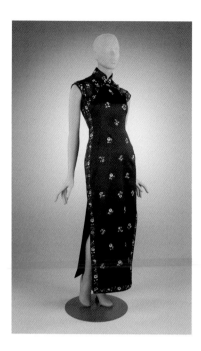

Dress for a woman (*qipao*)
Satin-weave silk; silk organza;
embroidery in silk threads
Shanghai, 2019
Guo Yujun and Xu Yulin

Given by GUO XU
FE.190-2019

Flower-shaped knot buttons (*huaniu*) were a popular
choice for embellishing *qipao*. On this black satin
dress, three buttons in the shape of five-petalled
flowers, made from padded pink silk and outlined
in strips of black satin, were specially designed
to complement the delicate floral embroidery pattern
and colour of the fabric.

 The garment was made by GUO XU, a Shanghai-based
brand specializing in bespoke *qipao*. Founded by Guo
Yujun (b. 1970) and Xu Yulin (b. 1973) in 2002, the
company's designs combine modern fashion silhouettes
with traditional Chinese embroideries. Unlike other
qipaos, which are cut on the grainline, this dress is cut
on the bias (at a 45° angle), allowing the fabric to hang
more gracefully on the body.

 The floral design was inspired by the story of the
'Heavenly Maiden Scattering Flowers', from the Buddhist
Vimalakirti Sutra. The birth of the Buddha was also said
to be accompanied by a rain of flowers. The design was
crafted by GUO XU's in-house embroiderers in the style
of Suzhou embroidery, characterized by naturalistic
and soft colours. Here, the designers opted for more
monochromatic tones and pastel colours to evoke
a sense of graceful femininity.

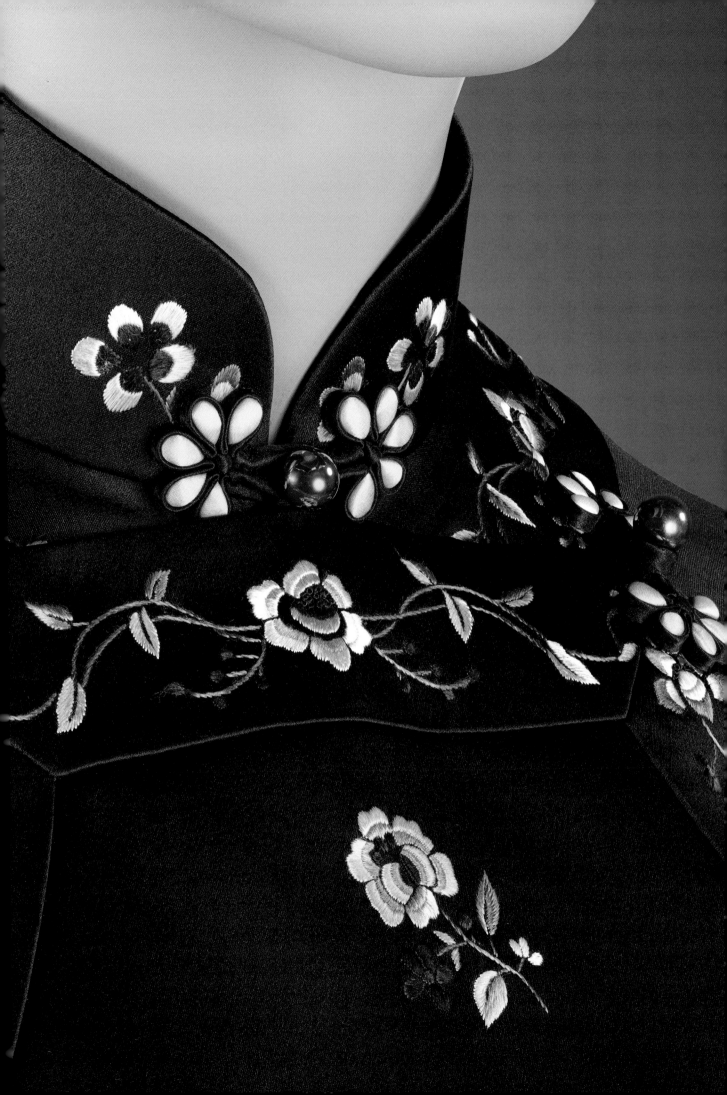

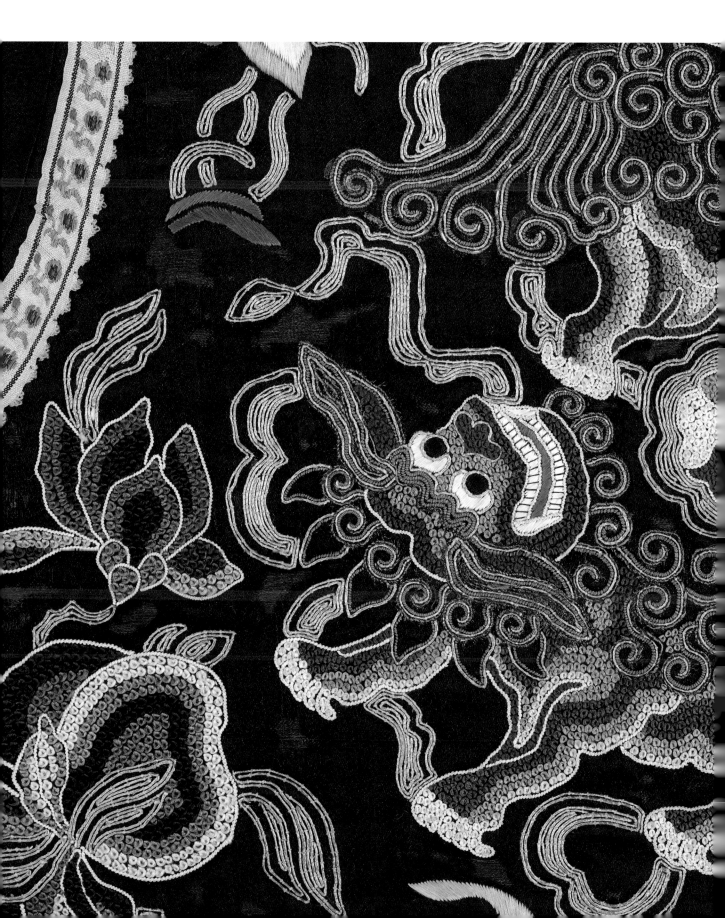

7. Embroidery

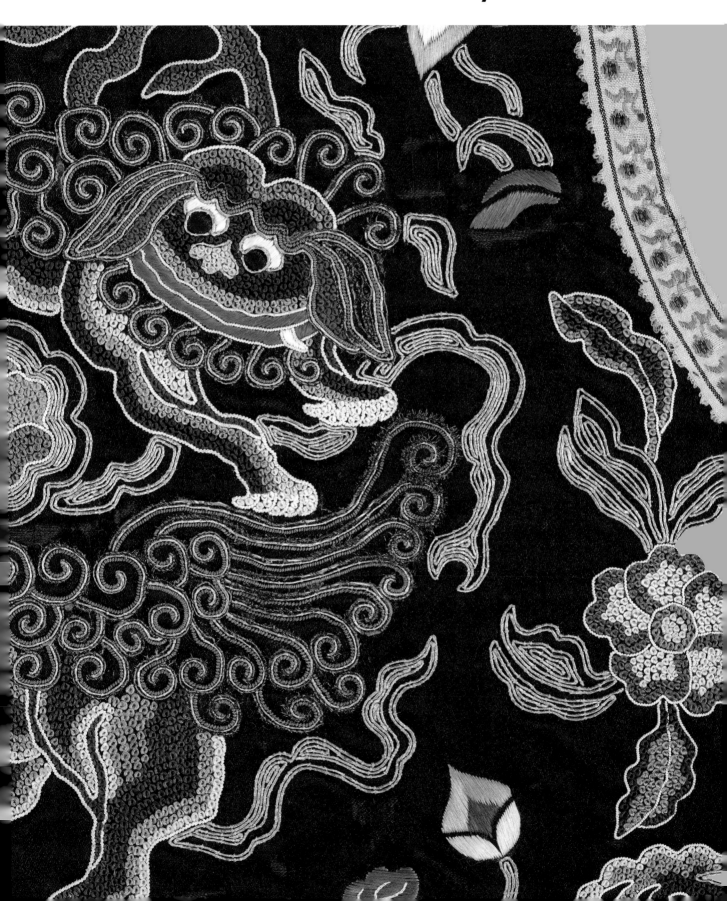

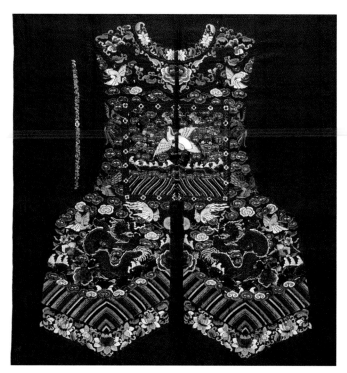

**Length of uncut fabric for
a court vest for a woman (*xiapei*)**
Satin-weave silk; embroidery
in silk and metallic threads
China, 1875–1900

Given by H.M. Commissioners
for the Exhibition of 1851
MISC.73A-1921

Ancestor Portrait of a Woman
Ink and watercolour on silk
China, 1800–1900

E.606-1954

This uncut length of dark-blue satin, comprising two front panels
and a collar band, was embroidered as part of a woman's court vest
(*xiapei*), and demonstrates how such garments were produced by
professional workshops in the 19th century. Court vests of this kind
were made for the wives of state officials, who wore rank badges
appropriate to the status of their husbands. The painting shows the
general style of court vest worn by a Han woman at the most formal
of occasions.

Here, the badge displays an egret, indicating that it was made for the
wife of a sixth-rank civil official. The rest of the surface area is filled with
birds and dragons, and floral and cloud motifs, all symmetrically arranged
and worked in satin stitch and couched gold-wrapped threads (gilt-paper
wrapped around a silk core). The vivid hues of the silk embroidery have
largely faded, and can now only be seen on the reverse (above left).
Court vests had a central front opening; the void area between the
two pieces is for the seam allowance. A tailor making this garment
would have finished it with a silk lining.

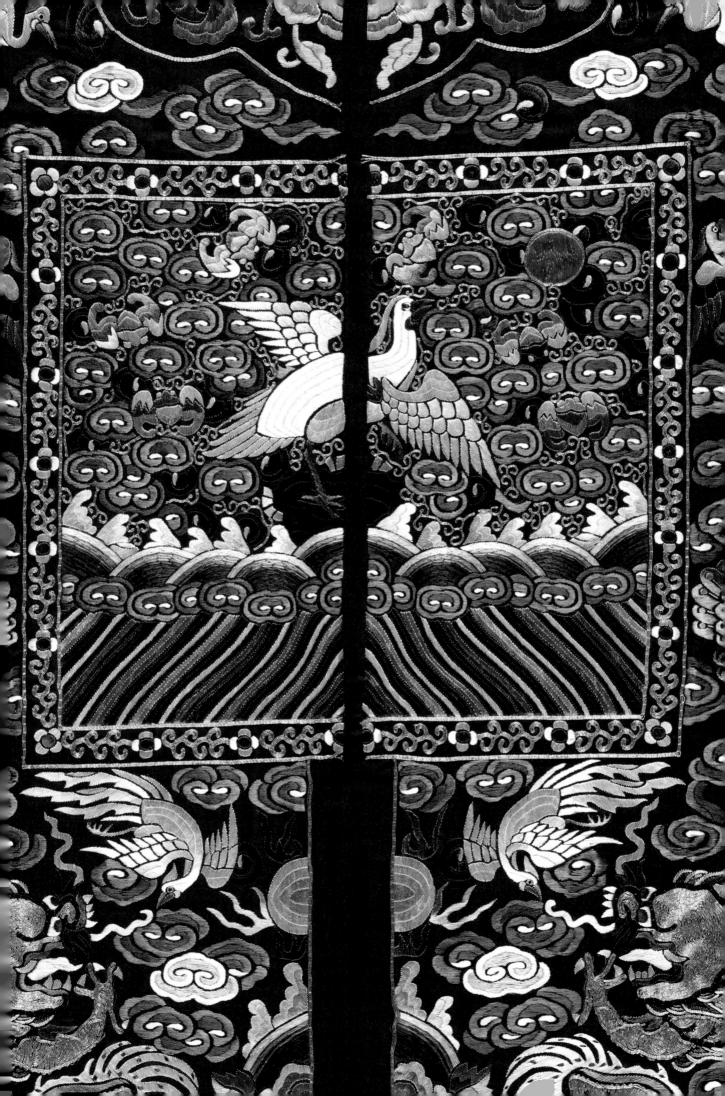

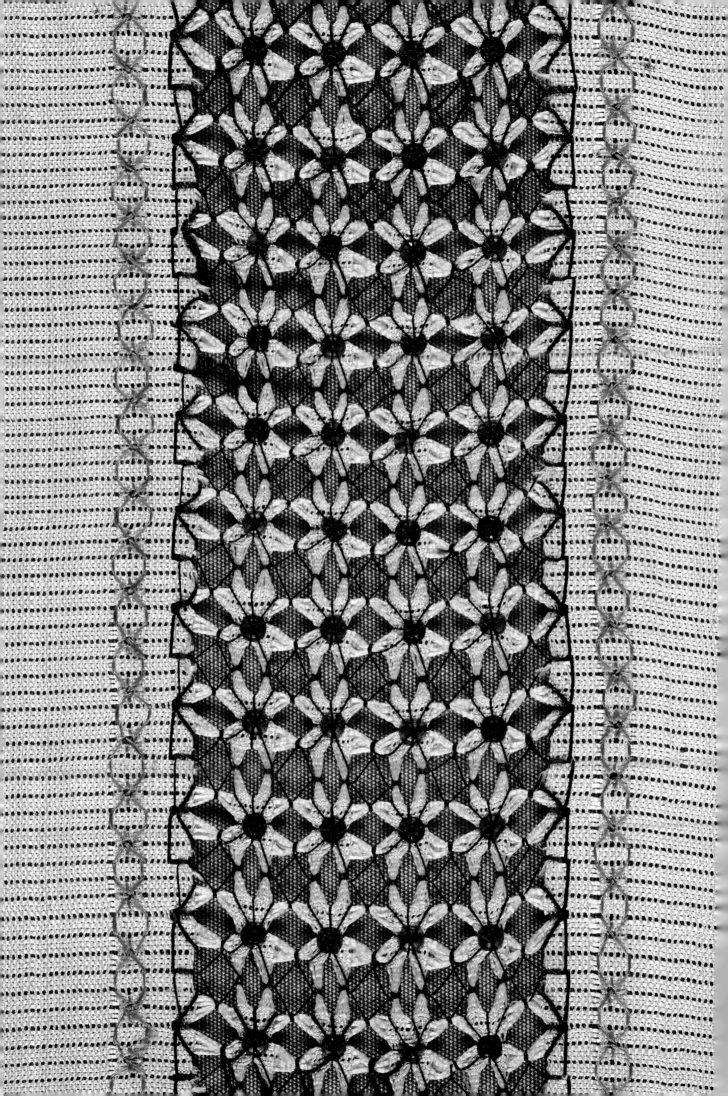

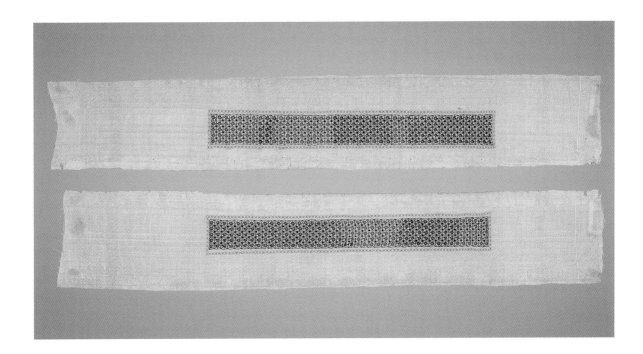

Embroidered silk bands such as these functioned as ornamental haberdashery, to be sewn onto the sleeves of a Han woman's robe. Each sleeveband is decorated at the centre with a lattice design of flower heads, worked in drawn-thread and pulled-thread work, accented with black silk and small tinsel spangles, with the border picked out in a beaded pattern of green silk.

Drawn- and pulled-thread embroidery techniques did not originate in China, but were introduced by European and American missionaries at the end of the 19th and beginning of the 20th century. They were best worked on loose, even-weave fabric, such as this pale-blue gauze-weave silk (*luo*), with the warps crossed to produce openings in the material. These finely executed sleevebands show the ingenuity and accomplishment of craftsmen in adopting new techniques, and are the earliest examples of Chinese drawn- and pulled-thread embroidery in the V&A collection.

Pair of sleevebands
Gauze-weave silk; embroidery
in silk and spangles
China, 1875–1911

Purchased with Art Fund support
T.133&A-1948

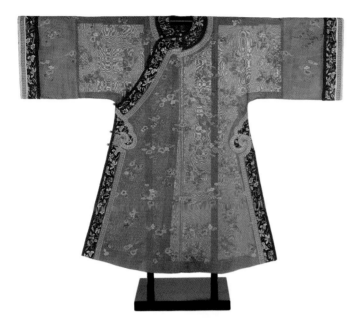

**Outer gown for a Manchu
woman (*changyi*)**
Gauze-weave silk;
embroidery in silk threads
China, 1850–1900

Given by Mrs Elsbeth Fuhrop
T.387-1967

Sprays of gourds and flowers worked in coloured floss
silks adorn the main body of this outer gown for a woman
(*changyi*). Gourds with tendrils were a popular decorative
motif for young married women; the gourd contains many
seeds, symbolizing fertility and the desire to bring sons
and grandsons into the family.

The plain, transparent teal silk gauze provided both
an ideal canvas for embroidery, as well as some challenges.
The weave structure of the fabric, the weight of the
embroidery, and whether the garment would be lined
or unlined were all considerations for the embroiderers
when choosing what materials and techniques to use
while making the gown.

Here, the gourds, flowers and tendrils have been
worked in short, straight stitches with coloured silks,
a method that was less likely to pull the gauze out
of shape and helps give the robe an airy feel. Skilled
embroiderers were known for their ability to interpret
the designs given to them. In this case, the gourds have
been decorated with a variety of geometric patterns,
including a jazzy wave that showcases the embroiderer's
creativity and wit.

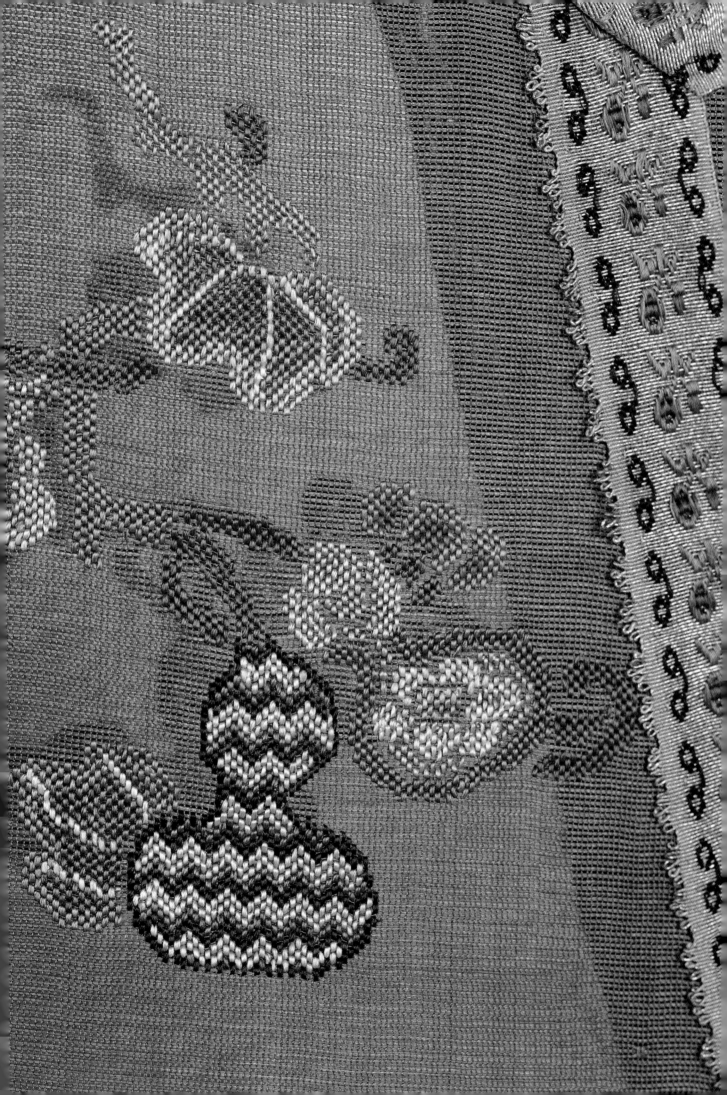

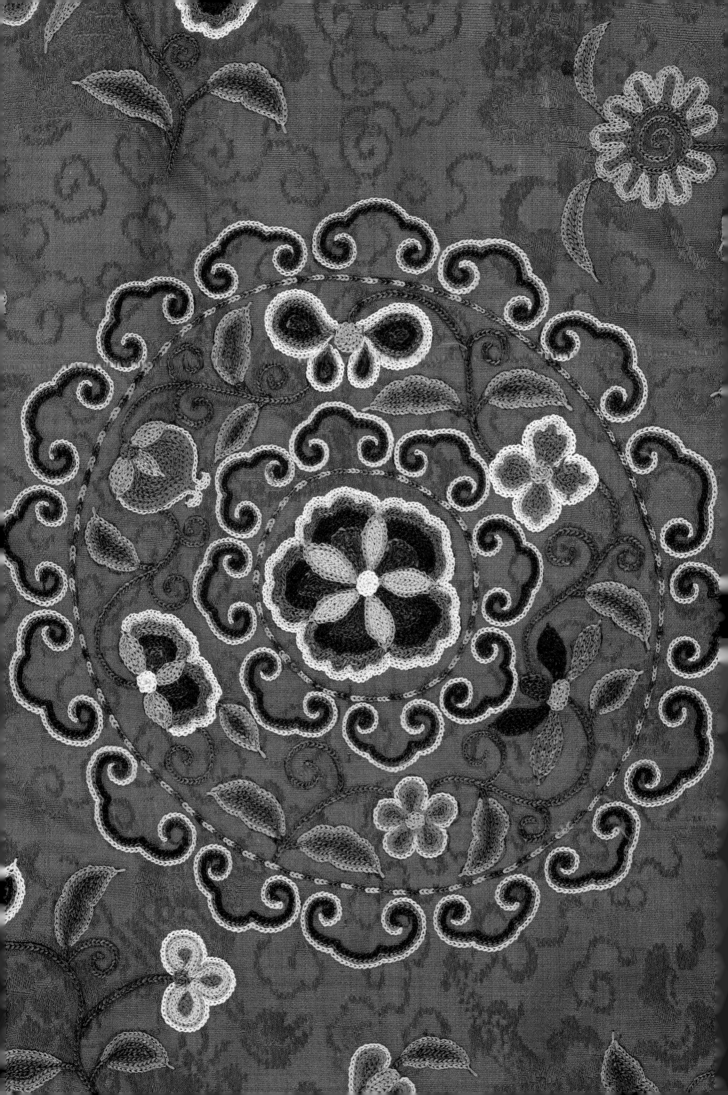

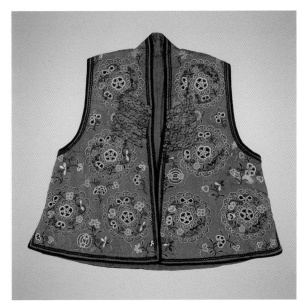 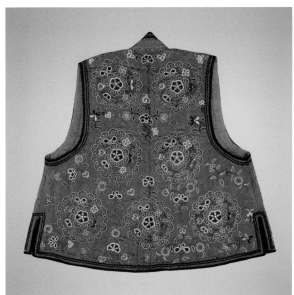

The radial floral medallion was a popular design for embellishing Uygur festive dress for men and women. Its structural rendering reflects foreign influence, particularly the introduction of Buddhist idealized lotus-like flowers (*baoxianghua*), one of the most popular designs in the Tang dynasty (618–907) for decorating textiles, metalwork, ceramics and mural paintings. Here, each medallion is embroidered in coloured floss silk, using a very fine chain stitch (*suoxiu*) – the most ancient form of Chinese embroidery, with the earliest surviving examples dating to the 4th century BCE – and features an open flower at the centre, encircled by lobed cloud motifs and a scrolling branch of flowers.

Waistcoats such as this example in vivid red silk damask, characterized by four bands of brocaded silk applied at each side of the front opening, were distinctive garments worn by married women with children (*juwan*). It came into the museum's collection as part of a set donated by George Sherriff (1898–1967), comprising a magenta coat (p. 140), blue tunic (p. 59), green trousers, a tasselled hat, and leather boots and overshoes (p. 213). Sherriff, a renowned plant hunter, recorded that he acquired the pieces in Khotan, a large oasis town in southwestern Xinjiang, which was famous for its high-quality jade and silk production.

Waistcoat for a Uygur woman (*jajáza*)
Silk damask; embroidery in silk threads
Khotan (Hetian), Xinjiang, 1800–1900

Given by Captain George Sherriff
T.31A-1932

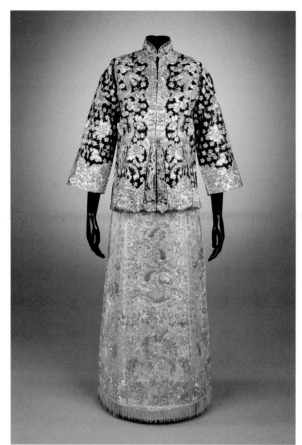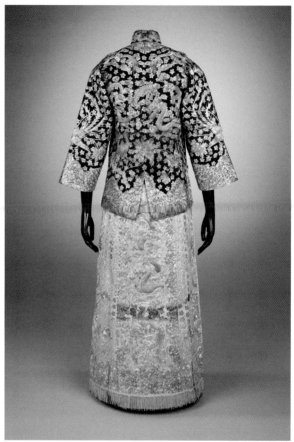

Bridal ensemble (*qun gua*)

Satin-weave silk; embroidery
in silk and metallic threads
China, 1930s

Supported by the Friends of the V&A
FE.66:1, 2-1995

In China, bridal dress has always been the most elaborately decorated of attire; according to tradition, the bride was 'empress of the day'. Weddings required garments of a specific colour, usually red, the common colour for all Chinese festive occasions. This ceremonial bridal ensemble, comprising a black jacket and pink pleated skirt, is in a style that was popular in the first half of the 20th century. Han Chinese girls did not generally wear skirts or wear their hair up until reaching adulthood. On her wedding day, a bride's skirt was an essential garment to mark this important transition in her life.

A dragon and a phoenix form the basis of the pattern, symbolizing the male and female elements of the marriage, with the peonies representing beauty and prosperity. These elements are heavily couched in gold- and silver-wrapped threads, with tiny stitches of coloured silks holding the metallic threads in place. The bodies of the phoenix and dragon are skilfully padded with cotton wadding to create a relief effect. The technique of raised embroidery is unique to Chaozhou, a city in eastern Guangdong province, and was traditionally used for embellishing bridal ensembles and theatre costumes. Both men and women were engaged in embroidery for local goods and for export, particularly to parts of South East Asia.

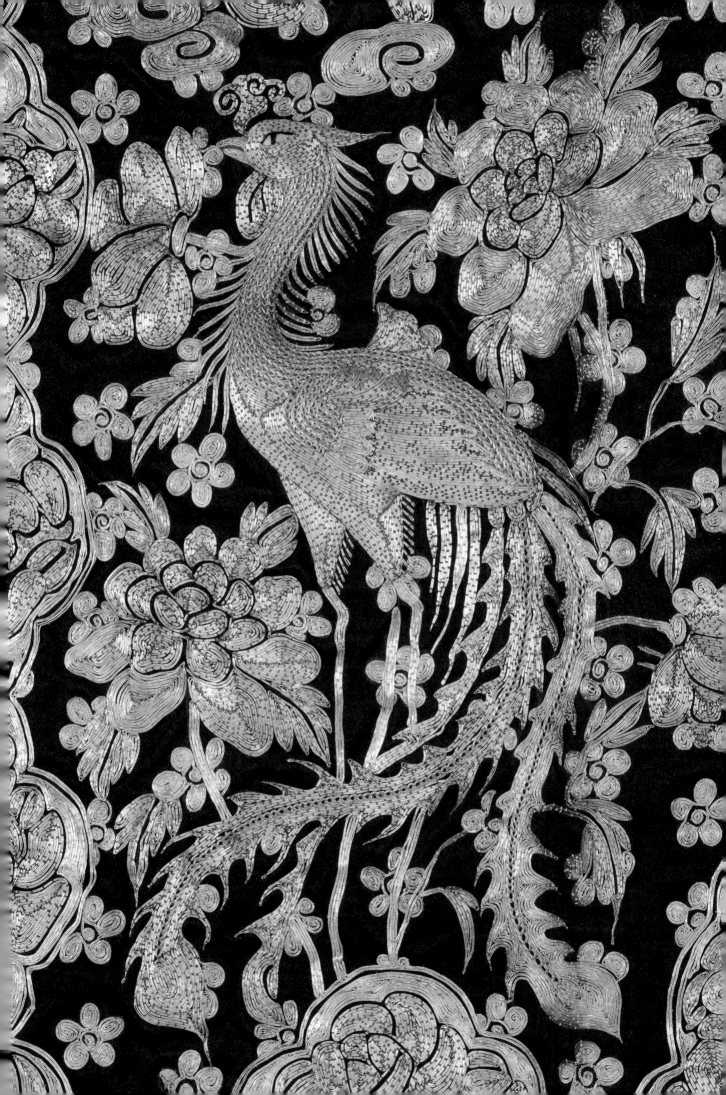

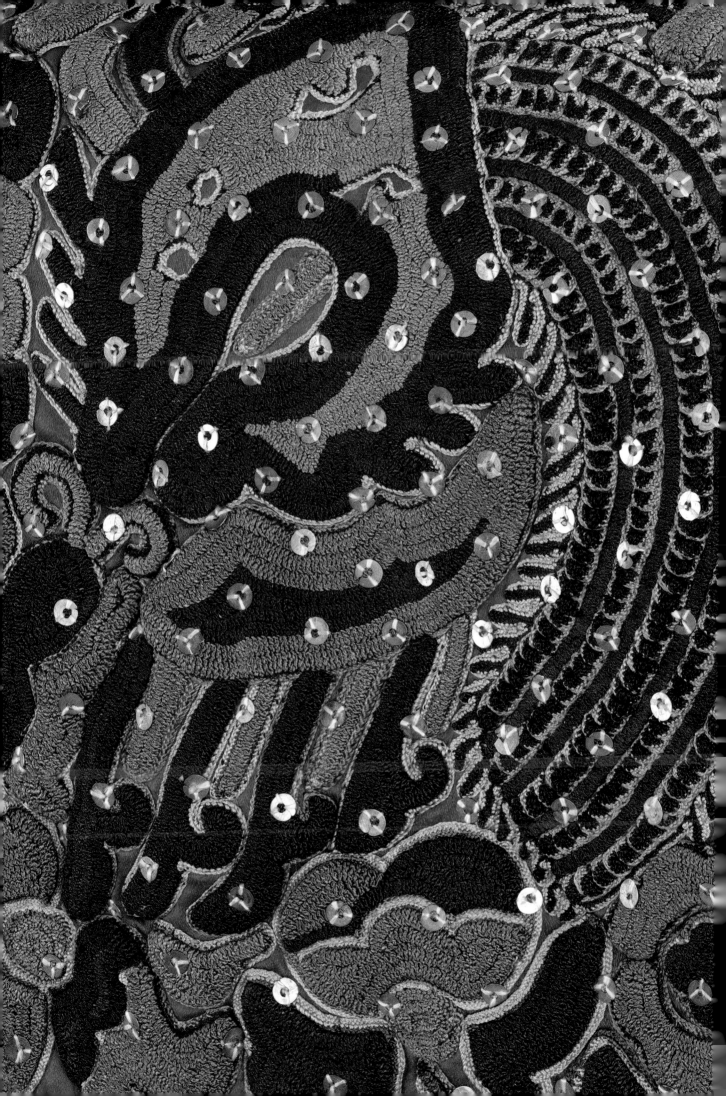

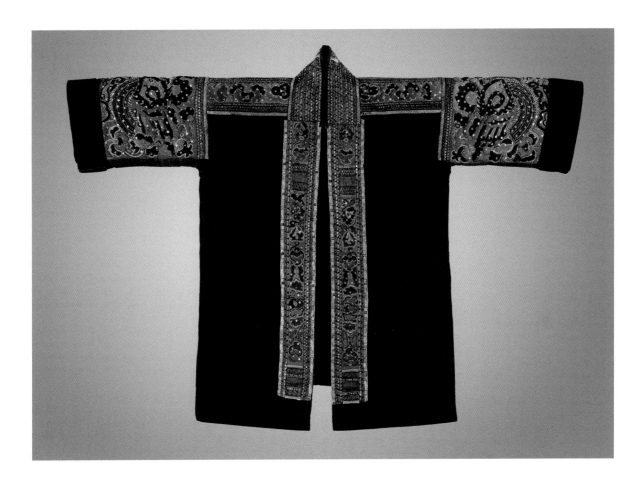

A young Miao woman would have worn this ornate, straight-cut jacket with a pleated skirt and elaborate silver jewelry at a courtship festival or wedding. The sleeves, shoulders and front opening are richly embroidered with highly stylized dragons, butterflies, gourds and pomegranates – designs that are associated with legends and religious belief, and passed down through families. The butterflies represent their ancestor, the 'Mother Butterfly', while the dragons are benevolent figures that ensure fertility and good fortune.

Historically, Miao women, who were accomplished in weaving, dyeing, embroidery and sewing, would have made their clothes at home. *Bian xiu* ('braid embroidery') is a technique that is unique to the Miao women of Taijiang county in eastern Guizhou province, where there is a long tradition of making silk plaits by hand, using a simple braiding stand or a basket and bobbins.

In this jacket, densely pleated black and khaki green braids on the sleeve panel have been couched on red silk to form a dragon's head and a butterfly, giving a textural three-dimensional effect. The main body of the dragon is built up of overlapping loops of two-tone plaits to give definition to the scales, with glittering brass spangles adding shimmer.

Festive jacket for a Miao woman
Twill-weave cotton; embroidery
in silk braids and brass spangles
Guizhou, 1940–50

FE.30-2004

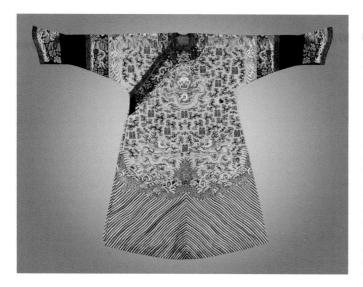

Festive robe for an empress (*jifu*)
Satin-weave silk; embroidery
in coral beads, seed pearls,
silk and metallic threads
China, 1850–1900

T.253-1967

Man Drilling Seed Pearls
Watercolour and ink on paper
Guangzhou, c. 1790

D.115-1898

This magnificent yellow silk robe, decorated with nine dragons and the 'Twelve Symbols', was probably made for a Qing empress. Thousands of white seed pearls have been used to depict the central dragon chasing a large pearl, with red coral beads forming the flames and the Chinese characters for *shuangxi* ('double-happiness'). Prized as organic gems, seed pearls and coral beads were mostly used for embellishing garments that would have been worn at celebrations by the emperor and empress.

Seed pearls are small natural pearls, formed in saltwater oysters or freshwater mussels. Red coral (*Corallium rubrum*) is a marine animal that would have been imported from the Mediterranean or South East Asia. Preparing such tiny beads for embroidery requires precision and a careful eye. Each step – from sorting hundreds of thousands of seed pearls to crafting coral beads less than 1 mm in diameter, drilling holes, threading and stitching – was undertaken by highly skilled craftsmen and embroiderers.

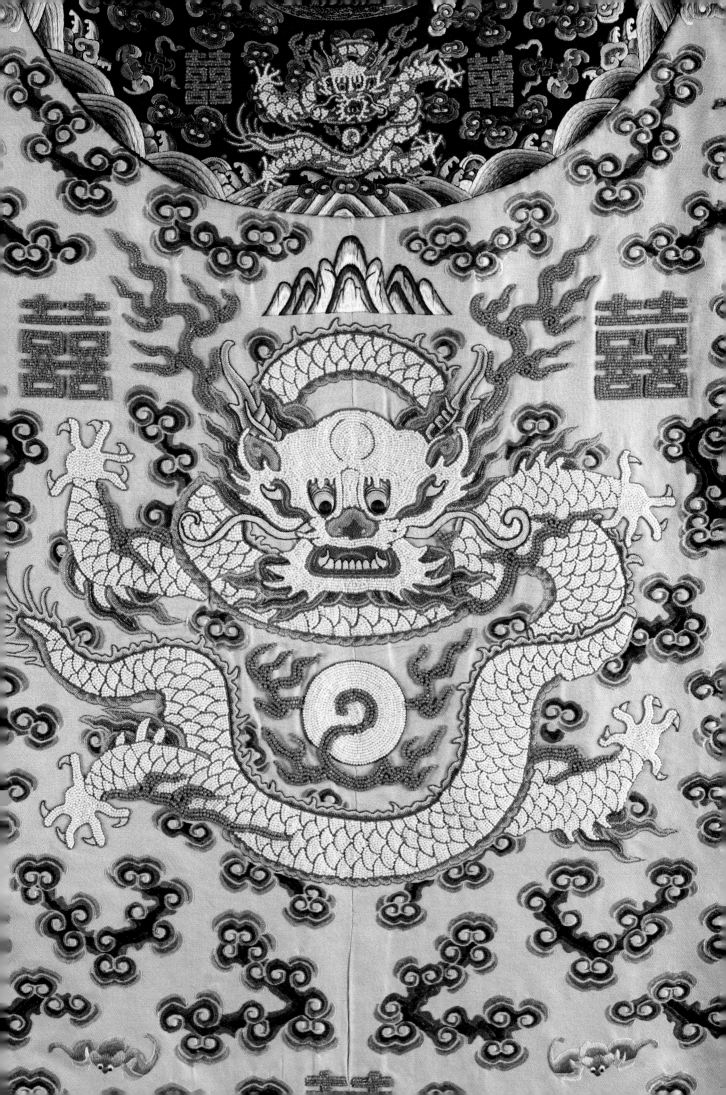

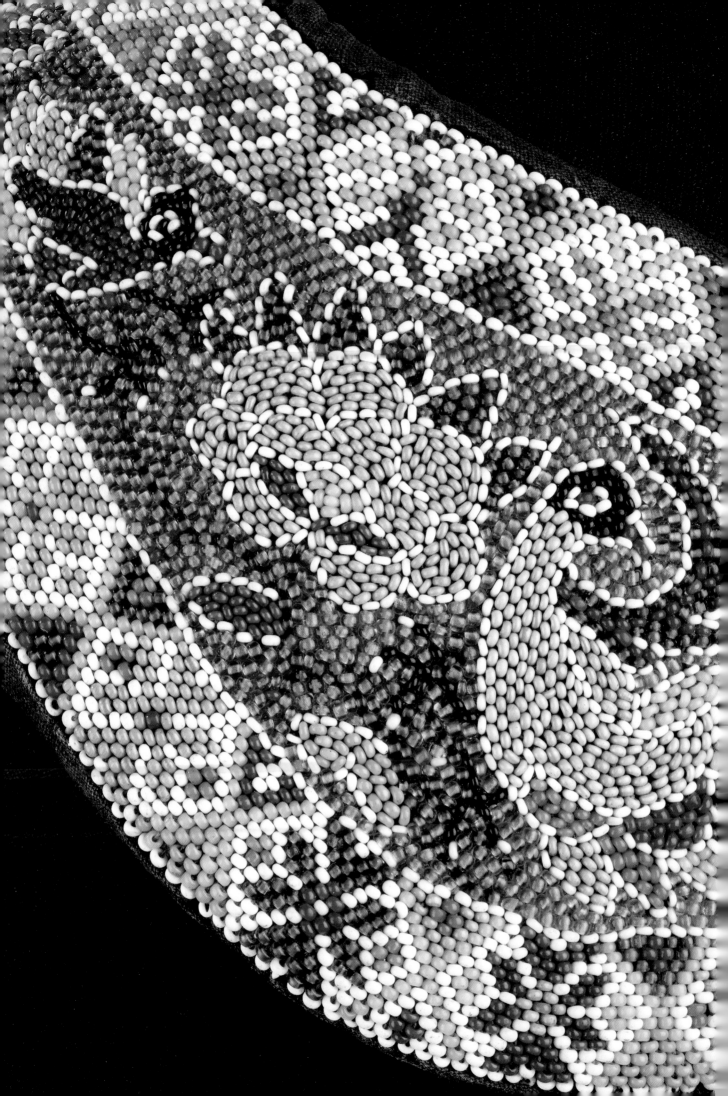

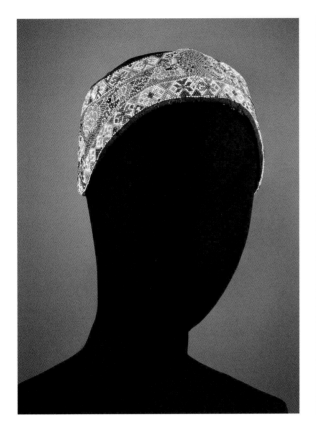 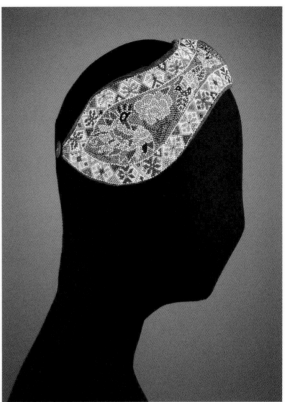

Peacocks, butterflies and peonies – all emblems of beauty, happiness and prosperity – adorn this charming headband, which is densely decorated with beads of transparent and opaque glass in a range of shades. The main production centres of glass-bead embroidery, which flourished in China in the early 20th century, were in Fujian and Guangdong provinces. Minuscule glass beads, or 'rice beads', were imported for embellishing women's fashion accessories.

The trend for wearing slippers or headbands decorated with rice-bead embroidery – possibly introduced by Chinese based in the Philippines – quickly spread, owing to the dazzling overall visual effect and tactile quality. Beads were stitched individually onto the fabric, or strung together and positioned, section by section, to prevent displacement and minimize the risk of the tiny beads falling off. As the headband became encrusted with glass beads, a backing of strong cotton canvas was necessary to help bear the weight of the decoration.

Headband for a woman (*mo e*)
Glass beads embroidered on cotton
China, 1910–50

Supported by the Friends of the V&A
FE.176-1995

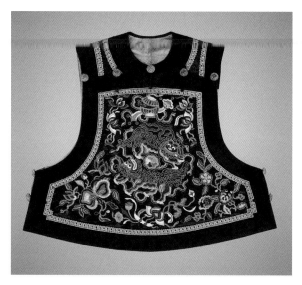 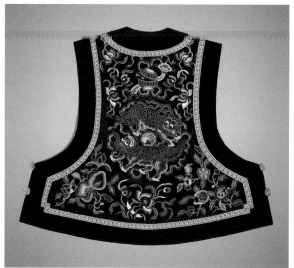

**Sleeveless jacket for a child
(*kanjian*)**
Satin-weave silk; embroidery in silk,
metallic and peacock-feather threads
China, 1850–75

T.84-1965

For centuries, clothing for children had generally been made as
miniature versions of adult garments. Although smaller in scale,
decorations were still chosen with great care and often had auspicious
meanings, displaying the love and aspirations of parents for their
children. Across the front and back of this sleeveless jacket for a child
(*kanjian*), two playful lions chase a brocade ball, worked in knot stitch
with floss silks and couched gold-wrapped threads.

Lions were not native to China, and such imagery would have been
brought into the country with Buddhism (lions are often found guarding
the entrances to Buddhist temples). In this context, the animals were
generally associated with protection from evil spirits. Here, their curly
manes and tails have an iridescent green tone derived from peacock-
feather threads. The use of such a splendid material is characteristic
of Cantonese embroidery (*yue xiu*), produced in Guangdong province.

Surviving examples woven or embroidered with peacock-feather
threads, including furnishing textiles and imperial robes, are extremely
rare, with the oldest dating to the early 17th century. The child who
wore this garment possibly came from a noble family.

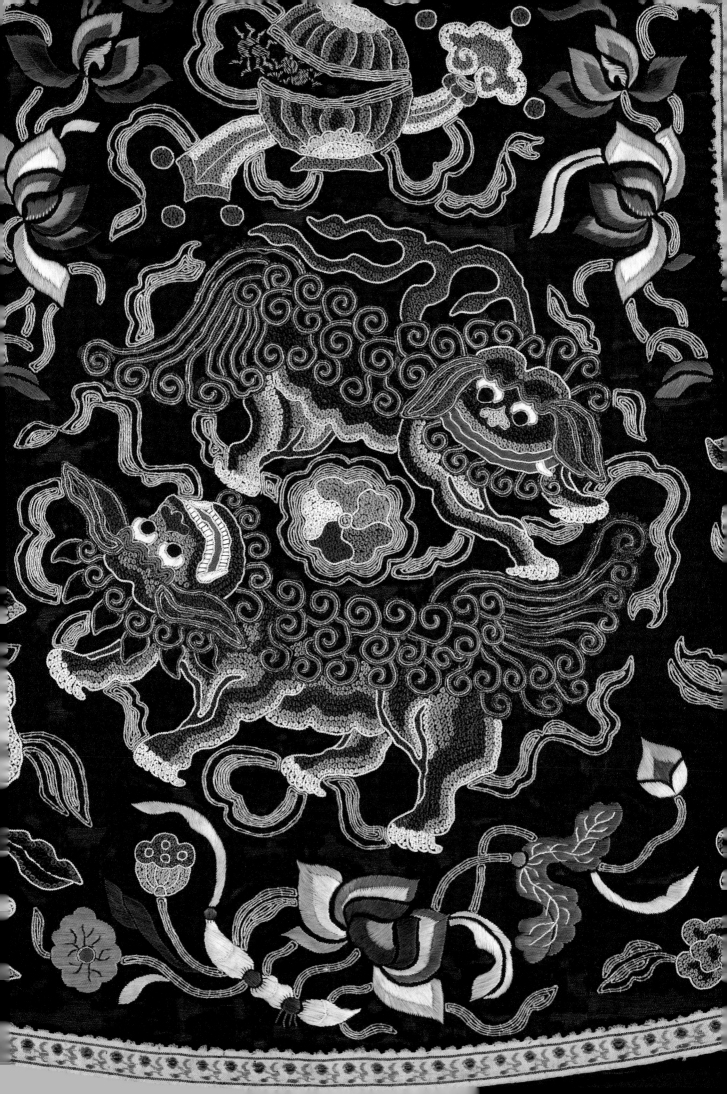

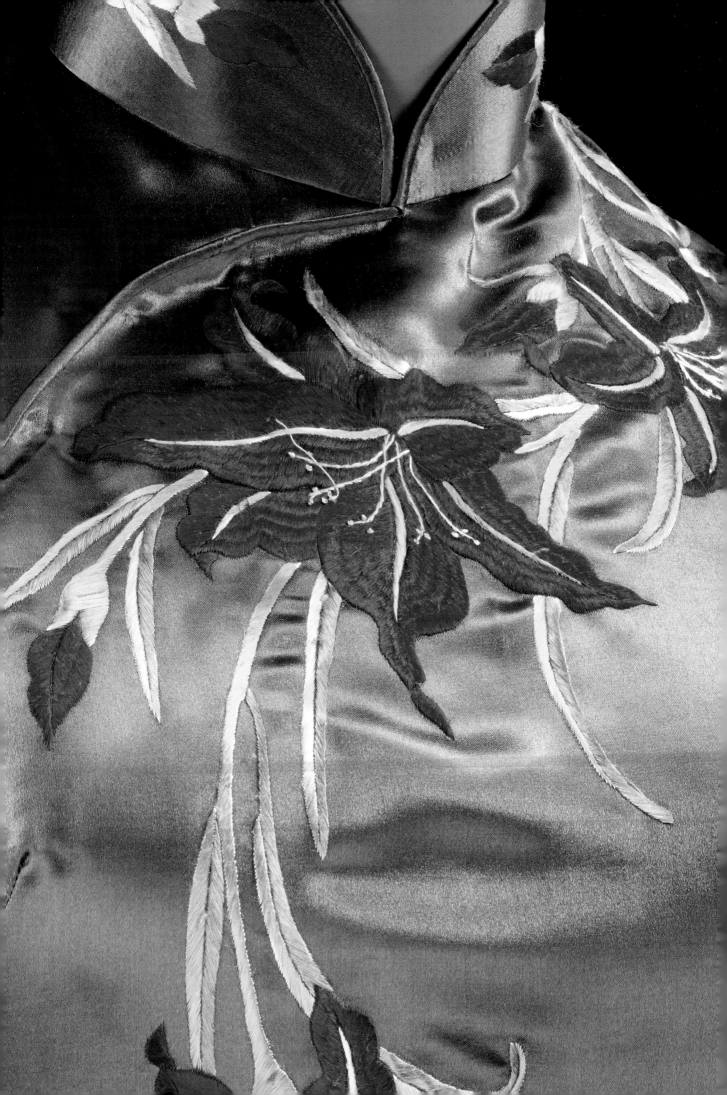

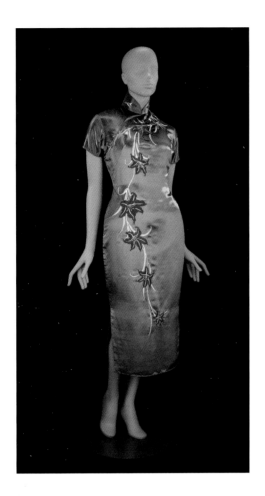

This *qipao* in grey satin from Hong Kong exudes simplicity and ultra-femininity. A sweeping line of asymmetric lilies worked in satin stitch adorns the front of the dress. The flowers are embroidered in red with white centres, with grey and white foliage. The design curls gracefully from the left shoulder, across the top front, and down the skirt. A spray of red lily buds is embroidered on either side of the front of the collar. It was popular to embellish the front of a plain silk *qipao* with a floral or dragon design, leaving the back unadorned.

Influenced by contemporary European fashion, the *qipao* emphasizes an hourglass silhouette and was typically worn over a western girdle. This calf-length dress is closely fitted to the waist and chest. The angular cut of the side seams creates a cinched-in waist, a body-hugging feature that is further enhanced by the adoption of western tailoring techniques, including bust darts at the front and waist darts at the back. This new silhouette gave the wearer the thin waist and long torso that were fashionable in the 1950s.

Dress for a woman (*qipao*)
Satin-weave silk; embroidery
in silk threads
Hong Kong, 1950s

Given by Richard A. and Janey M.Y. Cheu,
in memory of Dr Henry D. Cheu
FE.52-1997

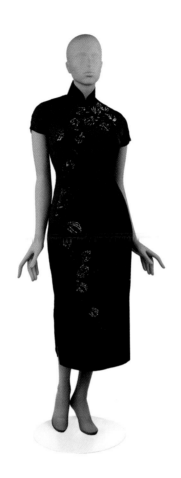

Dress for a woman (*qipao*)
Plain-weave silk; embroidery
in beads and sequins
Hong Kong, 1950s

Given by Richard A. and Janey M.Y. Cheu,
in memory of Dr Henry D. Cheu
FE.48-1997

Embroidery that adorned evening dresses would often incorporate beadwork or sequins. The front panel of this *qipao* is decorated with asymmetric fronds cascading from the left shoulder, across the front, and straight down the side of the skirt to the right. The fronds are formed of iridescent black sequins applied to the black silk, with a tassel of black beads dangling from each one. The same small beads are applied in swirling lines, linking the fronds.

The dress, which would have been worn with high heels, gloves and a beaded handbag, exemplifies the intricate skills of the embroiderers and the ingenuity of the tailors. The overall effect was designed to make the wearer stand out from the glamorous throng at a dinner or cocktail party. Beadwork embroidery was a new and thriving industry in Hong Kong during the 1950s, with the glass beads imported from Austria and the former Czechoslovakia. It was used to embellish a variety of products produced for local and export markets, including *qipao*, sweaters, skirts, gloves, handbags, collars and spectacle cases.

 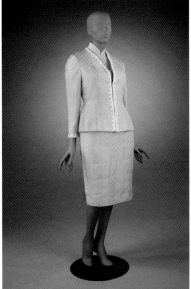

The 1950s were the golden age of *qipao* design, and created a boom in the Hong Kong tailoring industry. Following civil war and the Japanese invasion of mainland China in the 1940s, many wealthy families and textile entrepreneurs, as well as skilled tailors, emigrated from Shanghai or Guangdong province to start new lives in Hong Kong, where their skills and financial capital were highly valued.

This three-piece suit, made from pink wild silk, comprises a *qipao*, waistcoat and jacket. It was tailored by Hoover Co., located at 118 Leighton Road, Hong Kong. The jacket has three-quarter-length sleeves and an edge-to-edge front opening fastened with hooks and eyes, and is tailored to flare out at either side at the waist. At the back are shoulder darts and long waist darts. Three-dimensional sequinned flowers, arranged in groups of three, are sewn along the front opening and around the cuff ends. Each flower has been handcrafted with mother-of-pearl sequins.

This *qipao* is typical of the 1950s, emphasizing an hourglass figure. When worn on its own, it exudes an undeniably Chinese flavour. The addition of a waistcoat and jacket cleverly transforms it into a western-style ensemble, appropriate for attending a formal event.

Dress for a woman (*qipao*), waistcoat and jacket
Plain-weave wild silk; embroidery in sequins
Hong Kong, 1950s
Hoover Co.

Given by Richard A. and Janey M.Y. Cheu, in memory of Dr Henry D. Cheu
FE.56:1 to 3-1997

Dress for a woman (*qipao*)
Plain-weave viscose rayon-cotton blend;
machine-embroidery in rayon threads
Hong Kong, 1950s

Given by Richard A. and Janey M.Y. Cheu,
in memory of Dr Henry D. Cheu
FE.53-1997

Large, open daisy heads, one above the other, adorn the central front of this neon-orange *qipao*, machine-embroidered in rayon threads with white petals and black centres. Using machines for embroidery was an emerging industry in Hong Kong during the 1950s, when hand-embroidery was the norm, undertaken mostly by skilled migrants from mainland China. The garment is made from a blend of viscose rayon and natural cotton. Its vivid hue and bold pattern would have made it stand out at a time when most *qipao* were more subdued.

This *qipao* features an innovative cut that moves away from the traditional asymmetric opening. It fastens high on the right shoulder, with closely spaced press-studs that follow the curve of the armhole and continue under the arm, where there is a concealed zip-fastener in the side seam. This new type of cut creates an uninterrupted surface, ideally suited for the bold, machine-embroidered pattern.

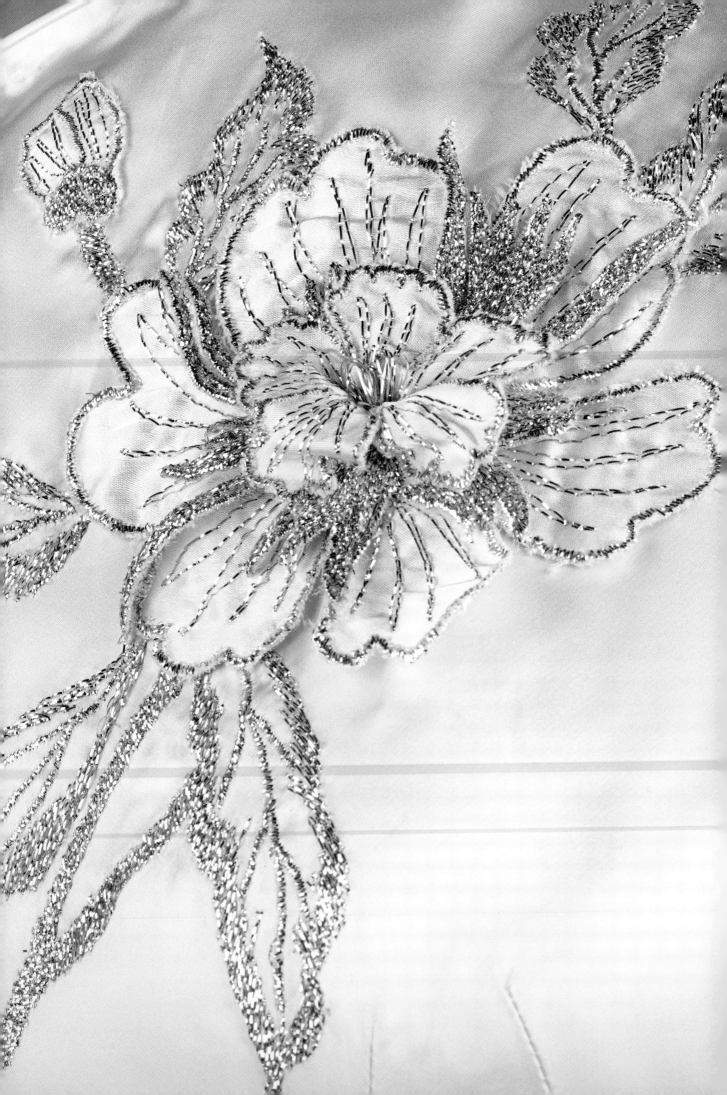

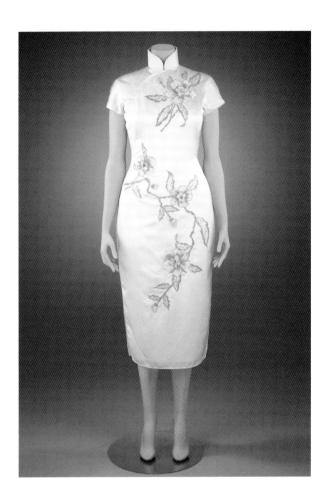

A large spray of flowers, placed asymmetrically, curls down the front of this dress from the left shoulder and across the skirt. The foliage is machine-embroidered straight onto the white satin, while the flower heads (with the uppermost one pictured opposite) were made separately from satin off-cuts and silver thread. The petals, delineated with silver thread, are partially sewn to the dress and bent upwards to give a three-dimensional effect.

The dress was made in a popular style of *qipao* that is different to those with decorative frogging and trims (see pp. 71, 157). The white satin is used as a surface for striking embroidery, rather than an expanse of silk to be framed with piping, and the only fastenings are unseen press studs. This *qipao* was worn by Alice Cheu (1914–1979) at the wedding reception of her stepson in San Francisco, California, in 1961.

Dress for a woman (*qipao*)
Satin-weave silk; embroidery
in metallic threads
Hong Kong, c. 1961

Given by Richard A. and Janey M.Y. Cheu,
in memory of Dr Henry D. Cheu
FE.49-1997

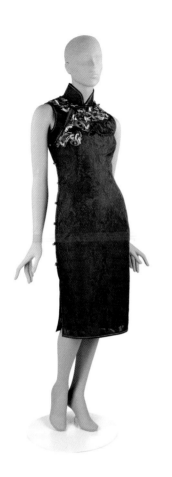

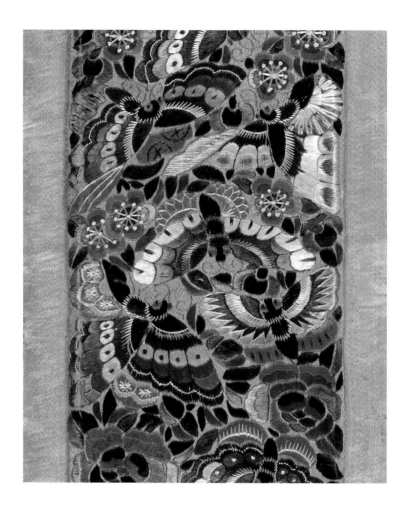

Dress for a woman (*qipao*)
Gauze-weave silk; embroidery
in silk threads
Shanghai, 2019
Guo Yujun and Xu Yulin
Given by GUO XU
FE.188-2019

Sleeveband for a woman's robe
Satin-weave silk; embroidery
in silk threads
China, 1875–1900
Purchased with Art Fund support
T.147-1948

This *qipao* is made from black silk gauze patterned with floral motifs
and lined with turquoise silk. It is fastened with nine loop-and-bead
buttons. The borders are edged with black bias-cut satin and turquoise
piping, with a broad *ruyi*-shaped satin band applied around the shoulder
and the overlap flap on the right. The band is embroidered with
butterflies flitting among chrysanthemum blossoms, an auspicious
design known as 'butterfly in love with flowers'. The design is inspired
by the embroidery seen on many pleated skirts and edgings of Han
women's garments of the late 19th and early 20th centuries.

Here, each butterfly has additional wings stitched to the body,
creating a three-dimensional effect, so that the butterflies appear
to be flapping their wings. These extra wings incorporate double-faced
embroidery of various geometric patterns and are the work of Suzhou
embroiderers, who use the distinctive technique of wielding two
needles in mirror movements. The secret behind this unique method
lies in the makers' skill in hiding the loose threads and knots, which
results in embroidery that appears equally well finished on both sides.

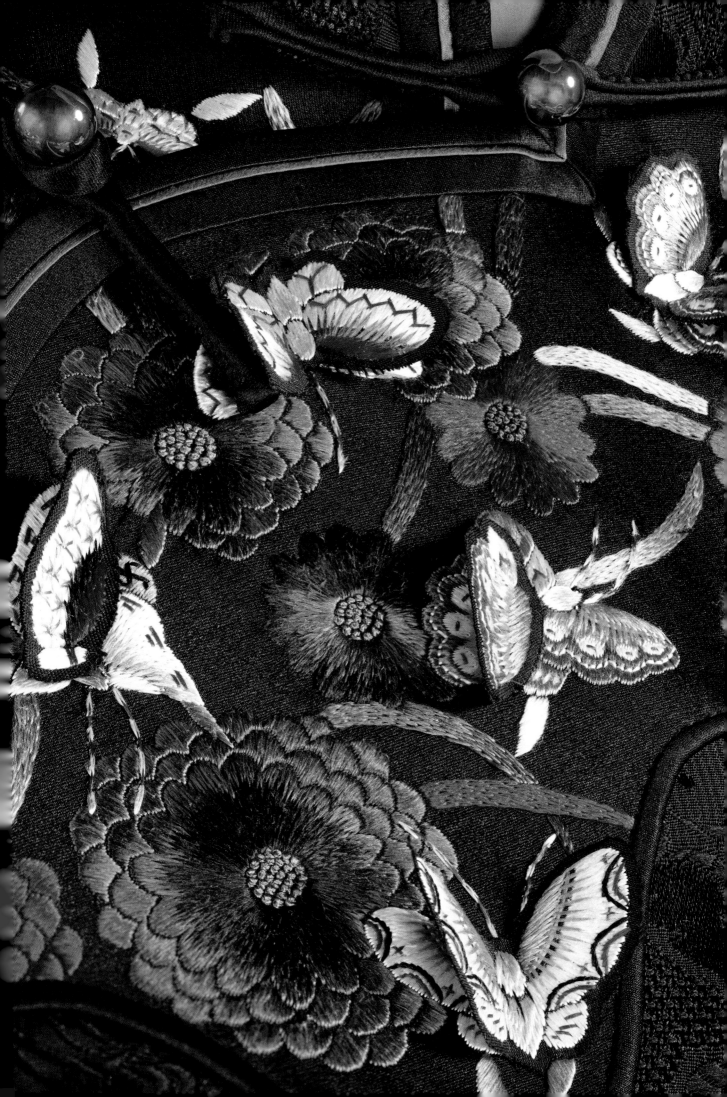

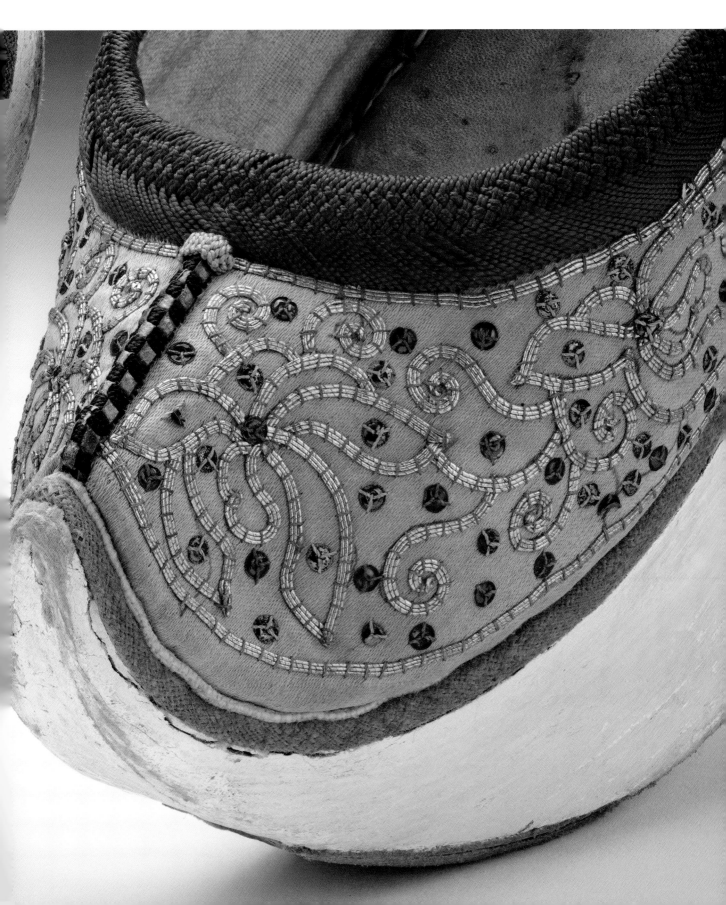

Pair of grass slippers (cao xie)
Plaited grass; woven straw
China, 1850–97

AP.61&A-1897

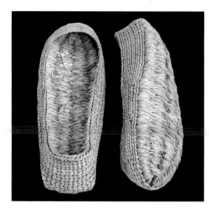

Grass slippers (cao xie) are among the oldest and simplest forms of outdoor footwear in China, with soles made from woven rice straw and uppers of plaited rush. Peasants wore straw shoes such as these while working in the fields, gathering firewood and herbs, or hunting in the mountains, regardless of the weather. Sandals made from straw were even fitted to the hooves of cattle and pigs to wear while being led along muddy roads. Although the shoes look uncomfortable to wear, their coarse soles grip efficiently on slippery surfaces.

In China, straw shoes are also associated with mourning. Traditionally, family members of the deceased would wear undyed coarse hemp clothing and headbands, along with straw sandals, at a funeral to express filial piety, putting aside personal appearance and comfort to grieve for the passing of loved ones.

These closed-toe slippers were originally acquired for the V&A's Bethnal Green branch, which opened in 1872, to illustrate the use of waste products. By displaying useful and commercial goods from around the world made from discarded materials, the museum aimed to promote corporate awareness of environmental sustainability and drive innovative uses from scraps or surplus materials.

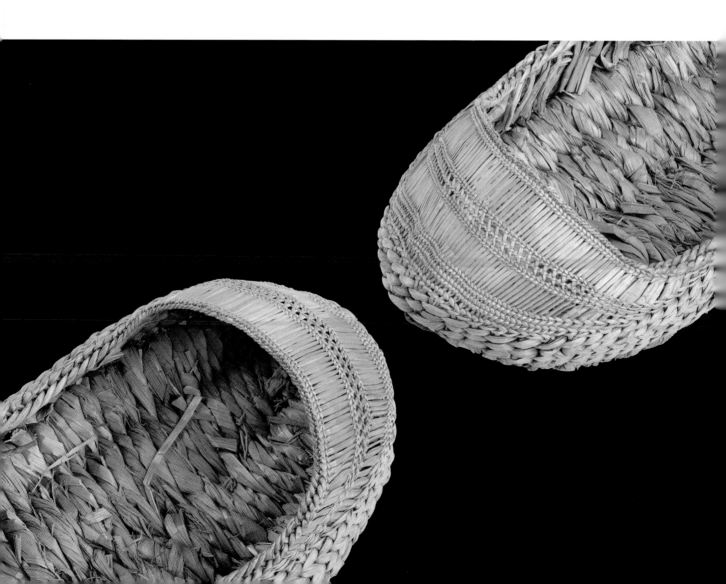

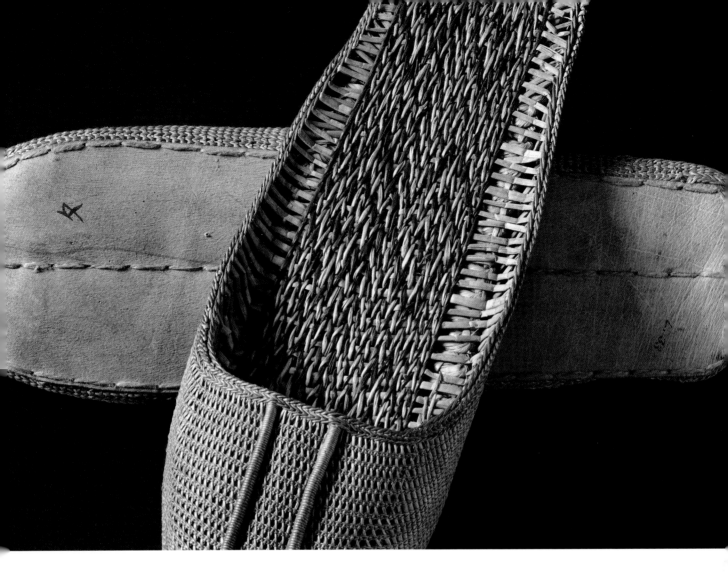

In the 19th century, well-to-do men wore backless, square-toed slippers like these at home as a type of relaxed footwear during the summer. This pair, made from finely plaited rushes, is decorated with a lozenge pattern in basketweave on the insoles, with leather soles for durability. The upper has a green paper interlining and double ridges to hold its shape. The number '9' is written in black ink, in cursive script, on the sole of the shoe. This type of numerical symbol appeared at the turn of the 20th century. Known as Suzhou numerals, they were used by traders to display the price of goods.

Prior to the gold rushes in California in 1849 and Australia in 1851, Chinese shoes had rarely been exported. But, as S. Wells Williams notes in *The Chinese Commercial Guide* (1863), the waves of migration from around China in the 1850s, including Guangdong and Fujian provinces, where many were facing destitution caused by famine and civil war, had vastly increased the export of neatly crafted straw slippers and other footwear. Eventually, many Chinese settled abroad and engaged in a variety of businesses.

Pair of grass slippers for a man (*tuo xie*)
Plaited grass; leather; paper
China, 1850–97

AP.60&A-1897

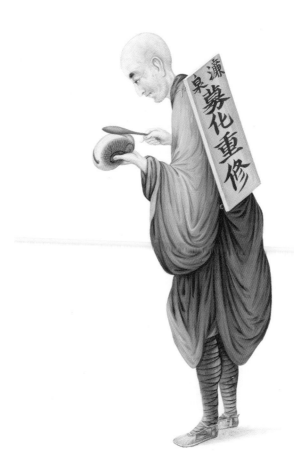

Pair of string shoes (*xian xie*)
Indigo-dyed cotton
Gansu, 2019
Wuyong (Useless)

FE.158:1, 2-2019

**Monk Begging on Behalf
of His Monastery**
Watercolour and ink on paper
Guangzhou, c. 1790

D.138-1898

The craft of making string shoes (*xian xie*) from hemp or cotton could date to as early as the Han dynasty (206 BCE–220 CE). In 2019, the same technique was used to make this pair of string shoes as part of a project devoted to the preservation of traditional crafts, led by fashion designer Ma Ke (b. 1971), the founder of Wuyong (Useless). She has made numerous visits to remote areas in different parts of China, recording traditional craft skills on the verge of extinction, along with the personal stories and reminiscences of aging generations of artisans.

These indigo-dyed, cotton string shoes have quilted soles, known as 'thousand-layered soles', for comfort and durability. The process of making the soles is time-consuming, and involves stiffening the cotton fabric with starch, using a paper pattern to cut out multiple sole shapes and trimming them with bias-cut cotton edgings. Finally, small stitches are sewn all over the soles, using thick cotton thread to give them a quilted appearance and texture. Ma Ke named the shoes *xing jiao* ('walking foot'), a reference to itinerant Buddhist monks who would travel to visit masters or educate followers.

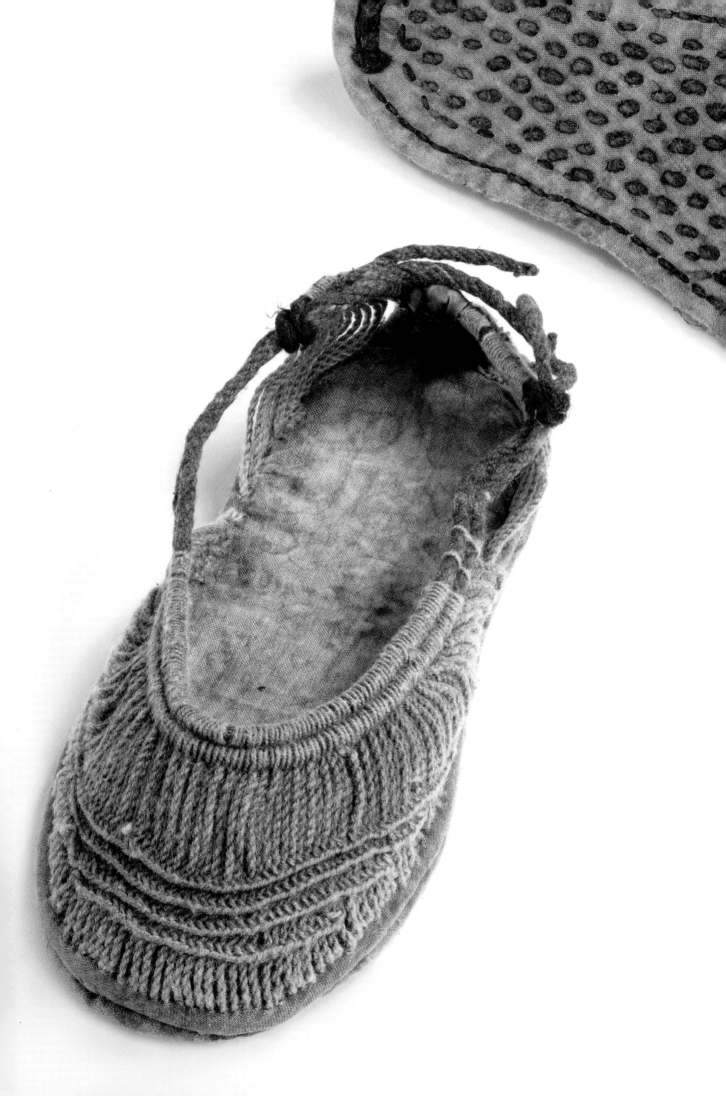

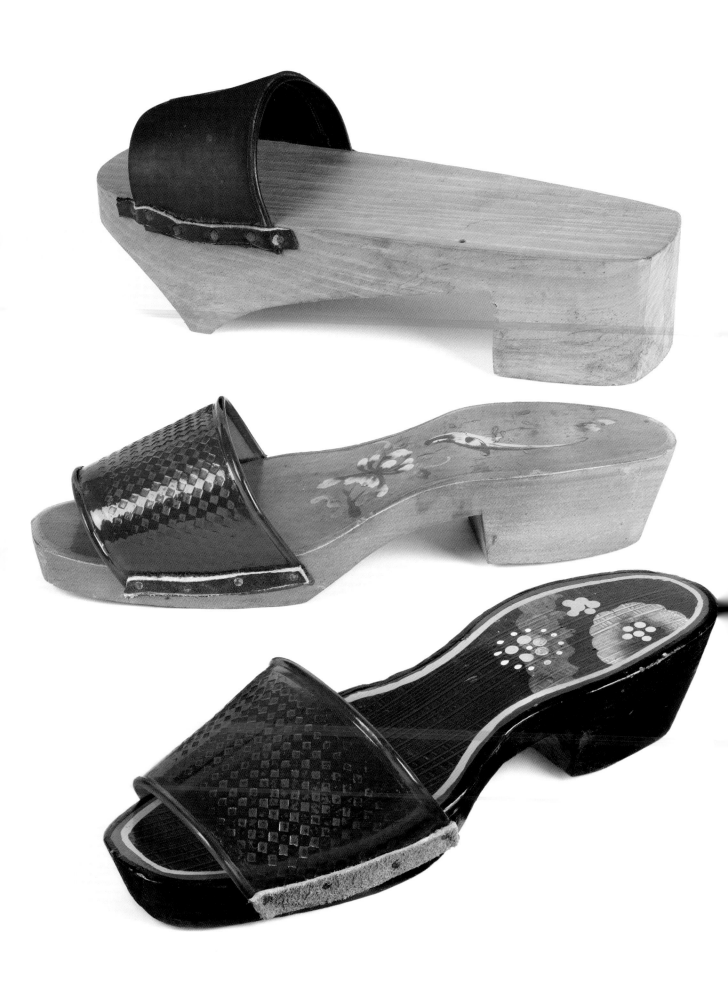

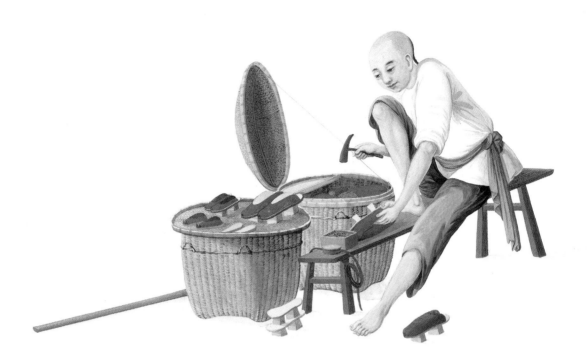

Wooden clogs (*muji*) such as these were worn by men and women in Hong Kong in the mid-20th century. Each clog is carved from a single block of wood, with an upper made from plastic. Men tended to wear plain clogs, utilitarian footwear that was ideal for butchers and fishmongers working in wet markets, while women preferred clogs that were decorated with lacquered designs of birds and flowers. At weddings, brides would also wear clogs with red soles and uppers.

The painting shows a clog-maker crafting two-toothed clogs with red backless uppers, an early style suitable for wet weather. Up until the 1950s and '60s, many Hakka people in Guangdong province still wore wooden clogs. Numerous towns and cities in southern China specialized in clog-making, with pieces exported to Hong Kong.

Wooden clogs (*muji*)
top to bottom

Carved wood; plastic; leather
China, 1950–80
Supported by the Friends of the V&A
FE.156:1-1995

Lacquered wood; plastic; leather
China, 1960–75
Supported by the Friends of the V&A
FE.155:1-1995

Lacquered wood; plastic; leather
China, 1960–80
Supported by the Friends of the V&A
FE.154:1-1995

A Clog-Maker
Watercolour and ink on paper
Guangzhou, c. 1790
D.70-1898

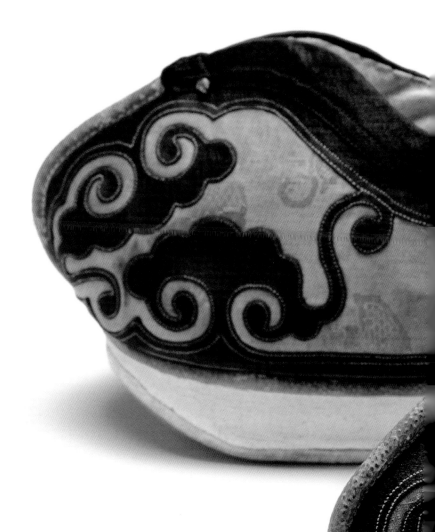

Pair of shoes for a man
Silk damask; satin appliqué;
cotton; paper; leather
China, 1800–75

FE.77:1, 2-2002

Men of the elite wore silk shoes with a padded lining,
such as this pair, in winter. The uppers, made from
green damask, have an applied design of clouds
and borders of blue satin, and are edged with green
piping. The soles are made of layers of paper.

 The shoes were edged with embossed donkey hide
known as 'shagreen', a term that derives from the
Persian *saghari* or Turkish *sagri*, and refers to untanned
donkey leather, which would be pressed with seeds
to produce an embossed texture and often dyed green.
From the 17th century onwards, the term was also used
to refer to leather made from the skin of a shark or ray.
The Chinese used donkey leather for fashioning
footwear and weaponry until well into the 19th century.

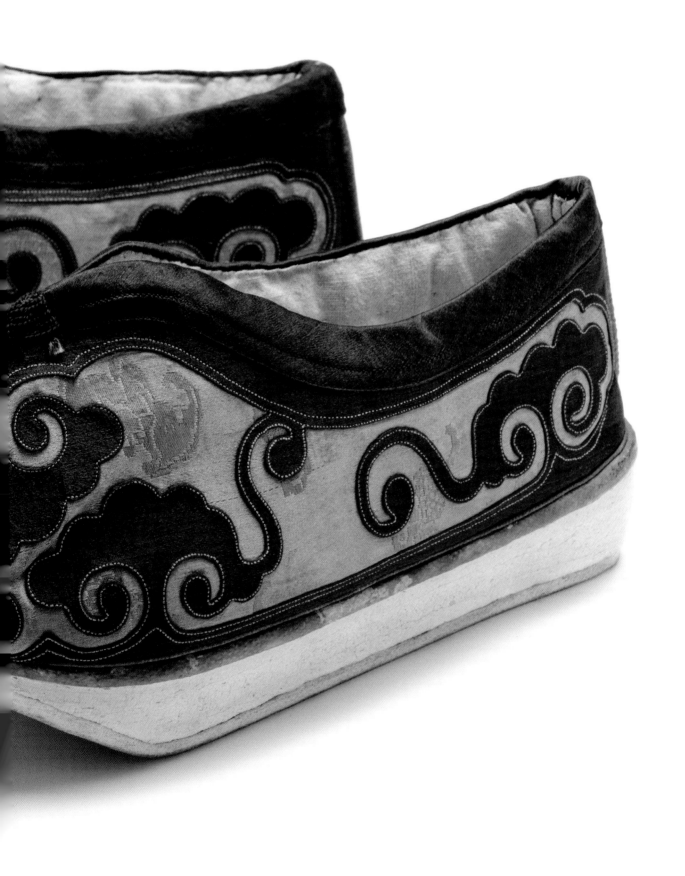

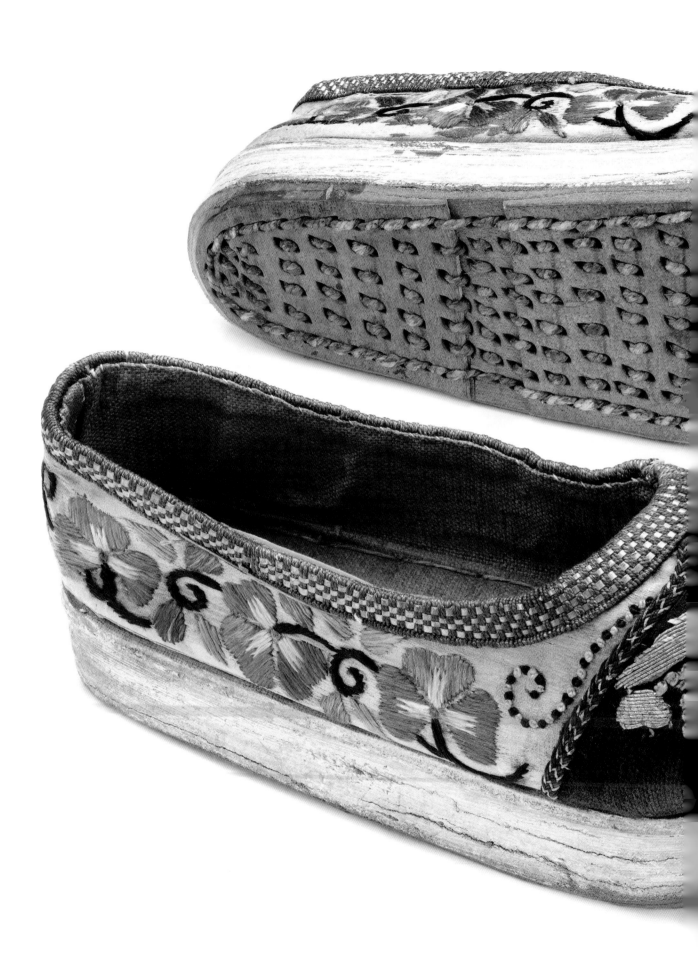

Pair of shoes for a child
Satin-weave silk; embroidery in silk
and metallic threads; paper; leather
China, 1875–97

AP.55&A-1897

Children's shoes were often used to showcase
a multitude of embroidery techniques. For this pair,
untwisted floss silks worked in satin stitches have been
used to depict floral scrolls on the yellow satin uppers.
The toe caps in brown velvet are embroidered with
couched gold-wrapped threads and knot stitches,
resembling a butterfly with flowers beneath its wings.
 The top line is edged with buttonhole stitches
in twisted magenta yarn, arranged closely together,
with flat gilt-paper strips woven in and out of these
foundation stitches to form a basketwork pattern.
This decorative technique, known as overlock
embroidery (*suo bian xiu*), was frequently used
to finish the raw edges of purses or shoe uppers.

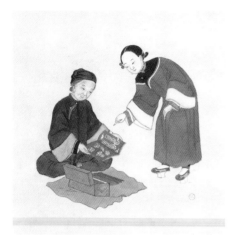

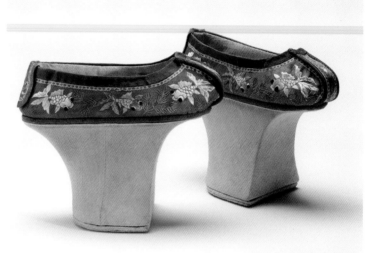

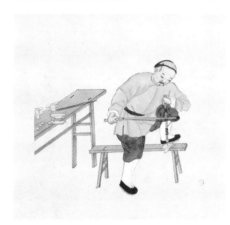

Pair of shoes for a Manchu woman
Satin-weave silk; embroidery
in silk threads; cotton; wood
China, 1800–75

FE.71:1, 2-2014

***Old Woman Selling Paper
Patterns for Embroidery***
Watercolour and ink on paper
Beijing, 1885
Zhou Peichun Workshop
(active c. 1880–1910)

D.1587-1900

Man Making Shoe-Soles to Order
Watercolour and ink on paper
Beijing, 1885
Zhou Peichun Workshop
(active c. 1880–1910)

D.1667-1900

Historically, being tall and having small feet was considered attractive in China. Manchu women did not bind their feet, and their footwear is distinct from the tiny shoes worn by Han women. Instead, women from high-ranking families wore exaggeratedly elevated shoes to create the illusion of smaller feet: the higher the base, the smaller the foot would appear. Here, the carved platform, nearly 13 cm (5 in.) high, is balanced on a smaller base. This style is known as *huapandi*, or *matidi*, because the platforms resemble a Chinese flower pot or horseshoe. The increase in height also gave women the appearance of a slender silhouette and an attractive gait.

The uppers of Manchu women's shoes were always lavishly decorated with auspicious designs in delicate embroidery, which would be executed before the shoe was assembled. Pattern books or paper patterns were available from specialist shops or itinerant vendors. Here, the red silk is adorned with bulging-eyed goldfish and water weeds. The word for goldfish, *jinyu*, is a homophone for 'gold and jade', and can be read as *jin yu man tang* ('may gold and jade fill your hall').

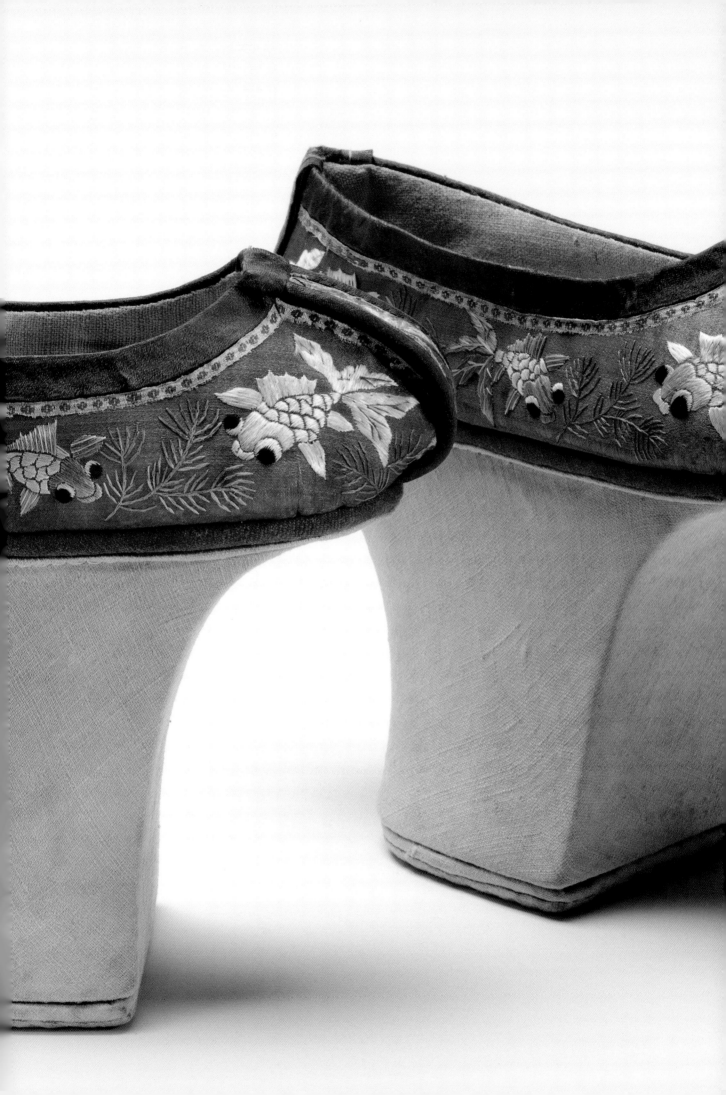

Pair of shoes for a Manchu woman
Satin-weave silk; embroidery
in metallic threads and spangles;
paper; leather
China, 1800–50

Given by Miss Caroline Nias
and Mrs Isabel Baynes
T.184-1922 and CIRC.300-1922

This striking pair of Manchu shoes would have elevated
their female wearer. The thick, boat-shaped soles are
made from layers of felted paper, whitened around the
edges, with stitched leather bottoms. Manchu women
of lower ranks used such shoes for outdoor wear.
The paper sole is rigid, but upturned towards the toe
to give a spring to the step. Being made from paper,
the shoes were much lighter than those made from
wood, but just as sturdy.

The Chinese developed the techniques of paper-
making during the Han dynasty (206 BCE–220 CE),
and the craft of making three-dimensional objects
out of paper is almost as ancient. In this pair, the shoe
uppers are made from peach-coloured satin, richly
embroidered with a floral trail pattern couched
in gold-wrapped threads, which glisten with green
and crimson spangles.

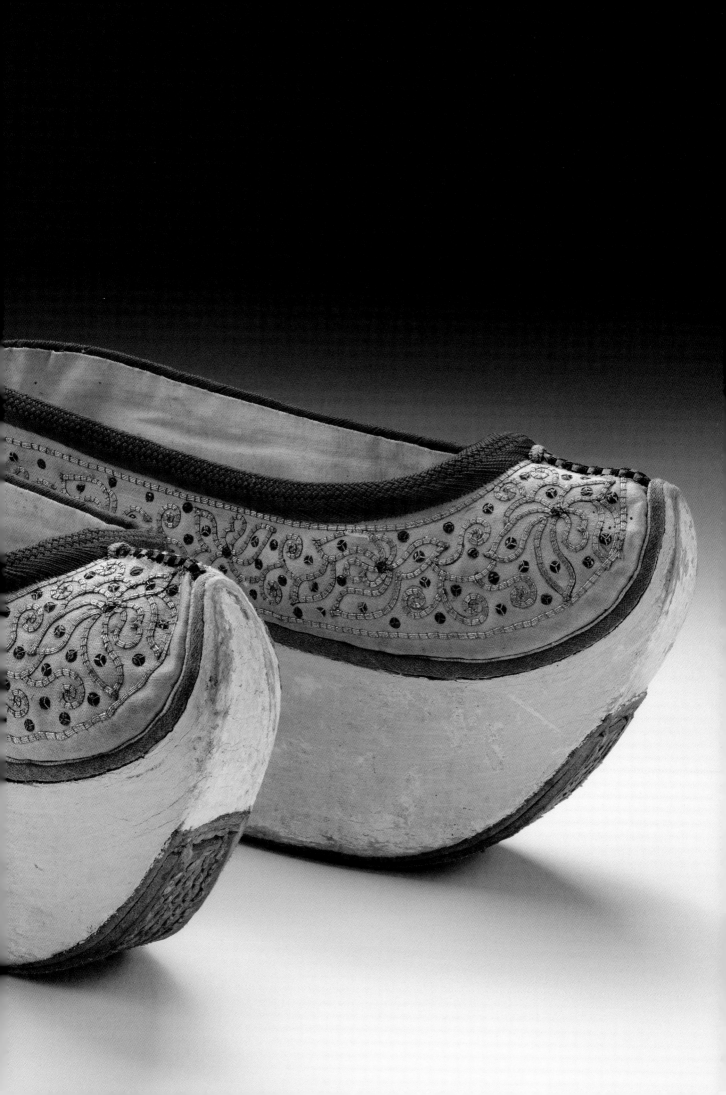

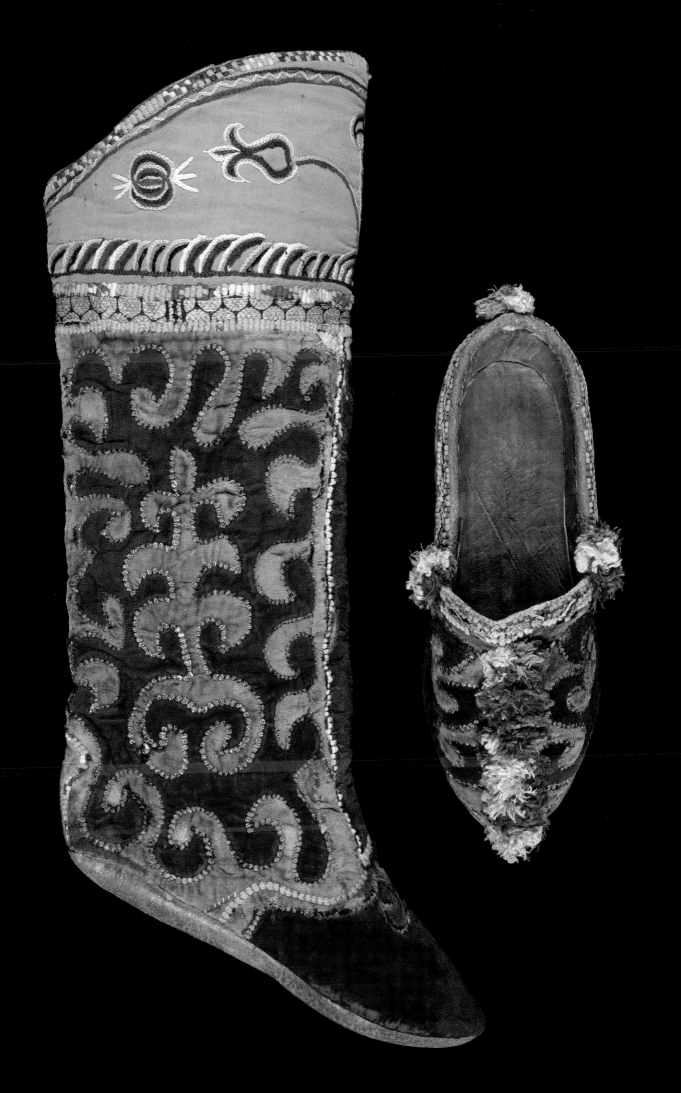

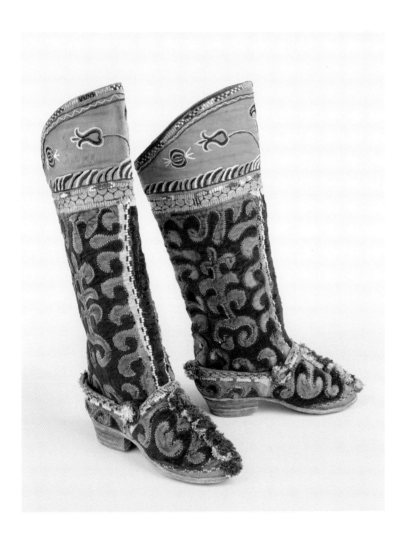

Uygur women generally wore long boots, made from leather or embroidered fabric, with high heels in winter. This pair of luxurious boots and overshoes are covered with red and green silk velvet, applied in a scrolled pattern, with the upper sections in a turquoise cotton fabric, embroidered in chain stitch with floral and wave patterns. The uppers and toe caps of the overshoes are edged with dyed green donkey leather and trimmed with tufts of coloured wool.

In Xinjiang, shoemaking was generally carried out by men with skills that had been handed down in the family, although the industry could also be entered through an apprenticeship. Overshoes such as these were primarily worn by the wealthy, and formed part of the *toyluq*, or gifts presented to the bride by the groom's parents. The overshoes protected the boots and were also practical: Uygurs would remove their shoes or outer slippers when entering a mosque to pray, a practice made easier by wearing overshoes.

Pair of boots and overshoes for a Uygur woman
Leather; silk velvet; cotton; wool; embroidery in silk and metallic threads
Khotan (Hetian), Xinjiang, 1800–1900

Given by Captain George Sherriff
T.31D to G-1932

Pair of mules
Figured silk, leather, floss silk
Shanghai, 2020
Suzhou Cobblers

Given by Denise Mengqi Huang
FE.55:1, 2-2021

***Emperor Daoguang and His Family
Enjoying Autumn in the Courtyard
(detail)***
Ink and colours on paper
China, 1821–50

The Palace Museum, Beijing

Naturalistic chrysanthemum blossoms, handcrafted from
pink floss silk twisted around copper wires, adorn this pair
of kitten-heeled mules. Artificial flowers such as these would
have been worn by both men and women as hair ornaments,
with different flowers according to the seasons.

For this pair of mules, Shanghai-born designer Denise
Huang (b. 1973) took inspiration from a hugely popular
Chinese period drama, *Story of Yanxi Palace* (2018), which
recounts the struggle of a palace maid in the court of the
Qianlong emperor (r. 1736–1795). The costume designs are
based on imperial collections held at the Palace Museum
in Beijing, and many of the female characters wear floss
silk flowers known as *rong hua*, a homophone for 'honour
and splendour'.

Streaming of the popular drama helped to raise
awareness of the traditional craft of making artificial flowers,
which is said to date back to the Tang dynasty (618–907), with
Nanjing and Yangzhou as the two major production centres.
Huang used such elements from historic Chinese culture
in her designs, but in unexpected ways that are often infused
with humour and imagination.

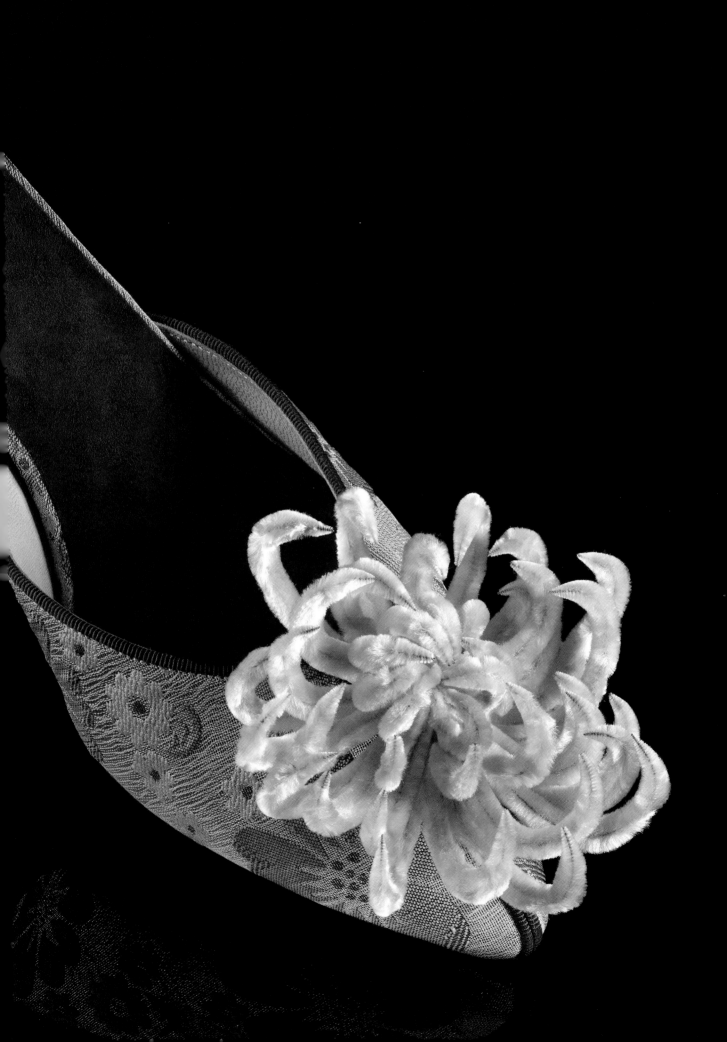

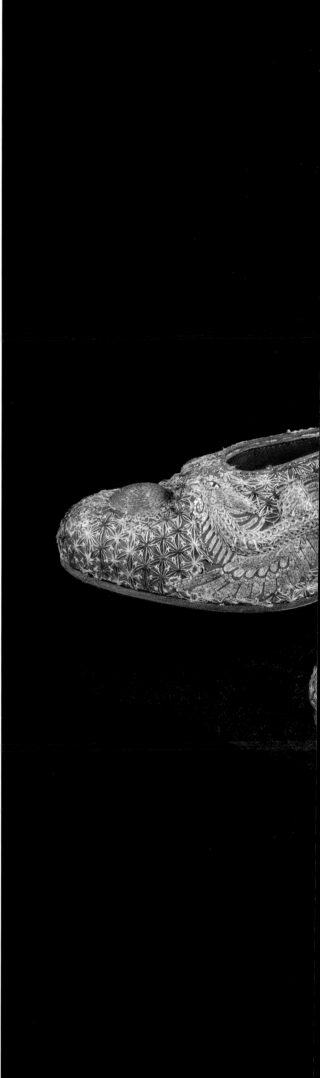

Pair of court shoes for a bride
Satin-weave silk; embroidery
in silk and metallic threads
Hong Kong, 1940–70
Sun Sun Shoes Factory

Supported by the Friends of the V&A
FE.72:1, 2-1995

Red is the primary colour for traditional Chinese
wedding ceremonies. This pair of red court shoes
would have been worn by a bride to complete
an ensemble of a matching jacket and skirt, known
as *hong gua*, or 'red gown'. The uppers are richly
embroidered with a dragon and a phoenix chasing
a pearl, worked in highly padded metallic couching
on red satin, so that the design stands out in relief.
Today, white wedding dresses are popular, but
traditional bridal ensembles are still worn for the
performing of rituals in front of parents and ancestors,
and during the wedding banquet.

These shoes were handmade by the Sun Sun Shoes
Factory, located at 32 Lyndhurst Avenue, Hong Kong.
The Hong Kong footwear industry began in the
mid-1920s, producing mostly rubber and canvas shoes,
and expanded rapidly in the 1930s to meet the growing
demands of the export market. By the 1950s, it was
thriving, making nearly every type of footwear –
including leather shoes, casual and formal, bespoke
and mass-produced – to cater to the latest fashions
in the local and overseas markets.

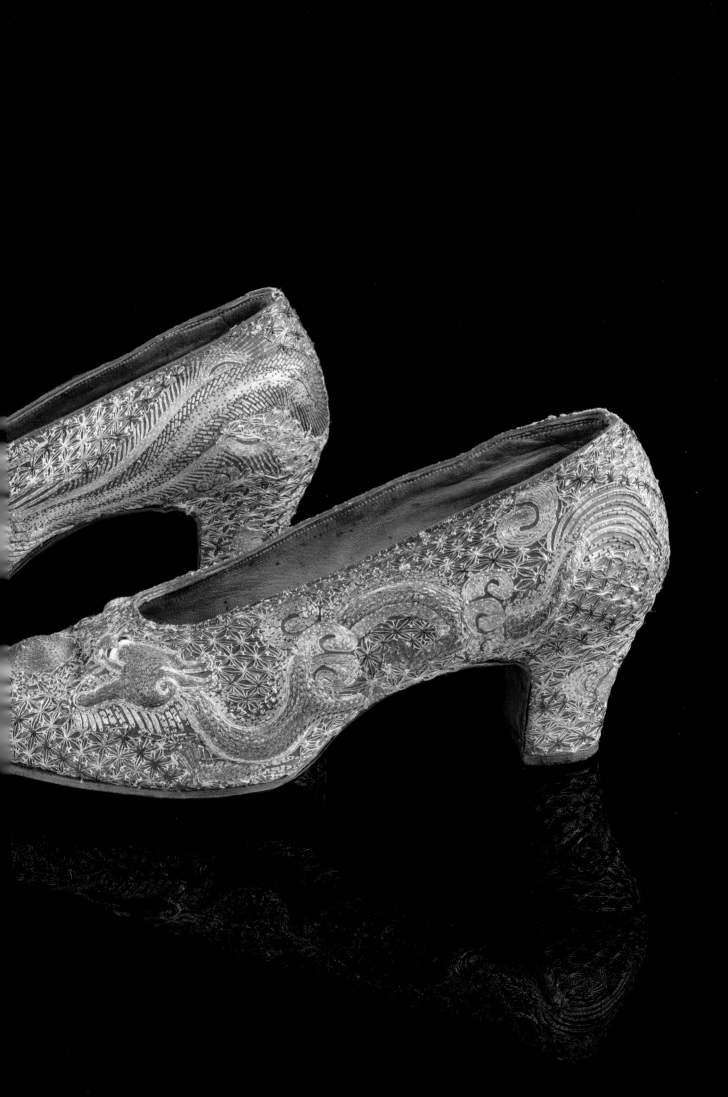

Ao Upper garment of the Han people.

Appliqué Method of applying decoration to a fabric's surface, usually by stitching pieces of other fabrics or trimmings.

Badam Almond (Persian).

Bian xiu Braid embroidery.

Bias cut Cutting the fabric at a 45°-angle to the weave.

Biji Piled-up pleats.

Brocading Creating a pattern in a weave with one or more discontinuous, supplementary wefts.

Bufu Insignia coat.

Buyao 'Step and sway'; a type of women's hair ornament incorporated with a 'trembling' feature.

Canvas work Form of counted thread embroidery, in which decorative stitches are worked on a canvas ground to create a dense pattern covering much of the ground material.

Cao xie Grass slippers.

Chaofu Court dress.

Chapan Type of overcoat worn by men and women in Central Asia.

Changyi Long robe with side vents to the armpits, worn by Manchu women as outer dress.

Chengyi Ready-made clothes.

Chenyi Long robe without skirt vents, worn by Manchu women as everyday wear.

Cosplay 'Costume play'; dressing up and pretending to be a fictional character.

Couching Embroidery technique with the threads laid on the fabric surface and secured with small stitches worked with similar or contrasting thread.

Crochet Form of lace worked with a hook and a continuous thread.

Cutwork Technique used to change the structure of a fabric by removing small areas. The spaces are sometimes infilled with decorative stitching.

Damask Single-colour, reversible fabric, with the pattern formed by contrasting shiny warp face areas and matt weft face areas.

Dart Stitched fold of fabric for helping to shape a garment.

Diancui 'Dotting kingfisher feather'; the technique of applying kingfisher feathers onto precious metals.

Dianzi Style of headdress worn by Qing court women on festive occasions.

Doppa Skull cap.

Double-faced embroidery Embroidery technique for achieving identical designs on both sides of the fabric.

Douli Wide-brimmed conical hat made from woven bamboo.

En tremblant To tremble (French).

Endless knot One of the Eight Treasures of Buddhism.

Essence d'orient Pearl essence (French); a substance derived from fish scales, used to coat glass beads to make imitation pearls.

Fengmao Hat with an extended back to block the wind.

Floss silk Untwisted silk thread.

Frogging Decorative fastenings.

Fu Bat; an emblem of happiness.

Gauze-weave Technique where the warps are crossed and uncrossed between the wefts at intervals to create a transparent openwork fabric.

Gusset Small triangular or diamond-shaped piece of fabric inserted under the arms or crotch to aid movement and facilitate a garment's fit.

Guyipu Secondhand clothes dealer.

Hanfu Traditional clothing of the Han people.

Hanyang zhezhong Fashion style led by China's Gen Z; a playful and eclectic combination of Chinese and western elements, often mixing classic and retro styles of western dress with *hanfu*.

Horse jacket A type of waist-length garment, derived from the riding jacket of the Manchu military.

Huaniu Flowery buttons.

Hufu Foreign dress.

Huxun wu 'Barbarian swirling dance'; a type of traditional Turkic dance that originated with the Sogdian people, also known as the 'Sogdian swirl'.

Jacquard loom: Punch-card device for selecting patterns on handlooms or power looms; invented initially to replace the drawboy or drawgirl, who worked with the weaver on the drawloom.

Ji Hairpin.

Jiapao Lined robe.

Jiaxie Resist-dyeing technique, where fabric is clamped between wooden boards carved with a pattern; also known as 'clamp-resist dyeing'.

Jifu Auspicious dress.

Jinyu Goldfish.

Juwan Young married woman with children.

Kanjian Sleeveless jacket, also known as *beixin* or *jinshen* ('close-fitting').

Kesi Tapestry weave technique using silk yarns, with open slits appearing between colour changes in the weft; also known as 'carved' or 'cut' silk.

Ku Trousers.

Ladao Wax knife.

Langan Baluster.

Liangmao Cool hat.

Lingzhi Fungus of immortality.

Lishui Standing water.

Macramé Knotting technique for string, cord or other yarns, with the knots arranged in varying sequences to create different patterns.

Magua 'Horse jacket'; a type of waist-length garment, derived from the riding jacket of the Manchu military.

Ma mian qun 'Horse-face' skirt; a panelled pleated skirt worn by Han women.

Matixiu Horse-hoof cuff.

Mitre The join between two pieces of braid laid at a 90° angle, so that the bisecting angle is 45°.

Mo e Headband worn by Han women.

Muji Wooden clogs.

Openwork Embroidery technique with the ground threads pulled or removed, then secured to form a mesh-like structure.

Pankou Decorative loop-and-knot buttons made from fabric or cords.

Peacock-feather threads Bluish-green silk threads entwined with peacock-feather filaments.

Pipa Four-stringed Chinese musical instrument.

Piqiu hua Flower-balls; decorative patterns of floral roundels.

Plain-weave An over-one, under-one weave structure for achieving an even, balanced weave.

Pulled-thread embroidery An openwork embroidery type with the warp and weft threads pulled together to make small holes by tightening stitches.

Qilin Mythical creature.

Qipao Style of fitted dress worn from the late 1920s, with a high collar, side closure and long side slits; also known as *cheongsam*.

Qun gua Traditional bridal ensemble for a Han woman, comprising a jacket and pleated skirt.

Raw silk Silk from which the gum (sericin) has not been removed.

Rayon Generic term for filaments made from modified cellulose; formerly known as 'artificial silk'. Developed in the late 19th century, it was the first manmade fibre to be mass-produced and became more widely available after the First World War.

Resist-dyeing Method of patterning fabric or yarn by protecting selected areas from dye with a resist agent, often wax or paste, which is then removed. Repeating this process creates a multicoloured pattern.

Ric-rac Flat, woven braid made in a zig-zag form.

Rong hua: 'Velvet flower'; artificial flowers made of floss silk on twisted metal wire.

Ruyi Lappet shape derived from a fungus. A homophone for 'everything as you wish it'; also refers to a sceptre.

Sasanian Iranian dynasty (224–651).

Satin Weave and fabric with a smooth, shiny surface, with the warp threads covering the wefts completely. Usually used for silk or manmade fibres.

Selvedge Outer edge of the fabric parallel to the warp, often more densely set than the rest of the fabric. Made by the wrapping of the weft threads round the outermost warp threads.

Shou: Character for 'longevity'.

Shuangxi Character for 'double-happiness'.

Shuttle Tool for carrying the thread of the weft yarn, thrown or passed back and forth between warps.

Sizing Compounds applied to yarn or fabric to improve smoothness, abrasion resistance, stiffness, strength, weight or lustre.

Sogdian Iranian peoples whose homeland, Sogdiana, was in present-day Uzbekistan and Tajikistan.

Suo bian xiu Overlock embroidery.

Tambour work Embroidery technique of forming surface chain stitches with a hook needle, often used to decorate machine net.

Tent stitch A short, slanted type of needlework made in even lines of stitches from left to right.

Tongcao Pith paper sourced from the *Tetrapanax papyrifera* plant.

Tongcao hua 'Pith-paper flower'; artificial flowers made from pith paper.

Toyi Ceremony.

Tulle Fine machine-made net with a hexagonal mesh of silk, cotton or manmade fibre.

Tuo xie Slippers.

Twill Method of weaving to produce a diagonal rib across the fabric.

Uygurs The main Turkic-speaking ethnic group in Xinjiang Uygur Autonomous Region in northwest China.

Velvet Weave and fabric with pile made with one or more additional warps, which are looped during weaving and then cut or left uncut to form the pile.

Velvet, voided Type of velvet with areas of ground with no pile, but in plain or satin weave to contrast with the texture of the pile.

Wa yun 'Digging cloud'; technique of cutwork with the fabric cut into the shape of a cloud.

Wanxiu Rolled sleeves.

Warp Threads secured to the loom that run the length of the fabric.

Waste silk Silk from broken or defective cocoons, or from the waste from reeling silk; occasionally spun into threads.

Weft Threads passed through the warps by the weaver, using a shuttle.

Wutuo Spiral pattern.

Xiapei Woman's court vest.

Xian xie String shoes.

Ya Elegance or refinement.

Yuanbaoling High, flaring collar shaped like an ingot.

Yunjian 'Cloud collar'; a quatrefoil yoke-like garment, covering the neck, shoulders, chest and back.

Zan Hairpins for women.

Zheshan Folding fan.

Bellér-Hann, Ildikó, *Community Matters in Xinjiang, 1880-1949: Towards a Historical Anthropology of the Uyghur* (Leiden and Boston, 2008)

Breward, Christopher, and Juliette MacDonald (eds), *Styling Shanghai* (London, 2020)

Campbell, Roderick B., et al, 'Consumption, Exchange and Production at the Great Settlement Shang: Bone-working at Tiesanlu, Anyang', *Antiquity*, vol. 85, no. 330, December 2011, pp. 1279-97

Carey, Jacqui, *Chinese Braid Embroidery* (Tunbridge Wells, Kent, 2007)

Chen, BuYun, *Empire of Style: Silk and Fashion in Tang China* (Seattle, 2019)

Cheng, Weiji (ed.), *History of Textile Technology of Ancient China* (New York, 1992)

Crill, Rosemary, Jennifer Wearden and Verity Wilson (eds), *Dress in Detail from around the World* (London, 2002)

Dickinson, Gary, and Linda Wrigglesworth, *Imperial Wardrobe* (Woodbridge, Suffolk, 1990)

Du, Bing Zhuang, *Chinese Fans* (Shanghai, 1996)

Finnane, Antonia, *Changing Clothes in China: Fashion, History, Nation* (London, 2007)

Forsyth, Thomas Douglas, *Report of a Mission to Yarkund in 1873, under Command of Sir T.D. Forsyth, with Historical and Geographical Information regarding the Possessions of the Ameer of Yarkund* (Calcutta, 1875)

Gao, Hanyu; trans. Rosemary Scott and Susan Whitfield, *Chinese Textile Designs* (London, 1992)

Garrett, Valery M., *Chinese Clothing: An Illustrated Guide* (Oxford and Hong Kong, 1994)

Gordon, Thomas Edward, *The Roof of the World: Being the Narrative of a Journey over the High Plateau of Tibet to the Russian Frontier and the Oxus Sources on Pamir* (Edinburgh, 1876)

Kite, Marion, 'Collagen Products: Glues, Gelatine, Gut Membrane and Sausage Casings', *Conservation of Leather and Related Materials* (Abingdon-on-Thames, Oxfordshire, 2006), pp. 192-7

Laing, Ellen Johnston, 'Notes on Ladies Wearing Flowers in their Hair', *Orientations*, vol. 21, no. 2, February 1990, pp. 32-9

Lee, Mei-yin, and Florian Knothe, *Embroidered Identities: Ornately Decorated Textiles and Accessories of Chinese Ethnic Minorities* (Hong Kong, 2013)

Ling, Wessie, and Simona Segre Reinach (eds), *Fashion in Multiple China: Chinese Styles in the Transglobal Landscape* (London, New York, 2018)

Nesbitt, Mark, Ruth Prosser and Ifan Williams, 'Rice-paper Plant – Tetrapanax Papyrifer: The Gauze of the Gods and its Products', *Curtis's Botanical Magazine*, vol. 27, no. 1, March 2010, pp. 71-92

Olsen, Stanley J., 'Dating Early Plain Buttons by their Form', *American Antiquity*, vol. 28, no. 4, April 1963, pp. 551-4

The Palace Museum, *Costumes and Accessories of the Qing Court* (Beijing, 2005)

— *Jewelry of the Empress and Imperial Concubines in the Collection of the Palace Museum* (Beijing, 2012)

— *Outer Garments of the Qing Imperial Consorts* (Beijing, 2014)

Paulocik, Chris and R. Scott Williams, 'The Chemical Composition and Conservation of Late 19th and Early 20th Century Sequins', *Journal of the Canadian Association for Conservation*, vol. 35, 2010, pp. 46-61

Qian, Gonglin, *Chinese Fans: Artistry and Aesthetics* (San Francisco, 2004)

Roberts, Claire (ed.), *Evolution and Revolution: Chinese Dress 1700s-1900s* (Sydney, 1997)

Rong, Xinjiang, 'The History of Sogdians in China', in *The Cambridge History of China, Part 2: Society and Realia* (Cambridge, 2019), pp. 374-83

Silberstein, Rachel, 'Cloud Collars and Sleeve Bands: Commercial Embroidery and the Fashionable Accessory in Mid-to-Late Qing China', *Fashion Theory*, vol. 21, no. 3, 2017, pp. 245-77

— *A Fashionable Century: Textile Artistry and Commerce in the Late Qing* (Seattle, 2020)

— 'Fashionable Figures: Narrative Roundels and Narrative Borders in Nineteenth-Century Han Chinese Women's Dress', *Costume*, vol. 50, no. 1, 2016, pp. 63-89

— 'Other People's Clothes: The Secondhand Clothes Dealer and the Western Art Collector in Early Twentieth-Century China', *West 86th: A Journal of Decorative Arts, Design History and Material Culture*, vol. 26, no. 2, 2019, pp. 164-87

Silverman, Cathy, 'Shagreen: The History and Conservation of Decorative Ray Skin in Furniture', *Material Imitation and Imitation Materials in Furniture and Conservation*, 13th International Symposium on Wood and Furniture Conservation (Amsterdam, 2016), pp. 63-73

Song, Zhaolin (ed.), *The Splendor of Ethnic Costumes and Accessories from Guizhou* (Taipei, 2015)

Vollmer, John E. (ed.), *Berg Encyclopedia of World Dress and Fashion: East Asia* (London, 2011)

Watt, James C.Y., et al., *China: Dawn of a Golden Age, 200-750 AD* (New York, 2004)

Williams, S. Wells, *A Chinese Commercial Guide* (Hong Kong, 1863)

Wilson, Ming (ed.), *Imperial Chinese Robes from the Forbidden City* (London, 2010)

Wilson, Verity, *Chinese Dress* (London, 1986)

Xinjiang Uygur Autonomous Region Museum, *Costume Essence in Ancient Western Regions* (Beijing, 2010)

Yang, Yuan (ed.), *Chinese Costumes: Fashions for 100 Years* (Hohhot, China, 2003)

Zhang, Hongjuan, *Bead Embroidery: Art and Design* (Beijing, 2018)

Zhang, Xueyu, 'Studies on the Tongcao Flower-making in the Qing Court in the 18th Century,' *Social Science of Beijing*, 2018, pp. 66-75

Zhao, Feng, *Treasures in Silk: An Illustrated History of Chinese Textiles* (Hangzhou, 1999)

Zhao, Feng (ed.), *Textiles from Dunhuang in UK Collections* (Shanghai, 2007)

Zhou, Xun, and Gao Chunming, *5,000 Years of Chinese Costumes* (Hong Kong, 1987)

Zhou, Xun, and Gao Chunming (eds), *The Dictionary of Chinese Dress and Accessories* (Shanghai, 1996)

Acknowledgments

I would like to express my heartfelt gratitude to all those who have contributed to this project.

First and foremost, I would like to thank Sarah Duncan for her superb photography, and to Elizabeth-Anne Haldane, Nora Brockmann, Lauren Isles and Katrina Redman, who have devoted their time and expertise to the preservation and mounting of these garments. I am especially grateful to metal conservator and gemmologist Joanna Whalley for her identification of gemstones and pearls.

Many thanks to Xiaoxin Li and Anna Jackson, Curator and Keeper of the Asia Department at the Victoria and Albert Museum, for their guidance, encouragement and feedback throughout the writing process, and to Hannah Newell at V&A Publishing for steering me through the production process.

I would also like to thank the team at Thames & Hudson for their dedication to the detail in producing this book, with particular thanks to editor Elain McAlpine and production controller Susanna Ingram, as well as picture researcher Fredrika Lökholm and Isa Roldán for her beautiful design.

Lastly, I would like to thank my family and friends for their patience and support during the long hours of research and writing.

Picture Credits